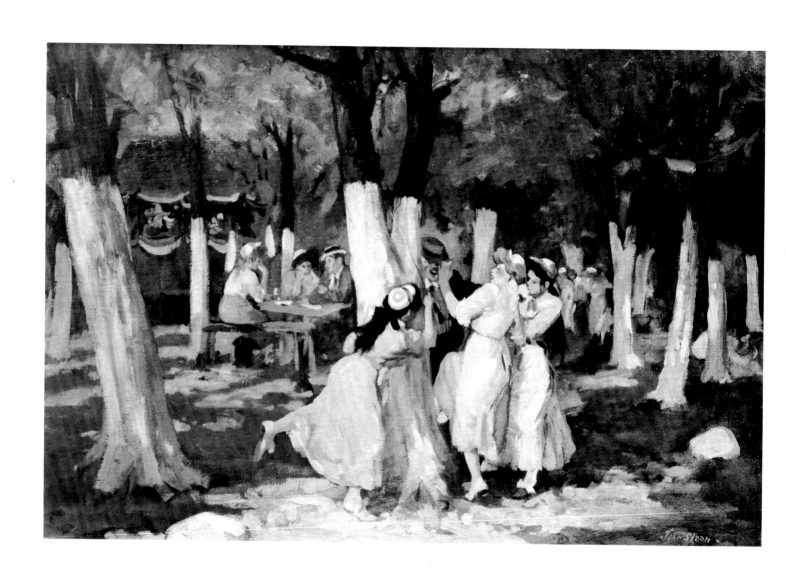

Turn-of-the-Century America

PAINTINGS GRAPHICS PHOTOGRAPHS 1890–1910

by Patricia Hills

Whitney Museum of American Art, New York

Sponsored by JCPenney in celebration of its 75th anniversary

to my mother,
Glennie Gorton Baker

Turn-of-the-Century America
Paintings, Graphics, Photographs, 1890–1910
Copyright © 1977 Whitney Museum of American Art,
945 Madison Avenue, New York, N.Y. 10021

Library of Congress Cataloging in Publication Data

Hills, Patricia.
 Turn-of-the-century America.

 Bibliography: p.
 1. Art, American—Exhibitions. 2. Art, Modern—19th
century—United States—Exhibitions. I. Whitney Museum
of American Art, New York. II. Title.
N6510.H5 760'.0973'07401471 77-7543
ISBN 0-87427-019-7

Turn-of-the-Century America
Paintings, Graphics, Photographs, 1890–1910

Whitney Museum of American Art, New York
June 30–October 2, 1977

The St. Louis Art Museum, St. Louis, Missouri
December 1, 1977–January 12, 1978

Seattle Art Museum, Seattle, Washington
February 2–March 12, 1978

The Oakland Museum, Oakland, California
April 4–May 28, 1978

COVER: Detail of *Central Park, 1901,* by Maurice Prendergast.
Watercolor on paper, 14⅜ x 21½ inches.
Whitney Museum of American Art, New York.
FRONTISPIECE: John Sloan. *The Picnic Grounds,* 1906/07.
Oil on canvas, 24 x 36 inches.
Whitney Museum of American Art, New York.

Contents

Acknowledgments

Wɪᴛʜᴏᴜᴛ ᴛʜᴇ ɢᴇɴᴇʀᴏᴜs help of a great number of individuals I would not have been able to organize this exhibition within our tight time schedule. I want especially to thank the public and private collectors, as well as the following, for calling my attention to collectors, research resources and art works:

Albert K. Baragwanath; Leroy Bellamy; Dr. E. Maurice Bloch; Arlene Boatwright; David Brooke; John Caldwell; Bruce Chambers; Sarah Clark; Arthur Cohen; John Coplans; Evelyne Daitz; Benjamin Eisenstat; Rowland Elzea; Sarah Faunce; Stuart P. Feld; Lois Marie Fink; John Gernand; Lucretia Giese; Lloyd Goodrich; Frank Goodyear; Robert C. Graham; Elizabeth H. Hawkes; Therese Thau Heyman; Frederick D. Hill; John K. Howat; Martha Jenks; Robert Flynn Johnson; David Kiehl; Eileen King; Susan Kismaric; Antoinette Kraushaar; Kenneth A. Lohf; Dennis Longwell; Robert Looney; Laura C. Luckey; Reginald McGhee; Jerald C. Maddox; Mary Jean Madigan; Peter Morrin; Michael Moss; Weston Naef; Nancy Neilson; George Neubert; Ann Percy; Dorothy W. Phillips; Dianne H. Pilgrim; George Post; Robert Rainwater; Henry Reed; Gary Reynolds; Georgia Riley; Nancy Rivard; Anne Rorimer; Naomi and Walter Rosenblum; Elizabeth Roth; Robert Scurlock; Darrel Sewell; Lewis I. Sharp; Mrs. John Sloan; Natalie Spassky; John Szarkowski; Nicki Thiras; William H. Truettner; Jerry Tucker; Robert C. Vose, Jr.; Roberta Waddell; Samuel J. Wagstaff; Jean Weber; Joe Crawford; James Maroney; Steven Miller.

I also want to thank the staff at the Whitney Museum. I am particularly grateful to Jennifer Russell, Assistant Curator, who took on the task of hunting down photographs for the illustrations and for attending to numerous details with patience, intelligence and a good humor which sustained us all. Anita Duquette and David Hupert made useful suggestions, and Mary Anne Staniszewski typed many parts of the manuscript. I wish to thank Tom Armstrong, Director, for his initial support, for his advice while I was formulating the perimeters of the exhibition, and for his continuing enthusiasm.

Joseph Bourke Del Valle, the book's designer, made recommendations which clarified many decisions regarding the catalogue. Mitchell Cutler was indispensable in tracking down dates and information about many artists and their works. Harriet Rosen was also involved in researching material.

I am also grateful to Arthur Anderson, Chairman, Department of Fine Arts/Performing Arts at York College, City University of New York, where I teach full time, for his support of my project.

Wanda Corn, Deborah Gardner and Naomi Rosenblum read parts or all of the manuscript in various states of its development. Their constructive criticisms were most helpful to me while I was sifting through the research material and developing a number of interpretations in the process of writing the essay.

Finally my deepest gratitude is to my husband, Kevin Whitfield, who encouraged me throughout all the stages of the exhibition and who read the catalogue essay in its many drafts. His comments and insights were invaluable. To our children, Christina, Mary, Bradford and Emily, whose committment to their own kind realism has kept our lives in balance, my special thanks.

P.H.

Foreword

THE TURN-OF-THE-CENTURY years have a special significance for JCPenney as our company was founded in 1902 in Kemmerer, Wyoming.

It is a privilege for us, in celebration of our 75th anniversary, to sponsor the Whitney Museum's first in-depth survey of the pictorial arts of the turn-of-the-century period.

By examining the rich variety of paintings, photographs, posters, cartoons, and illustrations included in this exhibition, viewers will gain a fresh insight into the dynamics of an optimistic yet turbulent era of marked social change and economic expansion in this country.

We are indebted to Patricia Hills for her illuminating documentation of the turn-of-the-century era and for her selection for this exhibition of the most exemplary works of art produced in the period.

Donald V. Seibert
Chairman of the Board
J.C. Penney Company, Inc.

Lenders to the Exhibition

Achenbach Foundation for Graphic Arts, The Fine Arts Museums of San Francisco; Addison Gallery of American Art, Phillips Academy, Andover, Massachusetts; Brandywine River Museum, Chadds Ford; Museum of Fine Arts, Boston; The Brooklyn Museum, New York; Museum of Art, Carnegie Institute, Pittsburgh; Case Western Reserve University, Cleveland; The Art Institute of Chicago; Columbia University, New York; Cooper-Hewitt Museum of Decorative Arts and Design, Smithsonian Institution, New York; Corcoran Gallery of Art, Washington, D.C.; The Currier Gallery of Art, Manchester, New Hampshire; Delaware Art Museum, Wilmington; The Detroit Institute of Arts; Ex Libris, New York; Ben and Beatrice Goldstein Foundation, New York; Graham Gallery, New York; Hirschl and Adler Galleries, New York; Hirshhorn Museum and Sculpture Garden, Smithsonian Institution, Washington, D.C.; Hudson River Museum, Yonkers, New York; The Hyde Collection, Glens Falls, New York; Kraushaar Galleries, New York; Montclair Art Museum, Montclair, New Jersey; Munson-Williams-Proctor Institute, Utica, New York; Clyde M. Newhouse and Newhouse Galleries, New York; New Jersey State Museum, Trenton; The Metropolitan Museum of Art, New York; Museum of the City of New York; The Museum of Modern Art, New York; National Academy of Design, New York; The New York Public Library, Astor, Lenox and Tilden Foundations; The Oakland Museum; The Parrish Art Museum, Southampton, New York; Pennsylvania Academy of the Fine Arts, Philadelphia; Free Library of Philadelphia; Philadelphia Museum of Art; The Phillips Collection, Washington, D.C.; Piedmont Driving Club, Atlanta; Museum of Art, Rhode Island School of Design, Providence; International Museum of Photography at George Eastman House, Rochester, New York; Memorial Art Gallery of the University of Rochester, New York; The St. Louis Art Museum; Robert Schoelkopf Gallery, New York; Seattle Art Museum; Vassar College Art Gallery, Poughkeepsie, New York; University of Virginia Art Museum, Charlottesville; James Van DerZee Institute; Washington University Gallery of Art, St. Louis; Library of Congress, Washington, D.C.; National Collection of Fine Arts, Smithsonian Institution, Washington, D.C.; National Gallery of Art, Washington, D.C.; Whitney Museum of American Art, New York; The Witkin Gallery, Inc., New York; Worcester Art Museum, Worcester, Massachusetts; Yale University Art Gallery, New Haven; University of California at Los Angeles Research Libraries; The Forbes Magazine Collection, New York; Scurlock Studios, Washington, D.C.

Mrs. Raymond Pace Alexander; Arthur G. Altschul; Jeffrey R. Brown; Mrs. Charles Burlingham; Marian W. Cobin; David Daniels; Mr. and Mrs. Benjamin Eisenstat; Robert C. Graham; Mr. and Mrs. Raymond J. Horowitz; Mrs. Diana Bonnor Lewis; Robert Mapplethorpe; Ray Winsor Moniz; Joel S. Post; Mr. and Mrs. Meyer P. Potamkin; Joseph Pulitzer, III; Walt Reed; Naomi and Walter Rosenblum; Eugene M. Schwartz; Mrs. John Sloan; Victor D. Spark; Mr. and Mrs. Ralph Spencer; Samuel J. Wagstaff; Mrs. Fred S. Walter; Paul F. Walter; Jane Penfield. Anonymous lender.

Introduction

The Expansionist Spirit in America

In 1890 a period in American history drew to a close, with the Superintendent of the Census reporting that the Western frontier no longer existed. That same year James G. Blaine, Secretary of State, declared, "Our great demand is expansion. I mean expansion of trade with countries where we can find profitable exchanges."[1] The frontier, it seems, was about to move overseas.

Indeed, "expansion" seems to be the word that best characterizes the period from 1890 to 1910 when the country was marked by an unprecedented growth of the economy in terms of building construction, industrial development, consumer goods manufacture, land acquisition, foreign trade and international finance. In terms of population, the country grew in that twenty-year period from a figure over 62.9 million to almost 92 million, with much of the gain the result of an accelerated immigration. (In 1907, the number of arriving immigrants totaled over 1.28 million, the highest figure ever.)

In presidential politics the era saw the rise of the flamboyant and energetic Theodore Roosevelt, a figure who stirred controversies, made enemies and captured the imaginations of millions of Americans, including the cartoonists and satirists. If his tenure did not define the era, it certainly characterized it.

As the decade of the 1890s opened, Roosevelt was a presidential appointee on the Civil Service Commission. In 1895, he was made head of the New York City police board where he earned a reputation as a zealous reformer. In the meantime, Roosevelt's ambitions were aimed at higher goals. He had read Captain Alfred Thayer Mahan's timely book *The Influence of Sea Power Upon History, 1660-1783* (1890) and had become converted to the belief that the United States must become a major sea power. Aided by his friend Senator Henry Cabot Lodge and others, he managed to secure the post of Assistant Secretary of the Navy in 1897. With the outbreak of the Spanish-American War, he resigned this post and organized, along with Leonard Wood, a volunteer regiment known as the Rough Riders. After the war, the returning hero handily won the governorship of New York in 1898; two years later, he was tapped by the Republican Party to run as a vice-presidential candidate with the incumbent, President William McKinley.

On September 6, 1901, McKinley was shot by an anarchist during a visit to the Pan-American Exposition in Buffalo. The day he died, September 14, Roosevelt was sworn into office. Roosevelt's assumption of presidential duties provided him with the unprecedented opportunity to move the United States onto stage center of world politics. Already the country had acquired overseas territory: in 1899 the U.S. gained Puerto Rico, the Philippines and Guam; in 1900, the U.S. annexed the strategically located Hawaiian Islands. Roosevelt believed that the overseas expansion—called "imperialism" by his enemies—was essential for the economic and political interests of the country, and he plunged the U.S. into further involvement in Far Eastern, African and Central American affairs.

He was also shrewd enough to sense the changes being wrought within American society, and the need to promote national unity as a first step toward international expansion. A strategy he adopted was to respond to the social reformers and spur government action to relieve some of the miseries of the poor and to regulate organized wealth. He urged child labor regulations, supported numerous land conservation measures and pure food acts, and initiated the anti-trust suits against the big corporations, all measures which met with popular support.

An aspect of expansion was the immigration of Europeans and Asians to America and migration of workers from the farms to the cities. European peasants, impoverished and often persecuted in the Old World, were lured by the promises of fresh opportunities in America and by the promotional efforts of American industrialists looking for cheap labor. Concurrently the period saw shifts of the black population within the country. Driven by the increased terrorism of mob violence and lynchings, and attracted to the prospect of jobs, some 200,000 blacks migrated from the South to the North and West between 1890 and 1910. Both immigrants and blacks settled primarily in the large cities and experienced numerous hardships. Overcrowded tenements with windowless rooms were breeding grounds for tuberculosis and in bitter cold winters pneumonia took a fearful toll. Human and institutional adversaries were more formidable, and immigrants and blacks found discrimination on the jobs and in the unions.

To the social reformers of the period, Roosevelt's measures represented only the first beginnings of the programs needed to eradicate the deplorable living conditions of the working people of the crowded cities. The prolonged economic depressions of the era—the Panic of 1893 and those of 1903 and 1907—only aggravated the contradiction of vast poverty amidst plenty.

Industrial expansion which increased profits and the blatant conspicuous consumption of the new rich, inevitably created countercurrents of resistance. As wages were reduced, organized labor protested with its major weapon, the strike. During the 1890s and into the twentieth century there was an increase in the number of strikes, with the Homestead strike of 1892 and the Pullman strike of 1894 being among the most prolonged and violent of the decade. Meanwhile, trade union membership soared from 447,000 in 1897 to 2,072,700 in 1904. The writer Upton Sinclair and the labor leader Eugene Victor Debs converted to socialism; other radicals also embraced Marxist ideology, especially after the unsuccessful Russian Revolution of 1905 raised the possibility of world-wide revolution.

The 1890s also witnessed an expanded number of women in the urban work force, both native-born Americans and immigrants. Working women carried on struggles to raise their wages and improve work conditions; in 1909, women shirtwaist makers organized a successful strike. Middle-class women found more opportunities to complete a higher education, and many entered the professions of law, medicine and architecture, although in absolute terms their numbers were still small. Many of these educated women led the social reform movements; in 1899 Jane Addams co-founded Hull House in Chicago, and in 1893 Lillian D. Wald started a visiting nurse service which became the nucleus of the Henry Street Settlement in New York. Other middle-class women demanded equal rights at the polls. Led by courageous women, such as Susan B. Anthony and Elizabeth Cady Stanton, feminists marched and lobbied to bring public attention and approval to their cause.

The spirit of expansion and innovation invaded other areas as well, and technological advances were made in the fields of communications and transportation. Electricity lit up the cities in the 1890s and telephones were becoming indispensible in businesses. In October 1899, the New York *Herald* invited Guglielmo Marconi to the United States to demonstrate his wireless device by giving on-the-spot reports of the America's Cup Race. The U.S. Navy took an interest, as did the United Fruit Company which used the device to direct and coordinate its plantation operations in Central America. From 1900 to 1910 Reginald Aubrey Fessenden and Lee De Forest experimented with the transmission of human voices over the air waves, and, in 1910, the voice of Enrico Caruso was broadcast over the air from the stage of the Metropolitan Opera.

In 1892 Henry Ford completed his first automobile, and by 1900 there were eight thousand cars on American roads. Reckless drivers became a menace, and city and state governments adopted rules of the road for motorists. In December 1903, Orville and Wilbur Wright flew their flying machine at Kitty Hawk, North Carolina; in 1908 they demonstrated an improved airplane to U.S. Government officials.

The late nineteenth century saw the development of the mechanical reproduction of images. George Eastman's roll-film camera was marketed in 1888, and throughout the 1880s and 1890s improvements were made in the mass reproduction of illustrations and photographs (see Section VII). Thomas Edison, who had pioneered the phonograph, was also experimenting with devices for showing pictures in motion. Another inventor, C. Francis Jenkins, actually made the first projector to show a motion picture in 1894. In 1896, the French brothers Louis and Auguste Lumière exhibited their home-made films in Paris to an audience. In April 1896 a motion picture made by Edison was shown as a vaudeville act to audiences at Koster and Bial's Music Hall in New York City. Shortly after that French moving pictures were also shown in New York City, and in 1903, the first story film, the 12-minute *The Great Train Robbery*, was shown to audiences.

In terms of live performances, show business was booming in America. Florenz Ziegfeld brought the famous Anna Held to his theater and introduced the musical "revue" to the U.S. with his *Follies of 1907*. Evelyn Nesbit, the most notorious showgirl of the era, played the central figure in the trial of her playboy husband Harry Thaw charged with the murder of her ex-lover Stanford White. In the early decade of the twentieth century the famous actresses of the theater were Ethel Barrymore, Maude Adams and Julia Marlowe.

Entertainment on an international level took the form of the great expositions of the era—the World's Columbian Exposition at Chicago in 1893, the Trans-Mississippi International Exposition at Omaha in 1898, the Pan-American Exposition at Buffalo in 1901, the Louisiana Purchase Exposition at St. Louis in 1904, and the Alaska-Yukon-Pacific Exposition at Seattle in 1909—were excuses and occasions for each of the great imperialist nations to display, with a large measure of extravagance, the technological inventions and gadgetry of recent years. Thousands of visitors who went to marvel at American ingenuity lingered to see the variety of American art displayed in the exhibition halls.

Art and Aesthetic Theory at the Turn of the Century

Paralleling the social change, political activity and business expansion of those years, the fine arts also experienced a period of growth. Sadakichi Hartmann, writing *The History of American Art* (1901), estimated that there were at least three thousand artists working in New York, Boston and Philadelphia, and noted the "restless activity, noticeable principally in the success of the World's Fair, the two exhibitions of the Sculpture Society, the increase of public galleries, the opening of the Carnegie Art Institute...and in the introduction of mural painting."[2]

Clara Erskine Clement, in her *Women in the Fine Arts* (1904), also commented on the "activity and expansion in nineteenth-century art quite in accordance with the spirit of the time."[3] Clement credited the expansion to the willingness of artists to experiment with new kinds of subjects, to take advantage of travel opportunities, and to learn from the examples of Japanese art. But she also recognized that new methods of artistic expression such as photography, posters, and illustrations in books, magazines and newspapers were major factors.[4]

Although these writers applauded the range of activity, they often deplored the low level of artistic taste which many felt characterized the nouveau riche Americans whose patronage insured that very expansion of the arts. Hartmann's comments are characteristic of the boldness of art critics in 1901 to criticize the wealthy openly:

American men and women of advanced taste, such as can afford to patronise art, turn rather to epicureanism than to simplicity and strength. After accumulating their wealth, the rich have everything at their command, except the super-refinement of taste and manners which the European nobility have acquired through centuries of indolence.[5]

Charles H. Caffin in *The Story of American Painting* (1907) archly remarked:

The public demand for honest art is so small, the reward it offers to meretriciousness so cordial and handsome. Why not? You cannot make a silk purse out of a sow's ear. A society sprawling on materialism and wallowing in ostentatious display—what should it care for, or even know of, choiceness of taste and reverence for what is true in art? Naturally, since it pays the piper, it calls the kind of tune it likes; and the piper accordingly must debauch his art or step aside and rot. Under such circumstances the artist needs to have a more than commonly stout heart to continue to be true to himself....[6]

Samuel Isham noted in *The History of American Painting* (1905) that many artists had to adjust their style and subjects to suit a buying public which wanted beauty—especially beauty removed from urban realities.

Life in the country and in the open air is more inspiring than that penned up in city rooms and it has been more painted, but even there the tendency has been to make a thing of beauty rather than to give the "true truth." Not only the artists but their patrons preferred it so. The American man finds enough of prose in the day's work. It does not sadden him; on the contrary, he enjoys it and puts all his energies into it, and when he turns from it he demands that art shall do its duty in furnishing delight and that uncomplicated by too much subtlety. He dislikes problem plays that finish badly and realistic novels that simply give again the life he knows, and he wants his pictures beautiful or at least pretty. He doesn't know anything about art, but he knows what he likes, as he proudly proclaims, and no perfection of craftsmanship is going to make him change his likes.[7]

The idea that a *beautiful* picture was antithetical to a *truthful* picture was shared by many at the time. George Santayana in his *The Sense of Beauty* (1896) stated unequivocally:

Science is the response to the demand for information, and in it we ask for the whole truth and nothing but the truth. Art is the response to the demand for entertainment, for the stimulation of our senses and imagination, and truth enters into it only as it subserves these ends![8]

In 1899 Arthur Dow reiterated the attitude that the creation of beauty, rather than truth, was the goal of art:

There are two ways of looking at a picture—one as a record of truth, the other as a work of fine art. The first is the common traditional way, the way of the majority of the people....The second idea, that a picture is a work of fine art, rests upon the thought that art exists only for the purpose of creating beauty; that a picture is not merely a record or memorandum kept for reference, but something beautiful in itself.[9]

To Dow, the audience for art was a special one which appreciated beauty.

To contrast truth to beauty was consistent with the art movement in Europe and America known as "aestheticism," the catch-phrase being "art for art's sake." The movement was a reaction to both the sentimental, anecdotal and nativist, mid-

century genre painting and the panoramic, detailed landscape vistas of the Hudson River School. Whistler, its most flamboyant spokesman, vigorously rejected the theory that painting was an art of imitation and declared that painting was primarily an art of arranging colors and lines on a surface:

> Art should be independent of all clap-trap—should stand alone, and appeal to the artistic sense of eye or ear, without confounding this with emotions entirely foreign to it, as devotion, pity, love, patriotism, and the like. All these have no kind of concern with it and that is why I insist on calling my works "arrangements" and "harmonies."...
>
> The imitator is a poor kind of creature. If the man who paints only the tree, or flower, or other surface he sees before him were an artist, the king of artists would be the photographer. It is for the artist to do something beyond this....[10]

The aesthetic movement was not only anti-realist but also a reaction to the strong tradition of academic idealism—the belief that art should improve upon nature and the imperfections of the human body, and emulate the forms and spirit of "classical" art, whether of fifth-century Greece or the High Renaissance.[11] In this view, art should address itself to questions concerning the "higher" values of religion and morality.

The academic artists, however, sooner or later had to deal with the art-for-art's-sake issue. Kenyon Cox, who championed the academic tradition in his *Concerning Painting* (1917), attempted to reconcile the debate as to whether painting was primarily an art of imitation or of arrangement. He admitted both: "Painting, then, is necessarily a mixed art, partly an imitative art and partly an art of relation. As an art of relation it is allied to the other fine arts and deals with its material as they deal with theirs,"[12] but was obliged to conclude:

> From the whole history of art as we know it, we can only conclude that, in its essential nature, painting is the art of representing on a plane surface (in contradistinction to sculpture which works in three dimensions or, as we say, in the round) the forms and colors of objects. Its origin is in the instinct of imitation. Its most fundamental appeal—not necessarily its highest appeal but its most universal and necessary one—is to the sense of recognition.[13]

To Cox, universal statements about ideal beauty or justice which could be recognized by a large number of people was primary. However, by settling on a solution which allowed the possibility that the aesthetic response—the response to the justness and beauty of formal relations—may be, after all, the "highest appeal," he was revealing himself closer to the art-for-art's-sake camp than he might have been willing to admit.

In 1907, at the point when aestheticism was about to be supplanted by a new emerging realism, Caffin put the issue in perspective:

> [Art for art's sake] had, as other such rallying cries, a modicum of sanity and much extravagance. It was in its best sense a protest against the dependence of painting upon literature, and against the tendency to consider the subject of more importance than the method of representation. It was an assertion never out of place, that the quality of the artistic form must be the final test of a work of art. But it ran to extravagance in assuming that the artistic form was the only test; that what it might embody was of no account at all; that the method of presentation was the first, last, and only important concern of the artist. It put asunder the twain that should be one flesh—the form and the expression. The result was for a time, sterility; much cry and little wool; plenty of good workmanship, but a poverty of emotional or spiritual significance.[14]

Others, at the time, also found that mere displays of technical excellence and decorativeness in a painting could not sustain their interest. The reaction to *mere* technique, soon became a reaction to *mere* beauty. If artists and writers turned to *truth* as a criterion of good art, there were often conflicting views as to what that truth was. Was it to be truth to objective reality, truth to the inner emotional needs of the artists, truth to the fantasies of their patrons, truth to the demands of the media, or truth to a "higher" ideal?

We are bound to inquire whether the art of the era reflected the changing social reality touched upon a few pages ago. Much of it did, but often in ways which are not readily apparent. Simple cause and effect formulae cannot explain the complexity. What we must examine are external historical events, technological developments, patterns of patronage, artists' personal lives, and style change in terms of their interconnectedness and contradictions. Some artists mirrored the concerns, fantasies and ambitions of their patrons—holding onto fading values and comfortable prejudices or idealizing and giving expression to the expansionist spirit. Other artists, particularly toward the close of the first decade of the twentieth century ignored the established art patrons and demanded that art should reveal the artists' responses to contemporary life.

The twelve essays which follow explore the variety of the forms, themes and techniques of the pictorial arts in those years by men and women who professed to be artists and serious

photographers.[15] The British art historian Frederick Antal, writing in 1949, called for such a broad approach:

Art historians are now in a position to take seriously into account the many-sidedness of any one period, the complexity of types of outlook, and the mode of thought among various sections of the public, in order to discover which style belongs to which outlook on life—the notion of style, of course, not being restricted to formal features, but including subject-matter. If we look at the whole of society, not only its topmost layers, we come to understand the *raison d'être* of all pictures, not only the best, the most famous, the full meaning of which cannot, indeed, be really grasped in isolation. The more carefully it is scrutinised, the more easily and naturally does the social, intellectual, and artistic picture throughout a period slowly unfold itself and the way in which its parts are connected become increasingly clarified.[16]

The visual material has dictated the approach and organization of the narrative. Some of the essays explore the historical circumstances, others describe the range of art styles within a given category, while others focus on those theoretical and aesthetic issues touched upon here. Although they are necessarily brief and many important artists have had to be eliminated from the discussion, the essays are intended to provoke further research and thought. Where relevant, the words of the contemporary critics and artists have been marshaled as evidence of certain trends, attitudes and theoretical positions. But the present is always in dialogue with the past, and our concerns today cannot help but inform our understanding of those words and that history.[17]

1. George Willoughby Maynard. *Civilization*, c. 1893. Oil on canvas, 54¼ x 36 inches. National Academy of Design, New York.

I The Mural Movement, Academic Idealism and Decorative Painting

WHEN THE WORLD'S COLUMBIAN EXPOSITION opened in Chicago on May 1, 1893, visitors were astonished by the splendor of the buildings, fountains, canals, walkways, bridges and terraces. Before it closed on October 30, more than 27 million visitors had passed through its gates.[18] The Exposition was a financial and popular success, a triumph for the enterprise of cooperation among the various architects, sculptors, painters, landscape-gardeners and workmen; and it made an impact on American architecture and city planning for the next twenty years. Of its success, Charles H. Caffin commented in 1907:

[The Exposition] taught... the desirableness, even the commercial value, of beauty. The shrewd, large-minded citizens of a city that is essentially the product and assertion of commerce discovered that they could give expression to their own local pride and attract business from outside, not only by following the old crude idea of attempting "the biggest show on earth," but by trying to make it the most beautiful. They succeeded....[19]

Pauline King in her book *American Mural Painting* (1902) was more effusive in her assessment:

The memory of the whole Exposition will remain as an evidence of the devotion to the ideal, which is as distinctly American as a turn for mechanics. Our foreign brethren... looked forward to triumphs of invention more hideous than the unsightly Eiffel Tower.... And what was the reality? Our architects, unaided by experience of precedent, and guided solely by theories and enthusiasm, made on the great waste space allotted to them a fair white vision of palaces that was lovingly named by popular voice *The White City, The Fair City,* and *The City of Dreams*....[20]

The Columbian Exposition was, moreover, important in the history of painting as the impetus to a revival of mural painting in America. The murals designed to accommodate themselves to the grand exhibition halls—the New York State Building, the Agriculture Building, and the Manufacturers and Liberal Arts Building—depicted idealized and heroic men and women representing the arts and sciences, and other standard personifications culled from the history of art, as well as new inventions, such as The Arc Light, The Morse Telegraph and The Dynamo.[21]

In terms of the subjects, styles and ideals which inspired the artists, the murals can be understood as the result of a confluence of contemporary tastes and needs, of historical prototypes, of classicizing tendencies, of aesthetic attitudes, and of stylistic proclivities. But without the taste and money of the patrons, the murals would not have been produced. Although the years 1893 to 1897 were years of economic depression, many businesses were expanding and there was not yet an income tax. The cultured men of wealth, such as Charles Freer, George J. Gould, J. J. Astor, Andrew Carnegie, Collis P. Huntington and William K. Vanderbilt, could more than afford to live as Renaissance princes and decorate their urban mansions and country estates accordingly. The cities, moreover, were booming with activity. As skyscrapers were constructed for commercial purposes, over a dozen new state capitols were erected by local politicians eager to proclaim the history and accomplishments of their regions. In short, both public and private patrons stepped forward to encourage the movement.[22]

American muralists were familiar with nineteenth-century European and American models. In France, Paul Baudry's Paris Opéra murals and Puvis de Chavannes's murals for the Panthéon found admirers among the many Americans studying in Paris. In the United States, artists recalled John LaFarge's decorations for Trinity Church, Boston, a structure designed in the 1870s by H. H. Richardson, and William Morris Hunt's murals for the Albany State Capitol. Before the Columbian Exposition opened, the Trustees of the Boston Public Library had commissioned Puvis de Chavannes, John Singer Sargent and others to design murals for the Library's halls and reading rooms.

Furthermore, the academic training offered by the Ecole des Beaux-Arts, Paris, and other state art academies had conditioned artists to methods and styles which seemed appropriate to mural painting. These academies, and the ateliers of artists who perpetuated their methods, emphasized the rules of drawing

and encouraged the study of antiquity and the High Renaissance as embodying timeless ideals of perfection and beauty.[23] That many American artists were drawn to an idealism based on universal values and the perfection of the human form reflects the post-Civil War spirit.

Idealism in art—the belief that art should be about uplifting ideals—had a long history in America. At mid-century, artistic idealism was associated with patriotism—"one of the best sentiments of the human breast" said one writer for *The Garland* of 1830.[24] Therefore, writers on art encouraged specifically American subject matter, such as the genre painting of William Sidney Mount, George Caleb Bingham and Eastman Johnson, or the landscape views of Asher B. Durand, Frederic Church and Albert Bierstadt. The "idealism" of these painters is still grounded in a particularizing and realistic style.

By the late nineteenth century, however, such scenes and views were considered old-fashioned—hopelessly anecdotal and mechanically realistic in their style. The artists returning from Europe in the late 1870s and 1880s were cosmopolitan and ambitious, analogues to the financiers jockeying for power in the world of international banking. To meet the new needs of cosmopolitan capitalism, the subject matter and the style had to change. The subject matter of art should not be particularized and geared to venerating local traditions, but universal and idealized, reflecting a consciousness that was cosmopolitan and international. Hence, those figure artists drawn to mural painting chose anti-realistic subject matter—idealized women, personifications of civic and religious ideals, or scenes drawn from classical history and mythology.

It can be no coincidence that as the anti-realist concept of art for art's sake gained ground, the academic figure painters were drawn to a decorative style which emphasized play of lines, frontality, simplification of form, and flattening of backgrounds. In other words, the subject matter and style then maturing were perfectly suited to the needs of architecture for a decorative and architectonic art.

The theoreticians of the mural movement judged that whereas deep-space illusionism may be appropriate for panel painting, it should be avoided in murals as a distraction from the architectural unity. The integrity of the flat wall must be maintained. The muralists learned from experience what worked best—pale colors were not always effective, figures often needed heavy outlining for legibility under dim lighting conditions; in short, the site should control many of the aesthetic decisions.

What emerged in the murals was a style which emphasized the three-dimensional modeling of the human form, careful and realistic drawing of drapery, clarity of silhouette and flat backgrounds. Symmetrical compositions with figures firmly planted in the middle kept the intellectual work controlled,

static, and unchangeable. The mural style conformed to the program of Beaux-Arts architecture—avoiding chaos through the rational ordering of spaces. It was also a style suited to the notions of conquest—recalling quite consciously both the classical style of Periclean Athens and the imperial style of Rome.

The mural painters maintained that their decorative art was more than simply "arrangements." Edwin Blashfield in his *Mural Painting in America* (1913) assumed the position of spokesman for other muralists:

> Good art is always art for its own sake, and often for the sake of much beside. If you begin to value it for its *limitations,* you are in danger.... It is true that in a decoration, pattern should appeal first of all—pattern and color and style—and to some extent this applies to every good picture, decoration or not. The sensitive observer quite forgets subject in undergoing the first delightful shock of a beautiful piece of work.... But besides having pattern, color, style, the decoration in a building which belongs to the public must speak to the people—to the man in the street. It *must* embody thought and significance.[25]

To Blashfield, who was openly propagandizing for mural painting in his book, the significance of murals was that they enhanced national prestige, promoted tourism, immortalized the features of important Americans, acquainted the spectator with history, and stimulated patriotism and moral behavior.[26]

A few years after Blashfield's book appeared the number of mural commissions fell off considerably. With the entry of the United States into World War I, building activity ground to a halt, which brought a subsequent loss of patronage to the muralists. However, mural painting was also losing much of its prestige. In the first years of the twentieth century, the movements for social reform put forth their own demands for down-to-earth, concrete embodiments of the ideals of "justice," "truth," and "good government." Thus, a younger generation of artists had no urge to continue the mural movement. They and the writers sympathetic to progress and to radical ideologies found the allegorical figures in mural painting to be sterile, without real significance to the man in the street, and devoid of personal feeling. Hartmann accused the mural artists of having "mumbled old formulas and flattered past style, instead of having resolved to be new."[27] Caffin agreed that the mural painters "are, for the most part, out of touch with the vital forces at work in the community, nor possessed of that vigour and originality which characterises the leaders in other departments of life."[28] The static, architectonic style must have seemed inappropriate to almost everyone in a rapidly changing world of telephones, radios, automobiles, airplanes and war machines.

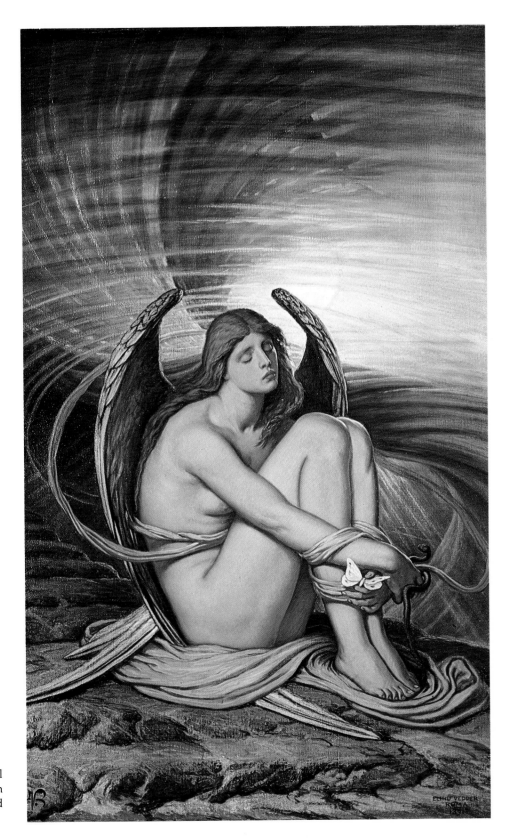

I. Elihu Vedder. *A Soul in Bondage*, 1891. Oil on canvas, 37⅞ x 24 inches. The Brooklyn Museum, New York; Gift of Mrs. Harold G. Henderson.

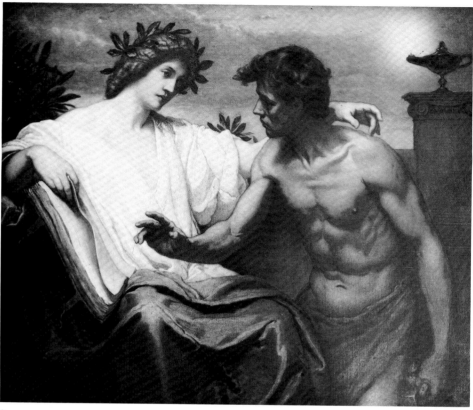

2

3

2. Kenyon Cox. *Science Instructing Industry,* 1898. Oil on canvas, 24 x 29 inches. Case Western Reserve University, Cleveland.

3. Kenyon Cox. *Augustus Saint-Gaudens,* 1908. Oil on canvas, 33½ x 46⅞ inches. The Metropolitan Museum of Art, New York; Gift of Friends of the Sculptor through August F. Jaccaci, 1908.

4. Will Hicok Low. *L'Interlude, Jardin de MacMonnies,* n.d. Oil on canvas, 19¼ x 25½ inches. University of Virginia Art Museum, Charlottesville.

5. Harry Siddons Mowbray. *The Destiny,* 1896. Oil on canvas, 30 x 40½ inches. Hirschl and Adler Galleries, New York.

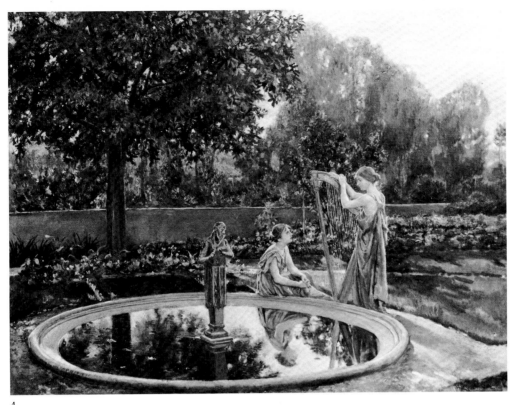

4

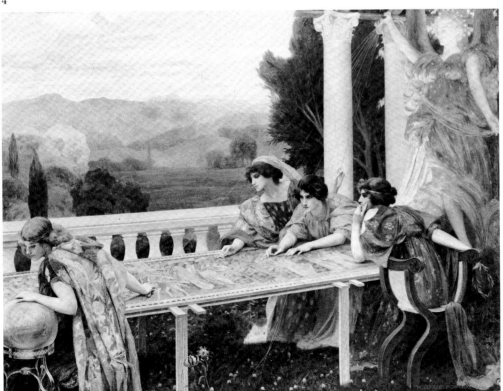

5

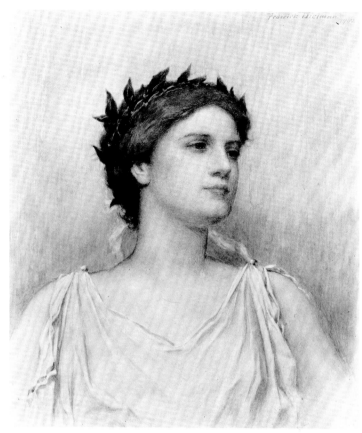

7

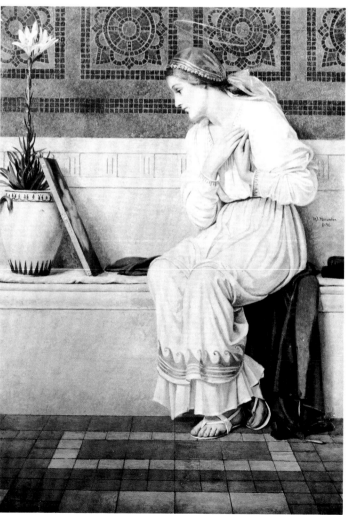

6

6. Mary L. Macomber. *St. Catherine*, 1896. Oil on canvas, 34½ x 24 inches. Museum of Fine Arts, Boston; Gift of the Artist.

7. Frederick Dielman. *Girl with Wreath*, 1902. Watercolor on paper, 14 x 12 inches. Hirschl and Adler Galleries, New York.

8. Edwin Blashfield. *Study of Figure in Panel of Music Room in House of Adolphe Lewisohn Esq.*, c. 1903–04. Charcoal on paper, 28 x 17 inches. Graham Gallery, New York.

9. Abbott Thayer. *Young Woman*, 1899. Oil on canvas, 39⅝ x 31⅝ inches. The Metropolitan Museum of Art, New York; Gift of George A. Hearn, 1906.

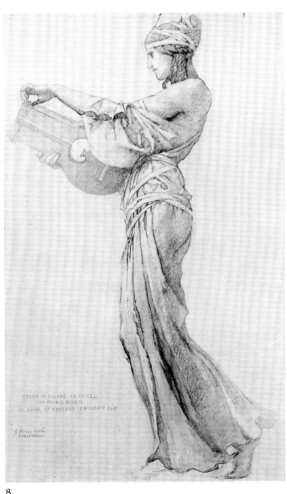

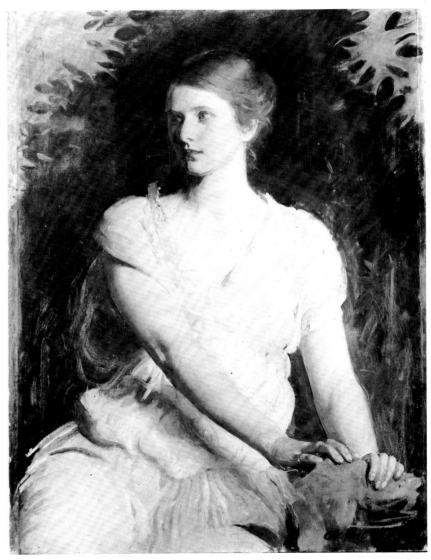

8

9

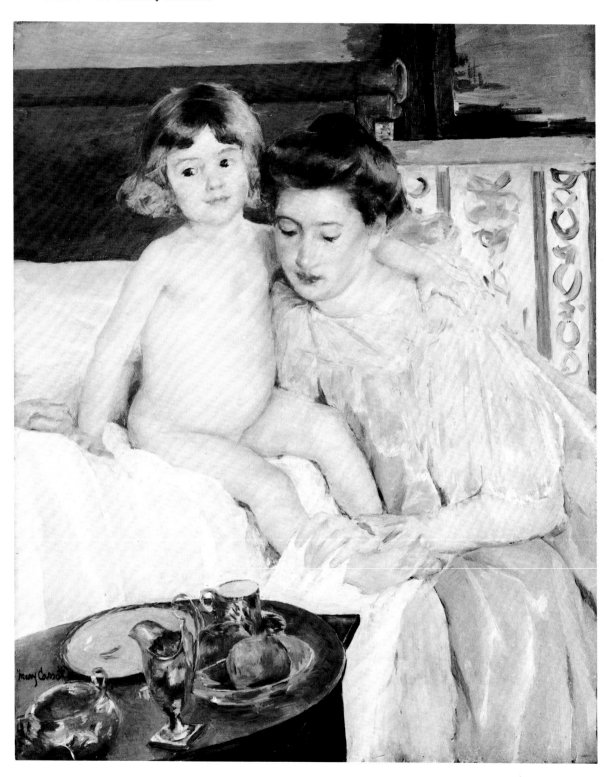

10. Mary Cassatt. *Baby Getting Up from His Nap*, 1901. Oil on canvas, 36½ x 29 inches.
The Metropolitan Museum of Art, New York; George A. Hearn Fund, 1909.

II Tonalists, Realists and Cosmopolitan Artists

At THE TURN OF THE CENTURY when many artists were coming to prominence as muralists, a number of landscape artists and realists uninterested in the idealizing themes of public art were exhibiting their work at galleries and special exhibitions. They represented parallel currents with their own different traditions and they appealed to different audiences. The seeming eclecticism—the diversity of styles, some of which drew on foreign sources and others which tapped an indigenous heritage—was part of the climate of artistic freedom and expansion in the arts. However, each style generally is tied to a specific world view, either shared by many or individual to one artist.

Writers on art during those years seemed unanimous in their praises of three landscape artists—George Inness, Homer C. Martin and Alexander Wyant—men who had found inspiration in the works of French Barbizon painters but who had evolved their own poetic style of painting pastoral landscapes of the American countryside bordering the cities and towns. Nature there represented a solace and spiritual balm to the frantic bustle of city life with its rapid growth, hectic industry, and increasing squalor.[29]

The appeal of the countryside, however, also represented a serious philosophical stance on the part of the artists who rejected not only science, materialism and rationalism, but also the rigid rules of the academy. Anti-intellectual and anti-academic, they revered their own subjective feelings about nature and sought to capture in paint the delicate tonalities and modulations of hushed, still moments—the dying light of day, the quiet moonlight, the early rays of dawn. The style evolved has been called "quietism" because of its mood of elegiac calm, and "tonalism" because the artists often used one color tone to dissolve nature and paint into a blur of poetic feeling.[30]

George Santayana's view of art as the "stimulation of our senses and imagination" was elaborated upon by George Inness:

> The purpose of the painter is simply to reproduce in other minds the impression which a scene has made upon him. A work of art does not appeal to the intellect. It does not appeal to the moral sense. Its aim is not to instruct, not to edify, but to awaken an emotion.... It must be a single emotion if the work has unity, as every such work should have, and the true beauty of the work consists in the beauty of the sentiment or emotion which it inspires.[31]

To Inness, only those details should be used which contribute to the reproduction of a general impression; superfluous details must be suppressed. Influenced by Swedenborgian philosophy, he also felt that nature embodied spiritual qualities which the painter should strive to capture.

Martin, Wyant and Dwight Tryon similarly tried for delicate effects—muted tones, a nuanced atmosphere, mellow and harmonious hues. Other painters of mood included Charles Warren Eaton, H. Bolton Jones, J. Francis Murphy, George H. Bogert, Emil Carlsen, Ralph Blakelock and Edward Steichen. Figure artists with affinities to the landscapists of mood were George Fuller and Albert Pinkham Ryder. However, the charm of transparency and paint surface is gone from much of their work we view today, and the present objects are merely lingering reminders of once poetic images.

To the tonalists, it was Whistler's art, as much as his ideas, which inspired their own creation. They saw in his paintings a delicate immateriality and poetry described sympathetically by Caffin who refused in 1902 to view Whistler's paintings as just art for art's sake:

> ... In all these pictures, it is the essence or innermost significance of the theme that Whistler treats; itself a quality so immaterial that he shrinks from expressing even matter in too distinct or tangible a form, enveloping it in a shrouded light, representing it as a concord of coloured masses with a preference for delicate monotony of hues and soft accentuations, seeking by all means to spiritualize the material.[32]

Leon Dabo, a disciple of Whistler, painted scenes of the Hudson which recall Whistler's nocturnes and symphonies.

The private and poetic response to nature's veils of mist and atmosphere was not shared by all the landscape artists of the

period. Many turned to Manet's boldly stroked impressionism for inspiration and looked at the world in terms of its sensuous material surfaces. Edward Willis Redfield, W. Elmer Schofield, and Winslow Homer translated nature into pictures of broad masses of flat pigment laid on the canvas with a firm touch. They sought to differentiate through color and texture the abrasive qualities of earth, shrubbery, and rock, the harsh character of icy water and blowing surf, and the dynamic forms of clouds swiftly moving through thick skies.

Critics at the turn of the century acknowledged that although realism had been "superseded by other aims and ideals of art," nevertheless, Winslow Homer and Thomas Eakins were recognized artistic forces.[33] Neither was interested in artifice, poetic reverie, or decorative rhythms; they focused instead on reproducing the reality of nature or of the human being with a palpable materiality.

The foremost realist figure painter of the period was Thomas Eakins. He refused to idealize the facts of the human body or to prettify the environment, although he venerated human endeavor and human intellect. His boxing and wrestling scenes were occasions to paint the male nude in an appropriately realistic setting. Through his teachings at the Pennsylvania Academy of the Fine Arts and his force of character, a tradition of realism without contrivance was passed along to younger Philadelphia artists.

More flexible and eclectic in style and subject matter was John Singer Sargent, a man of cosmopolitan manners and tastes who spent much of his time abroad. He did not need a rationale to paint the nude, and he did several posed male nudes in both oil and watercolor.

Another American abroad was Henry O. Tanner, who sought a refuge from the racial prejudice of America in the circle of European artists living in France. He, too, had been trained in the realist tradition at the Pennsylvania Academy of the Fine Arts and had evolved a figure style for his scriptural subjects that was sober and serious. His strongly modeled heads which emerged out of dark and abstract backgrounds combine the real with the ideal in order to sustain a mood of intensely felt religious sentiment.

A bold handling of paint and bravura technique marked the reputation of the cosmopolitan William Merritt Chase, an artist who began as a painterly but somber realist of the Munich School and who became known as an impressionist of highly keyed, summer landscape scenes. As a figure painter he could achieve glowing transparencies and delicacy of touch, as in *The Golden Lady* (Pl. II).

Mary Cassatt, another American figure artist of this period who spent most of her mature career in France, was a light-palette realist. She became friendly with Degas in the 1870s and frequently exhibited with the French Impressionists. However, she developed a wholly personal style stressing strong design, firmness of touch, and a creamy patina of contrasting blond tones. A close study of her paintings often reveals a sensibility aware of the psychological strength of women living domestic and circumscribed lives.

The international artistic currents also included the Art Nouveau style which emerged throughout Europe in the 1890s. Both John White Alexander and Alfred H. Maurer came under the influence of this consciously mannered style, which emphasized asymmetrical compositions, swelling shapes, subdued color, and mysterious black masses. To these artists the human figure—usually a woman with billowing skirts or swelling drapery—is treated as an interesting design element to be stylized and elongated. Oriental motifs such as bowls and round hand mirrors function as exotic props but also as shapes to balance the formal arrangement of the women's oval heads. That their American women have none of the overtones of decadence cultivated by their European counterparts may reflect the fact that neither American artists or their patrons were as yet world weary, mannered aristocrats, resigned to bored pessimism about the passing of the old order.

In California during the late 1890s the Arts and Crafts Movement influenced the artists Arthur F. Mathews and Lucia K. Mathews. Arthur had been a student of Gustave Boulanger and Jules Lefebvre at the Académie Julian in Paris in the 1880s, and when the Mathewses lived in Paris in 1899, Lucia attended Whistler's Académie-Carmen. More consistent and persistent than any other Americans at the time, their goal was to combine fine-arts painting with the craft tradition, and they produced a number of landscapes, figure studies, still lifes, murals and decorative art objects such as furniture and pottery, which were models of utility and beauty for a continuing tradition of California artists.

11

11. George Inness. *In the Valley,* 1893. Oil on canvas, 24 x 36¼ inches. The Art Institute of Chicago; Edward B. Butler Collection.

12. Dwight W. Tryon. *Before Sunrise,* 1906–07. Oil on canvas, 30 x 40 inches. Washington University Gallery of Art, St. Louis.

12

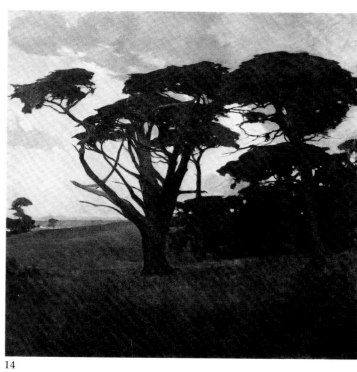

14

13

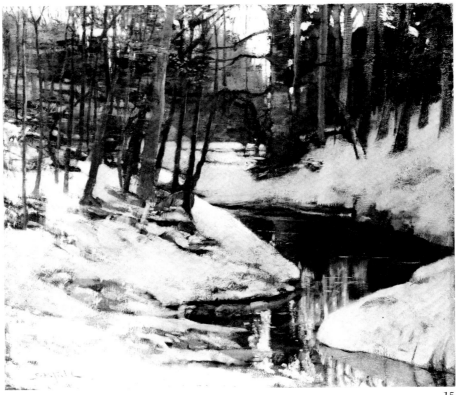

15

13. Edward Steichen. *Night Landscape*, c. 1905. Oil on canvas, 25 x 21 inches. Whitney Museum of American Art, New York; Gift of Mr. and Mrs. Ira Spanierman.

14. Arthur F. Mathews. *Monterey Cypress*, 1905. Oil on canvas, 48 x 52 inches. The Oakland Museum; Gift of Concours d'Antiques, Art Guild, The Oakland Museum Association.

15. W. Elmer Schofield. *Winter*, c. 1899. Oil on canvas, 29½ x 36 inches. Pennsylvania Academy of the Fine Arts, Philadelphia.

16. Edward Willis Redfield. *Hillside at Center Bridge*, 1904. Oil on canvas, 36 x 50 inches. The Art Institute of Chicago; W. Moses Willner Fund.

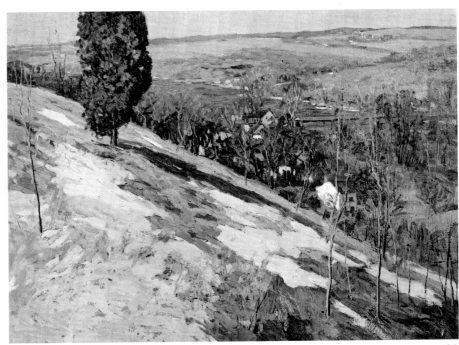

16

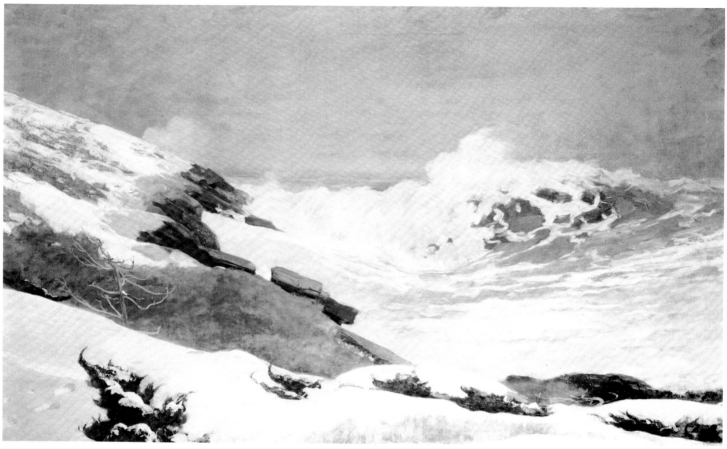

17

17. Winslow Homer. *Coast in Winter,* 1892. Oil on canvas, 28⅜ x 48⅜ inches. Worcester Art Museum, Worcester, Massachusetts; Theodore T. and Mary G. Ellis Collection.

18. Winslow Homer. *The Lookout—"All's Well,"* 1896. Oil on canvas, 40 x 30¼ inches. Museum of Fine Arts, Boston; William Wilkins Warren Fund.

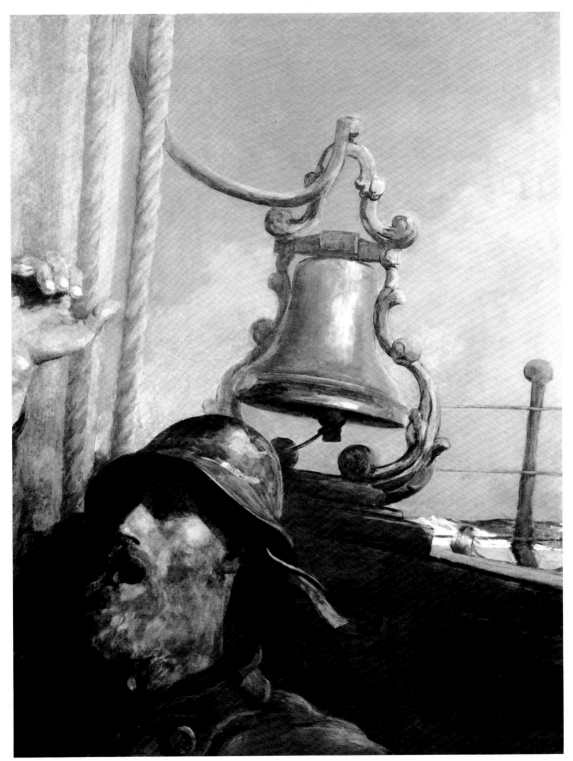

18

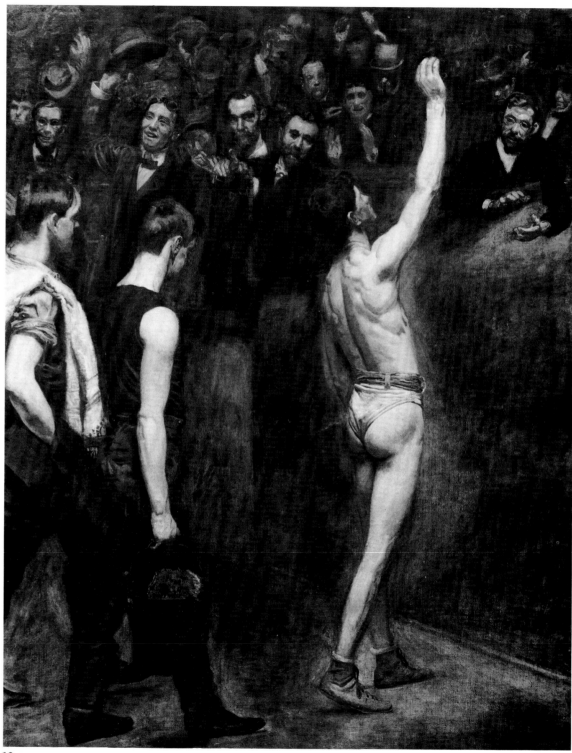

19

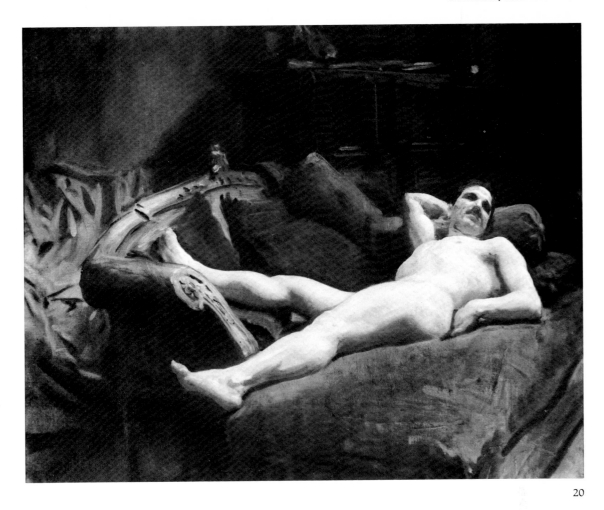

20

19. Thomas Eakins. *Salutat,* 1898. Oil on canvas, 49½ x 39½ inches. Addison Gallery of American Art, Phillips Academy, Andover, Massachusetts.

20. John Singer Sargent. *Male Model Resting,* 1890s. Oil on canvas, 22 x 28 inches. The Forbes Magazine Collection, New York.

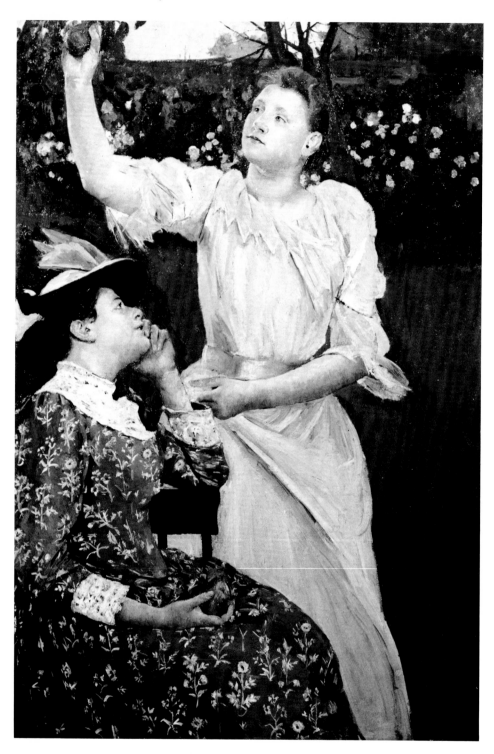

21. Mary Cassatt. *Young Women Picking Fruit*,
 1891. Oil on canvas, 51⅜ x 35¾ inches.
 Museum of Art, Carnegie Institute,
 Pittsburgh.

22. Henry O. Tanner. *Two Disciples at the Tomb,* 1906. Oil on canvas, 51 x 41⅞ inches. The Art Institute of Chicago; Robert Waller Fund.

23. John White Alexander. *The Blue Bowl*, 1898. Oil on canvas, 48 x 36 inches. Museum of Art, Rhode Island School of Design, Providence; Jesse H. Metcalf Fund.

24. Alfred H. Maurer. *An Arrangement*, 1901. Oil on cardboard, 36 x 31¾ inches. Whitney Museum of American Art, New York; Gift of Mr. and Mrs. Hudson D. Walker.

24

23

II. William Merritt Chase. *The Golden Lady*, 1896. Oil on canvas, 40⅝ x 32¾ inches. The Parrish Art Museum, Southampton, New York; Littlejohn Collection.

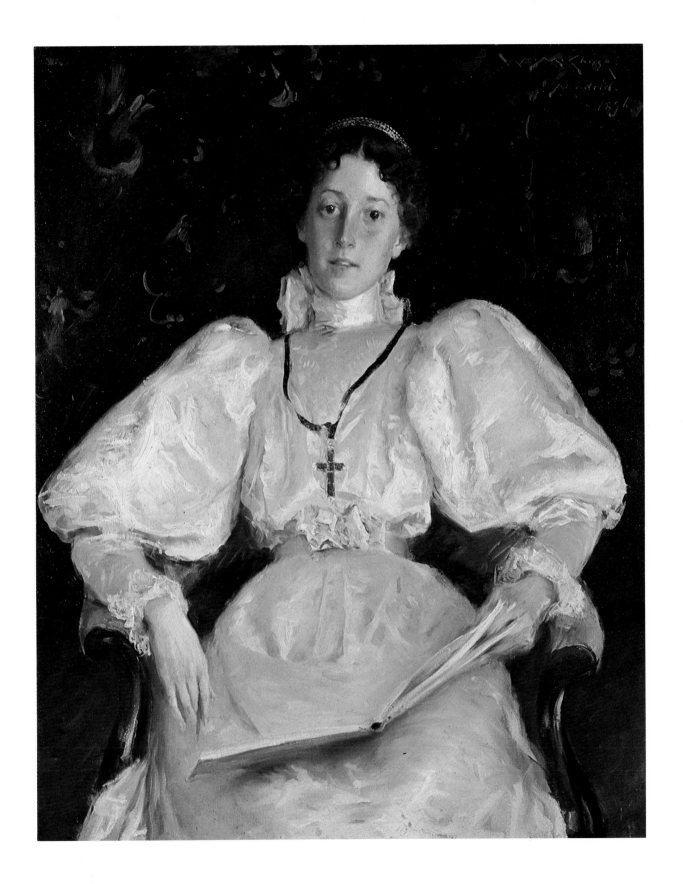

25. Cecilia Beaux. *Dorothea in the Woods,* 1897. Oil on canvas, 53½ x 40 inches.
Whitney Museum of American Art, New York; Gift of Mr. and Mrs. Raymond J. Horowitz.

III Portraits in Oil

Portraiture in oil maintained its status during the turn-of-the-century years. Wealthy patrons, unimpressed by the smallness of the commercial portrait photograph and its lack of resonant color and real painterly effects, continued to commission painters to represent themselves and their families for posterity. The oil portrait could not only capture an image of social and/or intellectual power but it also had a uniquely sensuous and precious materiality cherished by the collector of beautiful objects. Moreover, the oil portrait was itself a mark of social status and patrons competed for the privilege of being painted by a world renowned portraitist.

Some artists made a speciality of oil portraits—John Singer Sargent was in demand in London, Paris, New York and Boston. Cecilia Beaux had numerous commissions from Philadelphia society and business leaders. Thomas Eakins grudgingly accepted commissions, preferring to paint his friends; but Mary Cassatt, with her financial independence, could paint and draw whom she pleased. George de Forest Brush, Henry O. Tanner, Henry Oliver Walker and Edmund Charles Tarbell are known for other subject matter but did a number of portraits. Few figure artists did not occasionally accept a commission.

Artists and writers argued as to how the portrait artist should resolve the requirements of realism with the demands of art for its own sake. Sadakichi Hartmann defined the goal of the artist working on commission: "The aim of portrait painting is to produce a likeness—a likeness that reveals in one attitude as much of the sitter's individuality as is possible in a flat surface view," for, as Hartmann points out, the client deserves to get his money's worth.[34] However, many artists were only interested in creating works of art. Hartmann admits the impossibility of combining the two requirements, except in rare instances:

> It seems a portrait becomes a work of art only when sitter as well as artist have a strong and decided individuality. If these conditions do not exist a portrait invariably becomes a conventional interpretation.
>
> To produce a likeness of an ordinary vapid being is impossible without ignoring the laws of art in some way or other, and, sad to state, a portrait that is a work of art is rarely a perfect likeness.[35]

Hartmann singled out Sargent as the portraitist who "does not care a jot about the sitter's individuality if it does not harmonize with the decorative fancies of his marvelous execution."[36]

Controversial in his lifetime, Sargent was eclectic, talented, and urbane, but his total oeuvre in portraiture suggests that era of the rich, the beautiful and the powerful probably better than the work of any other artist. Charles Caffin called Sargent's sitters "the product of an age of nerves," and found in his portraits of them "an equivalent restlessness of manner, a highly strung intention, almost a stringiness of nervous expression."[37] His portraits of the newspaper publisher Joseph Pulitzer and the museum director Henry G. Marquand reveal public men of intelligence, quickness of mind, and business shrewdness (Figs. 27, 26). Art historian John C. Van Dyke, writing in 1919, rhapsodized over Marquand's portrait:

> How well he has emphasized the facts of the spare figure, the refined if somewhat weary face! How very effective the placing of the figure in the chair, the turn of the head, and that thin hand against which the head rests. Every physical feature is just as it should be. Look at the bone structure of the forehead, the setting of the eyes, the protrusion of the lower lip, the modelling of the mouth and chin.... The painter has given you only what he has seen, but can you not get out of these physical features—even from the thin patrician hand—some indication of the man's character? The painter *does* give the character of the sitter but not in the way the populace supposes. The effort is not conscious. The character is merely the result of accurately seeing and drawing the surface appearance.[38]

The characters of Sargent's portraits were not "merely" the result of a facile reportage of surface effects. Indeed, Sargent labored endlessly over many portraits, as for example *Mr. and Mrs. Isaac Newton Phelps Stokes,* in order to achieve the look of effortlessness and also to adjust the style to his impression of the sitter (Fig. 28). Mr. Stokes is represented as serious and introverted; Mrs. Stokes is the opposite—active, spontaneous, and self-assured.

Portraits of young women could be formal or casual. George

de Forest Brush's painting of Polly Cabot offers us a timeless image of an aristocratic young woman, which recalls the formal elegance and smooth, fragile beauty of a fifteenth-century Florentine heiress cloistered from the cares and trials of the world (Fig. 29). Cecilia Beaux's informal portrait *Dorothea in the Woods,* however, is a fleeting impression of a comely child, still tentative about the world, her hesitation revealed as much in her total body posture and her nervously clasped hands as in her face (Fig. 25).

Eakins's portraits of artists and friends often reflect his attitudes about human endeavor and the human mind, concerns which he shared with those friends. In *The Cello Player,* a large full-length portrait of Rudolph Hennig, Eakins focuses not on the special physiognomy and expression of the musician, but on the activity of concentration and of fingering the strings and bow of the instrument (Fig. 30). Highlights are therefore used to emphasize the forehead and hands of the musician; the totality reveals a point of view that defines and values men and women by the work they do. Other portraits are psychological probings of the individual human face. Eakins's *Portrait of Henry O. Tanner* represents the sensitive and reflective character of a black artist who throughout his life had to struggle against racial prejudice within American society (Fig. 32). Eakins had contempt for the bravura technique of Sargent. He preferred instead to build up his canvas in ways that would capture the sculptural qualities of the human head, the nobility of countenance and the humanity revealed in the eyes.

Tanner, in his *Portrait of the Artist's Mother,* painted a personal and sensitive study of a contemplative, mature woman (Fig. 33). She is a beam of light emerging out of the duskiness of a room—experiencing the passing of the years and the century in a mood of resignation.

The cultural leaders of the time can be remembered by the portraits done by Tarbell, Walker and others. The double portrait often tells more of each individual by showing the relationship of two family members. Tarbell's portrait *Henry Frick and Daughter Helen* expresses the personality of the determined industrialist—a man who would carve a career under the guidance of Andrew Carnegie, survive an anarchist's attack, crush a strike, build an enormous fortune in steel, and end as a philanthropist (Fig. 35). Feminine in the latest style of chapeau, and thrust into profile at the left is Frick's daughter Helen, a patron who would emerge from his shadow and convert his legacy into a museum and library. No personal intimacy passes between the two; they share, however, a similar drive and single-mindedness of purpose.

Whether true likenesses or works of art, these portraits remind us of the individuals as well as the types—musicians, artists, publishers, mothers, fathers, children, social leaders, cultural tastemakers, industrialists and art patrons—who had the means to commission an artwork or who were privileged to be friends of the artist. They are the dramatis personae of a social reality upon which they acted and were in turn responsive.

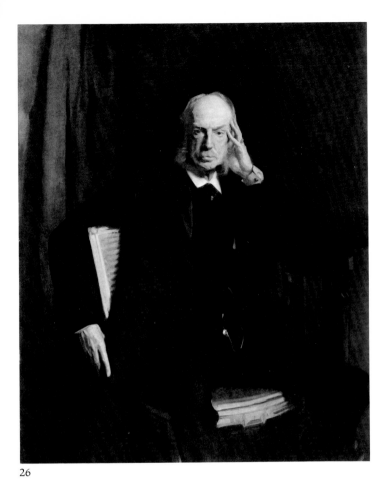

26

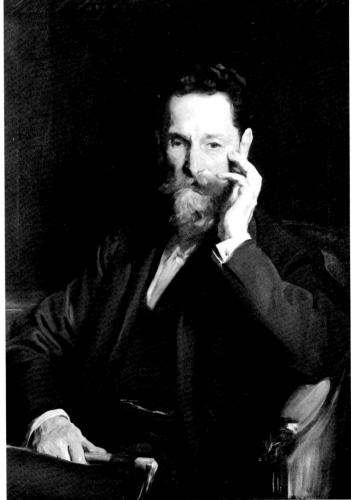

26. John Singer Sargent. *Henry G. Marquand,* 1897. Oil on canvas, 52 x 41¾ inches. The Metropolitan Museum of Art, New York; Gift of the Trustees, 1897.

27. John Singer Sargent. *Joseph Pulitzer,* 1905. Oil on canvas, 38½ x 28 inches. Collection of Joseph Pulitzer, III.

27

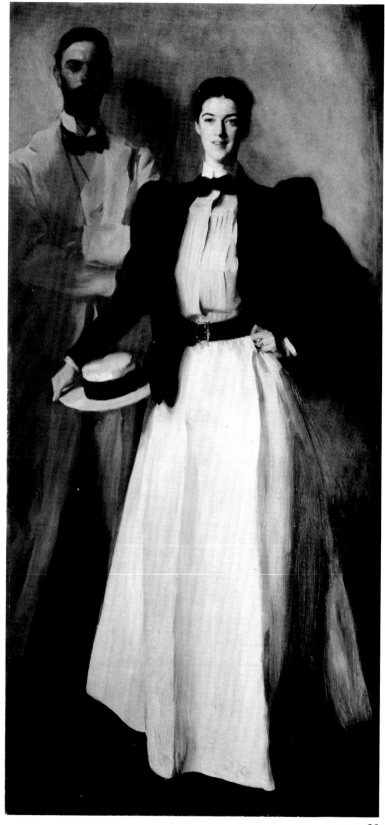

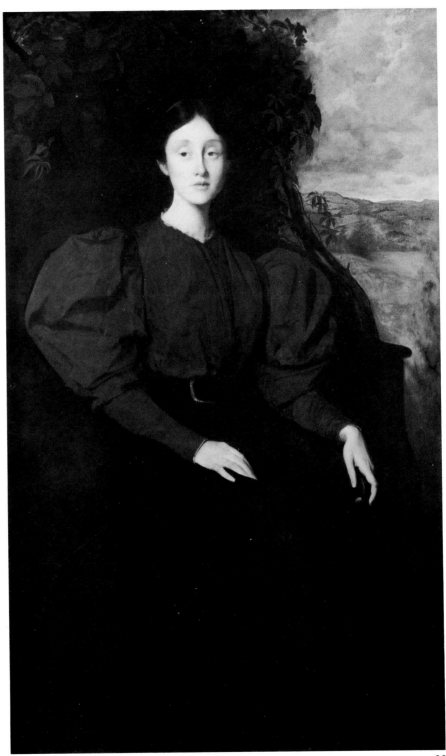

28. John Singer Sargent. *Mr. and Mrs. Isaac Newton Phelps Stokes,* 1897. Oil on canvas, 84¼ x 39¾ inches. The Metropolitan Museum of Art, New York; Bequest of Edith Minturn Phelps Stokes, 1938.

29. George de Forest Brush. *Miss Polly Cabot,* 1896. Oil on canvas, 58 x 36 inches. Philadelphia Museum of Art; Gift of the Friends of Philadelphia Museum of Art.

29

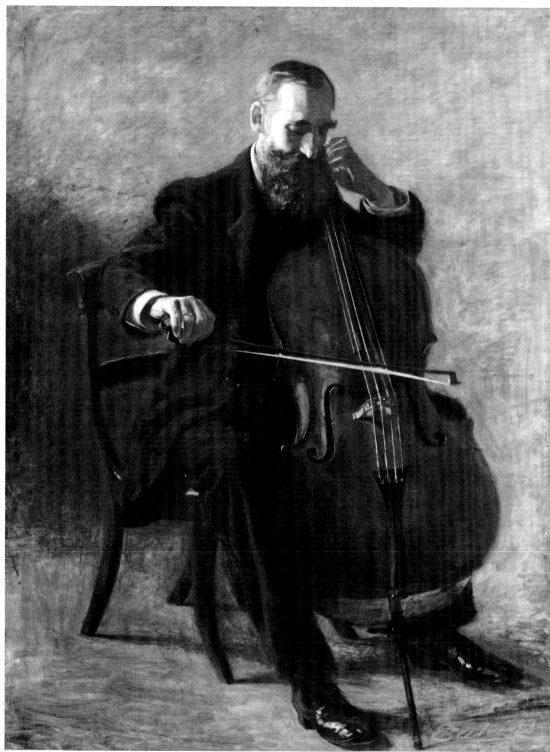

30

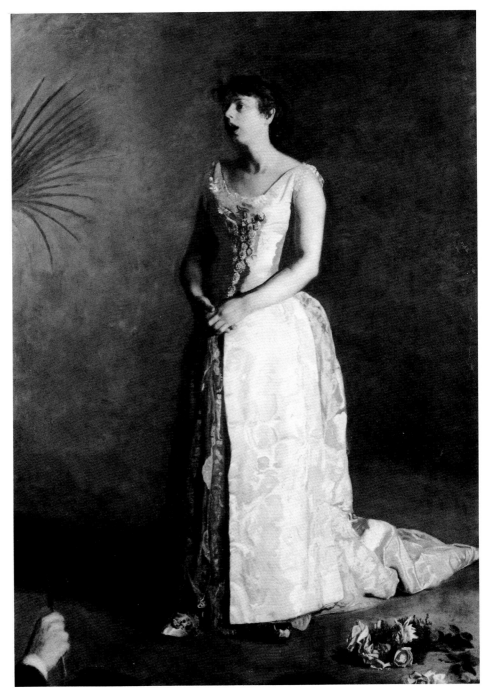

30. Thomas Eakins. *The Cello Player,* 1896. Oil on canvas, 64⅛ x 48⅛ inches. Pennsylvania Academy of the Fine Arts, Philadelphia.

31. Thomas Eakins. *Concert Singer,* 1896. Oil on canvas, 75 x 54 inches. Philadelphia Museum of Art.

31

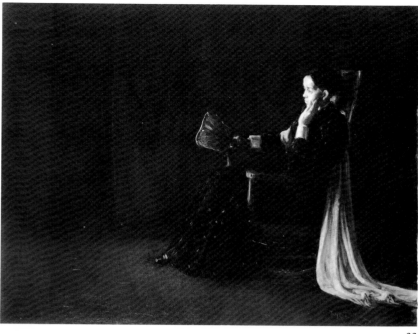

33

32

32. Thomas Eakins. *Portrait of Henry O. Tanner,* c. 1902. Oil on canvas, 24¹/₁₆ x 20⅛ inches. The Hyde Collection, Glens Falls, New York.

33. Henry O. Tanner. *Portrait of the Artist's Mother,* 1897. Oil on canvas, 29¼ x 39½ inches. Collection of Mrs. Raymond Pace Alexander.

34. Henry Oliver Walker. *Mrs. William T. Evans and Her Son John H.,* 1895. Oil on canvas, 36⅛ x 29⅛ inches. National Collection of Fine Arts, Smithsonian Institution, Washington, D.C.; Gift of William T. Evans.

35. Edmund Charles Tarbell. *Mr. Frick and Daughter Helen,* n.d. Oil on canvas, 31 x 23 inches. National Collection of Fine Arts, Smithsonian Institution, Washington, D.C.; Loan from Mrs. John Wilson McLain.

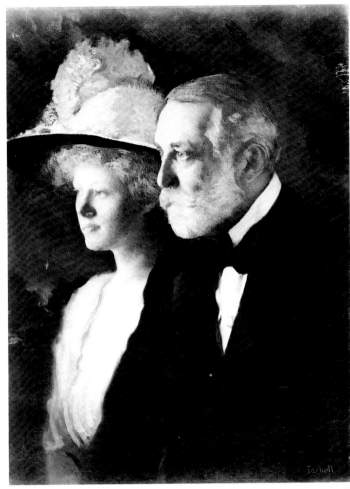

35

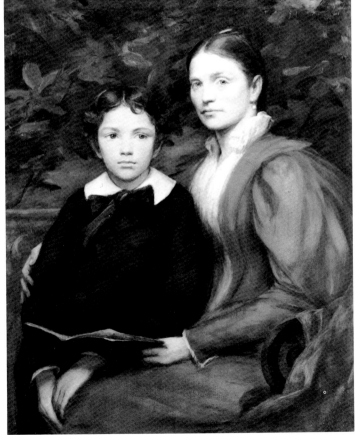

34

36. William Merritt Chase. *Portrait of a Woman: Reverie,* c. 1890. Monotype, 18⅞ x 15½ inches.
 The Metropolitan Museum of Art, New York; Purchase, Louis V. Bell, William E. Dodge and Fletcher Funds,
 Murray Rafsky Gift, and Funds from various donors, 1974.

IV The Genteel Media:
Pastels, Watercolors and Prints

THE PAINTERS OF THE PERIOD often turned from the serious purposes and demands of oil painting and picked up pencil or pen, pastel stick or watercolor brush, etcher's needle or lithographic crayon. The unique qualities of the so-called "minor" arts fascinated artists and led to a revival of interest in many of them. Their appeal lay not only in the quickness with which they could generally be executed but also in their gentility—their intimacy and their apparent divorcement from the business of commercial transactions. These pastels, watercolors, and prints were meant to be things of beauty and, whether their subject was a landscape view or a study of heads and figures, the aesthetic qualities were stressed.

In the late 1870s there had been a revival of interest in the use of pastel, a medium previously popular with eighteenth-century portrait artists.[39] In France, Giuseppe de Nittis became well known for his large, ambitious pastel works; and Edgar Degas and Mary Cassatt sent pastels to the exhibitions organized by the French Impressionists. The highly keyed and soft pure brightness of pastel colors as well as the blurred edges and loss of details conformed to the impressionist aesthetic which emphasized the quick impression and spontaneous execution. Cassatt made pastels throughout her life—studies of women and children as well as portraits.

One of the best known practitioners of the pastel in America was William Merritt Chase, a founding member in 1882 of the Society of American Painters in Pastel. Chase used the medium to render firm but delicate portraits. The colors in his *Portrait of Mrs. Chase* are applied with a dense patina of pressed powders creating velvet pale pinks and peach flesh tones as smooth as rose petals (Fig. 38).

Other artists followed the style of Whistler whose light, sketchy pastels on tinted paper were arrangements of colored smudges and wispy lines—mere suggestions of real forms. One reviewer writing on Whistler's pastels in 1889 said:

As a pastellist Mr. Whistler differs from all others....He has not the heaviness of the English school, the firmness and dash of the French, the broad nonchalance and security of the American. His style is even more personal than in his water-colors. He has the same habit of assuming relations of color to suit his mood and a touch even more evanescent and ethereal, almost fairy-like. Pastel in his hands seems like pollen brushed from the pistil of a flower.[40]

Artists such as John Henry Twachtman, Frederick Childe Hassam, Julian Alden Weir, Thomas Dewing and Lucia K. Mathews were all influenced by Whistler's delicate style.

Another medium revived in the late nineteenth century was transparent watercolor.[41] In 1866, the American Society of Painters in Water Colors was formed which became, in 1877, the American Water Color Society. Members held regular exhibitions through the end of the nineteenth century. Watercolor supplies are more portable than the easels and equipment required for oils, and artists such as Winslow Homer and John Singer Sargent made numerous watercolors during their travels. They both used broad brushes and utilized the white of the paper to achieve transparency and brilliance. Childe Hassam, Theodore Robinson and other impressionists were also attracted to the technique.

In the early years of the twentieth century, a watercolor artist with an individual style was Maurice Prendergast, whose paintings of pure and brilliant, translucent patches of color formed mosaics of everyday urban life—scenes of Venice and New York, and the summer beaches at St. Malo.

Prendergast, as well as Chase, also attempted monotypes—a medium which combines the qualities of painting and printmaking. In this technique the artist paints in colored inks or oils on an unetched metal plate or glass. Immediately a piece of paper is pressed against the plate to transfer the image to the paper. Each impression is unique, for after the ink from the plate has been removed, there are no etched or engraved lines to guide the artist for the next printing. One can only speculate why an artist would be involved with such an elaborate printing procedure for only one impression, except the appeal of a mechanical operation in which accident and human manipulation play a deciding role. Another attraction might be the magic that occurs when an image suddenly appears on paper. The

monotype with its rare and fragile beauty has an intimate charm rivaled only by etching.

Etching also experienced a late nineteenth-century revival. A number of artists founded the New York Etching Club in 1877. They were attracted to the intaglio technique whereby a copper plate covered with rosin was scratched through with a needle, and the plate slipped into a bath of acid which bit through the metal where it had been exposed by the scratches. Ink was then rubbed into the etched lines and the smooth portions of the plate were wiped clean. The plate, covered with a damp sheet of fine quality paper, was then run through the press and a picture resulted. The plate could be re-inked and the process could be repeated. During the 1880s publishers exploited the possibilities of etching and capitalized on the public interest. They issued a number of reproductive etchings, that is, etchings reproducing famous paintings. By the early 1890s this artistic printing was abandoned in favor of cheaper and more efficient methods of reproduction, and reproductive etching fell off.

During the 1880s artists turned away from etching because of what they felt was a decline in the quality of the medium. However, under the influence of Whistler, whose delicate etchings attracted artists, a number began to reconsider seriously the unique artistic possibilities of pure etching with its delicate but free meandering lines which need only suggest a form. Frank Weitenkampf in *American Graphic Art* (1912) assessed the new approach:

> The spirit that is animating these younger disciples of needle and acid is that of pure etching, of the art with its advantages and limitations. In the best of this newer work the true nature of the medium is respected and is adapted to each individuality,—a necessity in the practice of any art.[42]

John Marin, who was later to become part of the Stieglitz group of American modernists, did etchings while traveling and studying in Europe. The first and second states of his *Bridge Over Canal, Amsterdam* are particularly revealing of his sources and his future direction. The first state indicates his debt to Whistler; the second state suggests a night scene similar in mood to the nighttime city boulevards of Stieglitz (Fig. 45).

Mary Cassatt, who experimented with etching as well, seemed to prefer the hard, brilliant line of drypoint. In 1891 she added aquatint to a series of fine drypoint plates to create a suite of prints which recall the flat, decorative effects of Japanese woodcuts.

Fine-arts lithography in the 1890s achieved a greater fame than before—partly explained because of the popularity of the artistic poster. Again, Whistler offered a style that was quick and summary, whereas Sargent gave lithography the rich dark shadows and soft blacks traditional to the medium.[43]

The artists who involved themselves with these very private and personal art forms managed to isolate themselves from the social unrest and business expansion of the decades. They retreated to a self-conscious investigation of the expressive possibilities of each of the media. Their self-imposed challenge was to respect that medium—with its possibilities and limitations—and create images appropriate to it. The medium defines its own look. Weitenkampf was one of the earliest writers on graphics to understand the notion of "truth to materials":

> The medium, be it brush and canvas, chisel and stone, burin and wood block, or needle and copper-plate, has its possibilities and its limits, both of which must be clearly understood to produce the best results, results to which the nature of the medium gives its characteristic flavor. Respect for the medium does not imply hampering of individuality, but simply its orderly expression. Submission to the necessities imposed by the tool is no more a curb on genius than the grammar of a language. Genius will mold the method to its manner.[44]

Later the modernists would assert that the major theme of art—some claimed its only valid subject matter—was its self-definition. But to Weitenkampf and turn-of-the-century artists, the real freedom to create intimate expressions, or grand statements, followed the recognition of the material necessities of each medium.

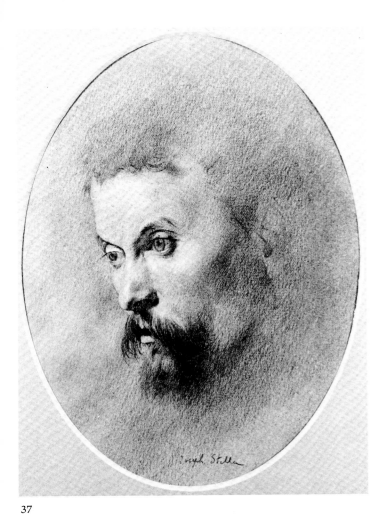

37

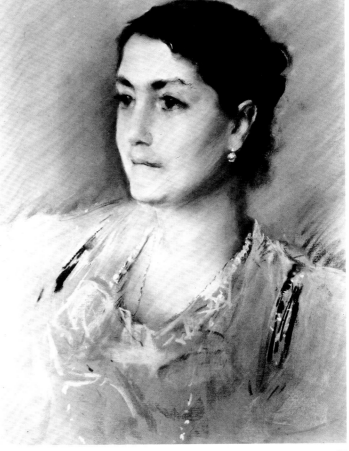

37. Joseph Stella. *Study for "Three Heads,"* n.d. Pastel and chalk on paper, 7¼ x 5½ inches. Collection of David Daniels.

38. William Merritt Chase. *Portrait of Mrs. Chase,* c. 1910. Pastel on paper, 20 x 16 inches. Collection of Mr. and Mrs. Raymond J. Horowitz.

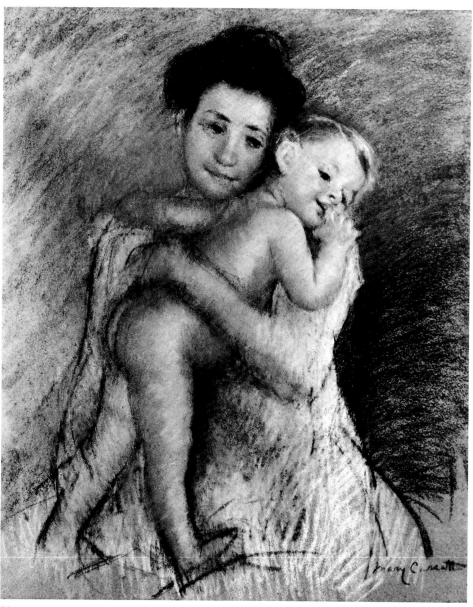

39

39. Mary Cassatt. *Tendresse Maternelle*, 1908.
Pastel on paper, 31 x 25 inches. Seattle
Art Museum; Gift of Mr. and Mrs. Louis
Brechemin.

40. Lucia K. Mathews. *Apricots No. 3*, 1908.
Pastel on gray paper, 20⅞ x 13¾ inches.
The Oakland Museum; Gift of Mr.
Harold Wagner.

41. Frederick Childe Hassam. *Isle of Shoals,
Celia Thaxter's Living Room*, 1892. Wa-
tercolor on paper, 15¾ x 12¾ inches.
Collection of Mr. and Mrs. Ralph
Spencer.

41

40

42

43

42. Winslow Homer. *Shore and Surf, Nassau,* n.d. Watercolor on paper, 15 x 21⅜ inches. The Metropolitan Museum of Art, New York; Purchase, Amelia B. Lazarus Fund, 1910.

43. John Singer Sargent. *Figure with Red Drapery,* n.d. Watercolor on paper, 14½ x 21³/₁₆ inches. The Metropolitan Museum of Art, New York; Gift of Mrs. Francis Ormond, 1950.

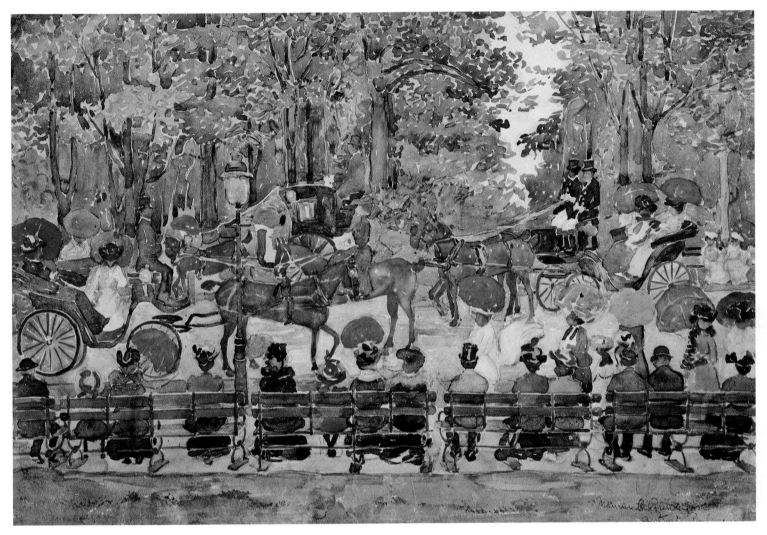

III. Maurice Prendergast. *Central Park, 1901*. Watercolor on paper, 14⅜ x 21½ inches.
Whitney Museum of American Art, New York.

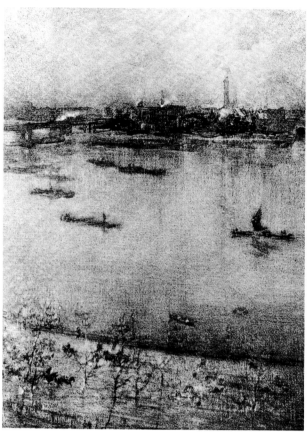

44

44. James Abbott McNeill Whistler. *The Thames*, 1896. Lithotint, 10½ x 7⅝ inches. The Metropolitan Museum of Art, New York; Harris Brisbane Dick Fund, 1917.

45. John Marin. *Bridge Over Canal, Amsterdam*, 1906. Etching (second state), 6 x 7½ inches. The Metropolitan Museum of Art, New York; Alfred Stieglitz Collection.

45

46. James Abbott McNeill Whistler. *Fruit Shop, Paris,* 1890s. Etching, 5 x 8½ inches (sheet). Collection of Paul F. Walter.

47. Mary Cassatt. *Feeding the Ducks,* 1895. Drypoint (first state), 11⅝ x 15½ inches. The Metropolitan Museum of Art, New York; Bequest of Mrs. H. O. Havemeyer, 1929.

48. James Abbott McNeill Whistler. *Siesta,* 1896. Lithograph, 6½ x 8¾ inches (sight). Collection of Paul F. Walter.

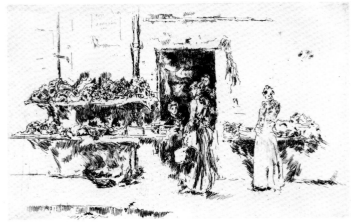

46

47

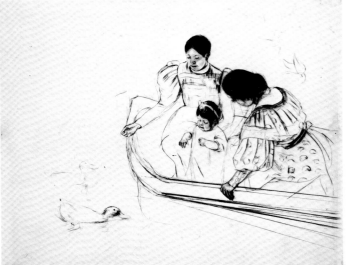

48

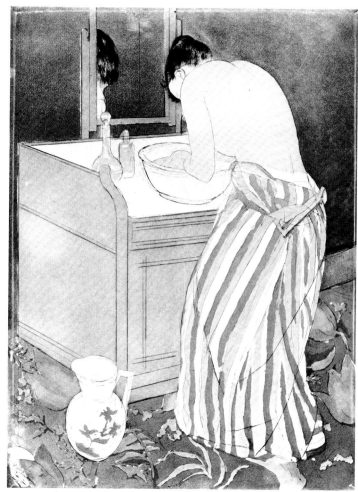

50

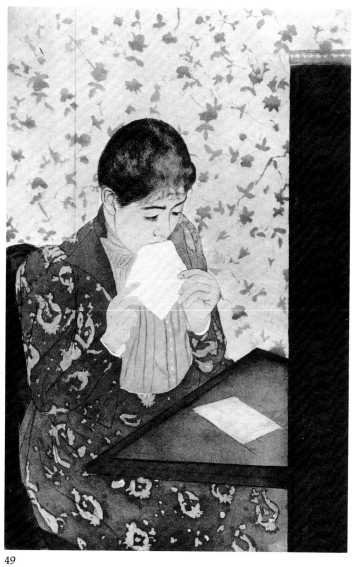

49

49. Mary Cassatt. *La Lettre,* 1891. Drypoint and aquatint, 13⅝ x 8⁵/₁₆ inches. The Metropolitan Museum of Art, New York; Gift of Paul J. Sachs, 1916.

50. Mary Cassatt. *Woman Bathing (La Toilette),* 1891. Drypoint and aquatint, 14⁵/₁₆ x 10⁹/₁₆ inches. The Metropolitan Museum of Art, New York; Gift of Paul J. Sachs, 1916.

51. John Singer Sargent. *Study of a Young Man Seated,* 1895. Lithograph, 11⁹/₁₆ x 9⁹/₁₆ inches. The Metropolitan Museum of Art, New York; Gift of Mrs. Francis Ormond, 1950.

51

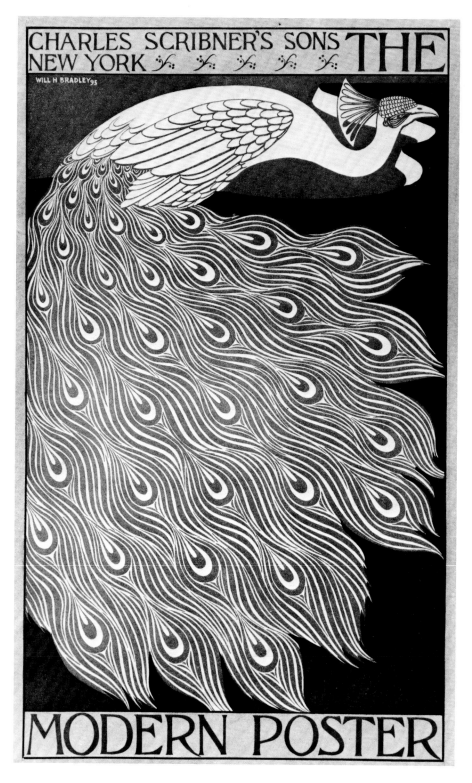

52. Will H. Bradley. *The Modern Poster*, 1895. Color lithograph, 19½ x 12½ inches (sheet).
Columbia University, New York; Engel Collection, Rare Book and Manuscript Library.

V Art Posters of the 1890s

IN THE MID-1890s, the art establishment became aware of a fad for art posters. Sadakichi Hartmann paused in his *History of American Art* to remark:

> The artistic poster had only a short reign in America. It started about 1895 and subsided within the year. The only truly artistic work that was done was a poster for the New York *Sun*, a theatrical poster for the "Masqueraders," by Will H. Bradley, and some smaller designs by Ethel Reed and E. Penfield.[45]

The popularity of the art poster, or "craze" as it was disparagingly called, certainly deserved more than a passing mention, for, in 1895, the poster business was thriving; Charles Scribner's Sons had issued the first American book on the poster, *The Modern Poster*, and later in December, S. Bing's first Salon de l'Art Nouveau had exhibited posters by Bradley and Penfield. By 1896, according to a recent estimate, twenty firms were producing only posters.[46]

The art poster movement of the nineteenth century began in France in 1869 when Jules Chéret printed the first color lithographic poster. Between then and 1891 Chéret created more than one thousand posters, many for theatrical companies, in a style which recalled the French rococo. Another French poster artist of the late nineteenth century was Eugène Grasset whose style of curving and swelling lines and flat, unmodeled forms followed the trend of William Morris and the English Arts and Crafts Movement.

Meanwhile, American publishers watched the poster movement with interest. In 1889, Harper & Brothers took the bold step and commissioned Grasset to do a cover for *Harper's Bazar* as well as two holiday posters for *Harper's Magazine.* The same year Louis Rhead, a transplanted English artist, designed holiday posters for the magazines *St. Nicholas* and *Century Magazine.* In 1890 the first poster exhibition was held at the Grolier Club in New York. Grasset did another poster for *Harper's* in 1892; its success prompted the management to issue different posters to advertise each month's magazine. In March 1893, *Harper's* art director, Edward Penfield, produced the first of many posters he designed for the firm throughout the 1890s.[47]

Soon the other leading quality magazines, *Scribner's, McClure's* and *Century Magazine* in New York, and *Lippincott's* in Philadelphia, hired designers for artistic advertising placards. Many of these magazines also had book divisions which advertised with similar cards. The "little magazines" of the decade, the short-lived but influential magazines of experimental prose and verse, such as *The Chap-Book* and the *Echo* of Chicago, *The Lark* of San Francisco, and *Moods* of Philadelphia, also issued posters.[48]

There was no uniform style for the poster of the 1890s, and the book and magazine publishers employed artists of varying tendencies. The art poster did, however, differ from the posters made by employees of lithography shops for other kinds of advertising such as circuses, theatrical productions and patent medicines.[49] Those commercial artists were untouched by the Arts and Crafts Movement and contemporary European graphic styles and perpetuated a figural and spatial naturalism which tended to be garish in color, crowded in composition and crude in execution.

The designers of the art poster were, on the other hand, extremely knowledgeable of the aesthetic possibilities of the art form, of the relationship between typography and image, and of their own individual approach. Moreover, they used the limitations of two-color or three-color printing to advantage. Will H. Bradley, a leader of the movement, expressed this self-consciousness:

> If we can only look over all the work, study it and understand it, we will find that we are on the threshold of a new art, an art composed of three things: First, and

paramount, the individuality of the artist; second, clear and vigorous thought; third, the utmost simplicity in the mode of expression.[50]

Bradley worked in Chicago for the firm of Stone & Kimball and later moved to Springfield, Massachusetts, where he established The Wayside Press. His style emphasized sinuous lines and flat swelling shapes, and was inspired, in part, by the graphic designs of the English artist Aubrey Beardsley. In his *Chap-Book Thanksgiving No.,* bright electric blues, dense navy blues and tomato reds form a decorative design that fills the sheet (Fig. 54). His *Modern Poster* was one of a signed and numbered edition which accompanied the Scribner's 1895 book (Fig. 52). As a designer of typeface, Bradley also sought to integrate lettering with the total design.

Others who worked in a highly decorative, linear, flat style were Elisha Brown Bird, Frank Hazenplug and Ethel Reed. Louis Rhead's posters for Louis Prang's publications featured Pre-Raphaelite women and used bright and unusual colors—lavenders, reds, and lime greens. A black line could expand into a shape defining the area of a naturalistic form as in the work of Blanche McManus; and lines could be repetitious and playful as in Charles Cox's witty advertisements for the bicycle magazine *Bearings* (Fig. 58).

Edward Penfield's style is descriptive; forms are simplified rather than exaggerated. Penfield believed that, "A poster should tell its story at once—a design that needs study is not a poster, no matter how well it is executed."[51] Penfield took men and women from the fashionable bourgeois urban world, reduced the modeling and placed them against flat backgrounds. At times he used a technique of lightly spattered complementary colors to fill in the flat areas. His French contemporaries who worked in a similar style, Pierre Bonnard, Henri de Toulouse-Lautrec and Théophile Steinlen, chose inhabitants of the Parisian demimonde, whereas Penfield's figures are the well-scrubbed, sometimes bored, American debutantes and their beaux. Other artists depicting urban life in styles similar to Penfield were Claude Fayette Bragdon, William L. Carqueville, J. J. Gould, Charles Allan Gilbert and Blanche Ostertag.

Maxfield Parrish studied with the illustrator Howard Pyle; during the 1890s he did several posters similar to the decorative formulae of the mural painters. He developed a preference for delicately colored, slightly modeled but heavily outlined, figures set against flat backgrounds of stylized foliage. Alice Glenny, about whom little is known, as well as Joseph C. Leyendecker, also used the decorative style of modeled figures symmetrically composed against flat backgrounds. Will Hicok Low, who was well known as a mural painter as well as an illustrator, used gold tints and a style which was meant to recall the bas-relief sculpture of classical Greece.

Artists most influenced by the Arts and Crafts Movement considered the poster a total design problem with the typography and color and texture of the paper of equal importance to the image. John Sloan's designs for the *Echo,* for *Moods* and for the Boston book publisher Copeland & Day made effective use of paper qualities, as did the designs of Arthur W. Dow, who had evolved theories of color based on his study of Japanese art. In San Francisco, Florence Lundborg made woodcuts for the magazine *The Lark,* and emphasized the roughly cut qualities characteristic of that medium.

Another California artist, L. Maynard Dixon, did posters for *Overland,* a literary magazine, and after the turn of the century, for *Sunset Magazine.* Dixon used a normal figure type, but emphasized a heavily outlined silhouette, of Indian or gold miner, set against the flat background of a desert sky.

By the end of the 1890s the art poster had all but disappeared. A number of reasons have been advanced for its demise. Many of the "little magazines," which sponsored and encouraged poster art and which kept alive the spirit of the Arts and Crafts Movement, could not sustain themselves commercially; and posters, whatever their artistic pretensions, had been commissioned for commercial reasons—to sell magazines and books. In the beginning of the 1890s these placards found their place in bookshop windows, at newsstands and on hoardings. But when they became collectibles, they left the street for the parlor; the mass audience for which they were originally intended was reduced to the collector and his friends. Commercial publishers soon realized that it made more business sense to put their money and time into developing halftone and color printing—into, in short, making the product (the magazine) more visually attractive and saleable.

The designers of the art poster either disappeared, as was the case with Ethel Reed and Alice Glenny, or they adapted themselves to the new needs of commercial illustration. John Sloan continued as a magazine illustrator and finally became a major figure in the history of American painting. Edward Penfield did placards for Hart, Schaffner & Marx; Maxfield Parrish did advertisements for Edison Electric Company; J. C. Leyendecker invented the Arrow Shirt man. Bradley turned to a career within the publication empire of William Randolph Hearst, and eventually found a place in the newly developing movie industry.

53. Florence Lundborg. *The Lark: August*,
1896. Woodcut, 16 x 12⅞ inches (sheet).
Columbia University, New York; Engel
Collection, Rare Book and Manuscript
Library.

54

55

54. Will H. Bradley. *The Chap-Book Thanks-giving No.,* 1895. Color lithograph, 20¾ x 13⅞ inches (sheet). Columbia University, New York; Engel Collection, Rare Book and Manuscript Library.

55. Louis J. Rhead. *Prang's Easter Publications,* 1896. Color lithograph, 24 x 17 inches. Museum of Fine Arts, Boston; Gift of L. Prang & Co.

56. Ethel Reed. *Folly or Saintliness,* 1895. Color lithograph, 18⅝ x 13¾ inches. Achenbach Foundation for Graphic Arts, The Fine Arts Museums of San Francisco; Gift of the Arthur W. Barney Estate.

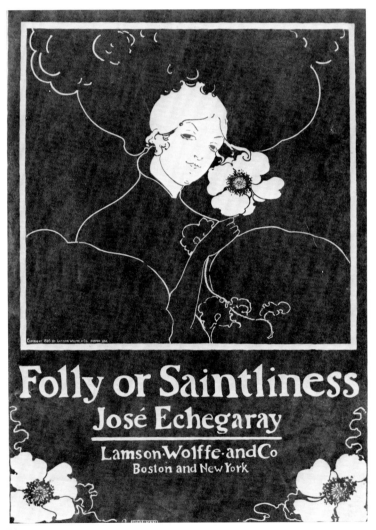

56

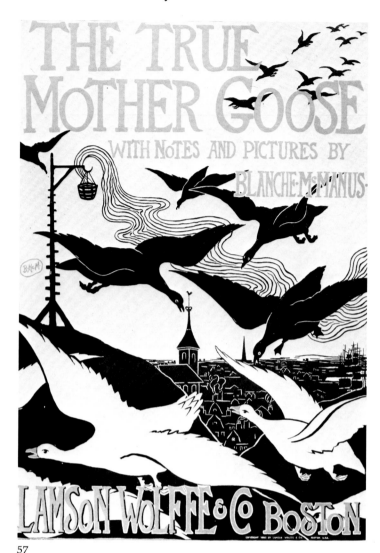

57

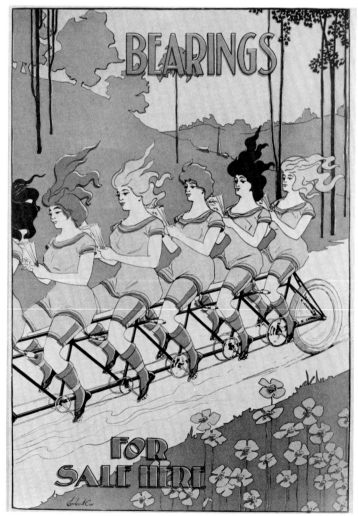

58

57. Blanche McManus. *The True Mother Goose,* 1895. Color lithograph, 20⅝ x 14⅜ inches (sheet). Columbia University, New York; Engel Collection, Rare Book and Manuscript Library.

58. Charles Cox. *Bearings for Sale Here,* 1896 (?). Color lithograph, 18⅛ x 13½ inches (sheet). The Currier Gallery of Art, Manchester, New Hampshire.

59. Edward Penfield. *Harper's July,* 1898. Color lithograph, 10 x 12¹¹⁄₁₆ inches. Delaware Art Museum, Wilmington; Gift of Walker Penfield.

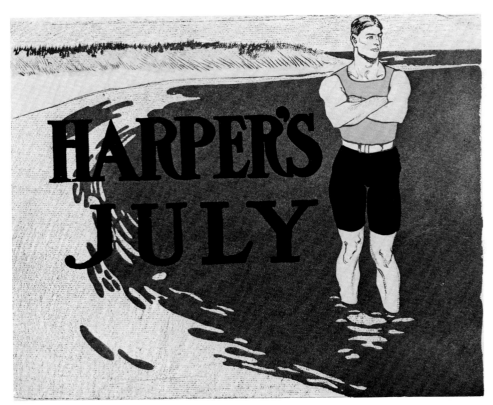

59

60. Edward Penfield. *Harper's May,* 1897. Color lithograph, 18⅛ x 13¼ inches (sheet). Columbia University, New York; Engel Collection, Rare Book and Manuscript Library.

61. Charles Allan Gilbert. *Wellesley College: Scribner's May,* 1898. Color lithograph, 22½ x 13¾ inches (sheet). Columbia University, New York; Engel Collection, Rare Book and Manuscript Library.

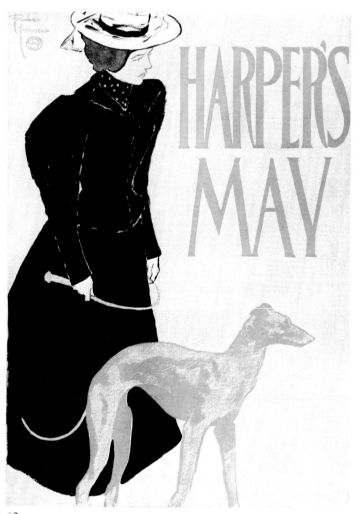

60

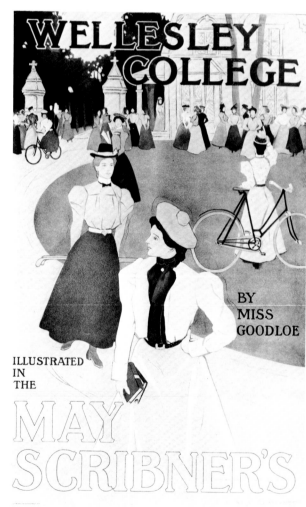

61

62. Maxfield Parrish. *The Century Midsummer Holiday Number. August.*, 1896. Color lithograph, 19⅞ x 13⅜ inches (sheet). Columbia University, New York; Engel Collection, Rare Book and Manuscript Library.

63. Alice Glenny. *Womens Edition (Buffalo) Courier,* c. 1895. Color lithograph, 27½ x 18⅛ inches (sheet). Columbia University, New York; Engel Collection, Rare Book and Manuscript Library.

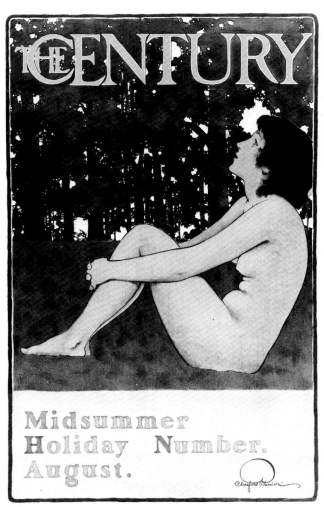

62

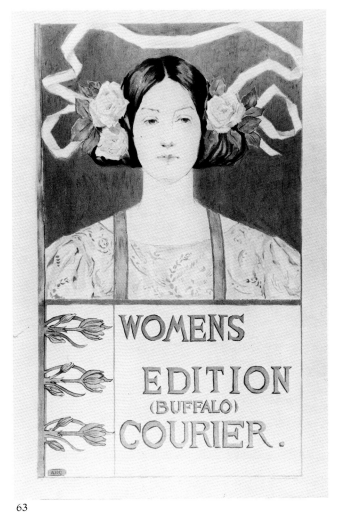

63

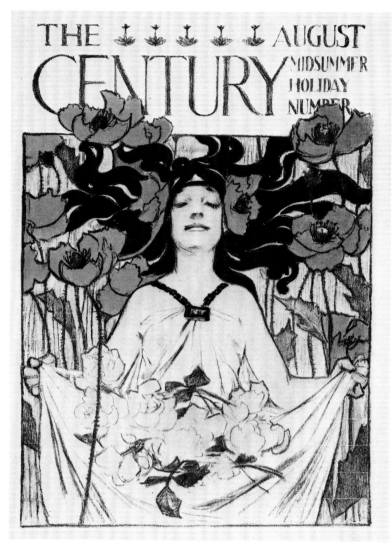

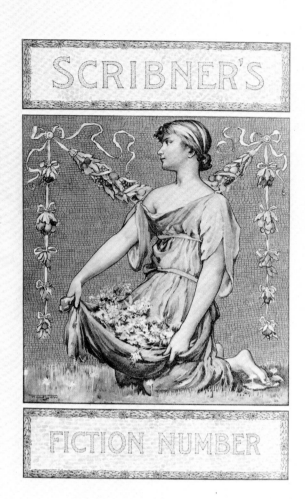

64

65

64. Joseph C. Leyendecker. *The August Century Midsummer Holiday Number*, 1896. Color lithograph, 21¼ x 16 inches. Photograph courtesy of the Delaware Art Museum, Wilmington.

65. Will Hicok Low. *Scribner's Fiction Number*, c. 1895. Color lithograph, 21¾ x 14 inches (sheet). Columbia University, New York; Engel Collection, Rare Book and Manuscript Library.

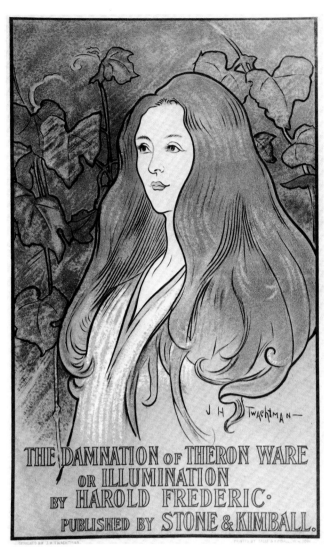

66

66. John Henry Twachtman. *The Damnation of Theron Ware or Illumination*, 1895. Color lithograph, 20⅝ x 12½ inches (sheet). Columbia University, New York; Engel Collection, Rare Book and Manuscript Library.

67. Arthur W. Dow. *Modern Art*, 1895. Color lithograph, 18⅞ x 14⅝ inches (sheet). Columbia University, New York; Engel Collection, Rare Book and Manuscript Library.

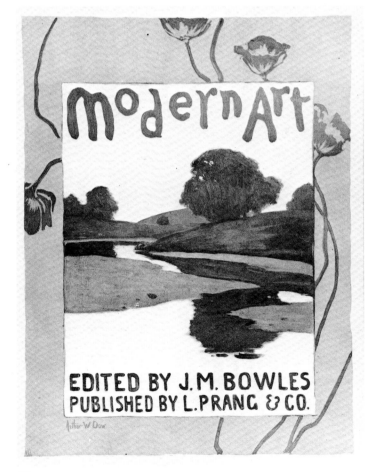

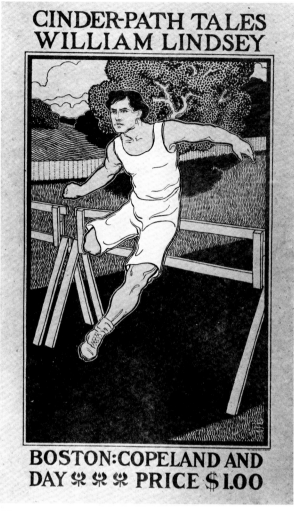

68

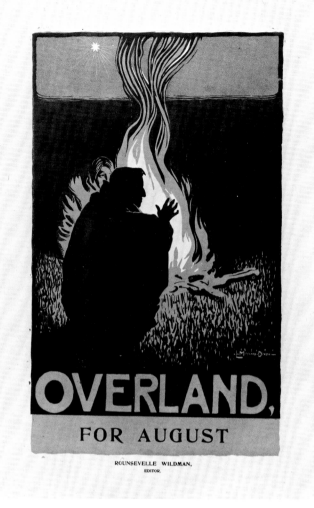

69

68. John Sloan. *Cinder-Path Tales*, 1896. Color lithograph, 23⅜ x 13½ inches (sheet). Columbia University, New York; Engel Collection, Rare Book and Manuscript Library.

69. L. Maynard Dixon. *Overland for August*, 1896. Color lithograph, 17¼ x 11 inches (sheet). Columbia University, New York; Engel Collection, Rare Book and Manuscript Library.

IV. J. J. Gould. *Lippincott's April*, 1897. Color lithograph, 16¼ x 13⅛ inches (sheet). Columbia University, New York; Engel Collection, Rare Book and Manuscript Library.

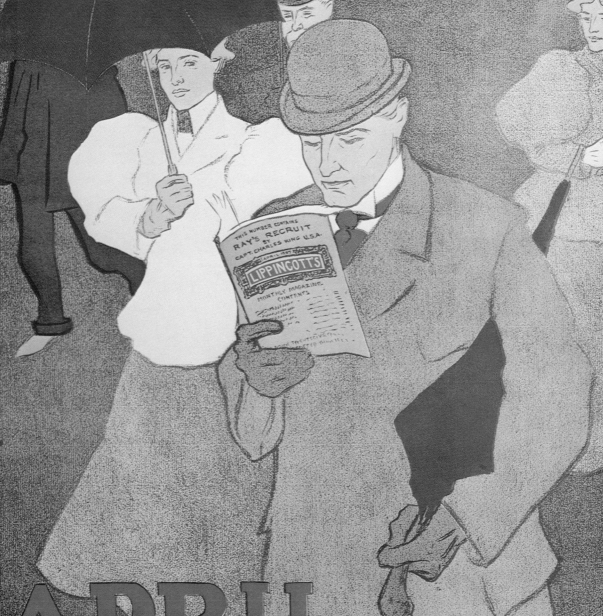

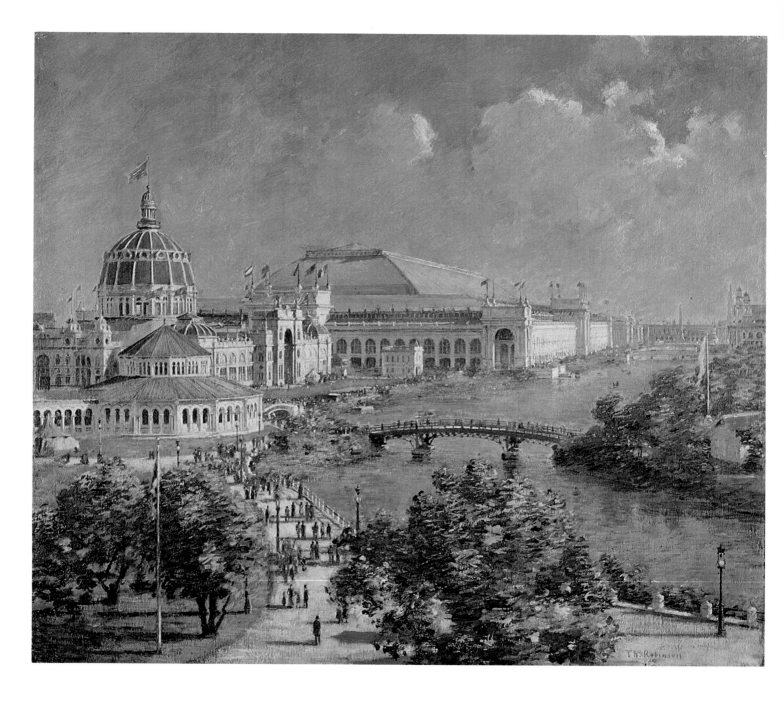

V. Theodore Robinson. *Columbian Exposition*, 1894. Oil on canvas, 25 x 30 inches.
Collection of Jeffrey R. Brown.

VI Impressionism, The Ten American Painters
and the Boston School

During the decades of the 1880s and 1890s a number of American artists gravitated to the artistic philosophy and technique of the French Impressionists. Earlier, in the mid-1870s, Mary Cassatt, who had become close friends with Edgar Degas, exhibited at several of the Impressionist exhibitions. At the same time, William Merritt Chase and others studying in Munich, were attracted to the work of Edouard Manet with its broad painterly strokes of black and white pigment accented with pink or vivid blue hues. But the impressionist technique which made its strongest appeal to the Americans in the 1880s was the one used by Claude Monet at Giverny—of short, homogeneous strokes, and a highly keyed palette.

Monet's style also eliminated detail and sought to capture the general appearance of a scene—the light and atmosphere of a particular and fleeting moment. As practised by Monet and others, impressionism was an optical naturalism by artists who believed that their bold, direct impressions of a scene were more true to our real knowledge of the world than the dark and tonal Barbizon painting, the Salon paintings of anecdotal genre, and the constructs of decorative mural painting.

Examples of the new movement of French art could be seen in New York. In 1886, the French dealer Jean-Marie-Fortune Durand-Ruel mounted an exhibition of some three hundred French paintings; two years later, he established a gallery in New York and held exhibitions of the work of Monet, Camille Pissarro and Alfred Sisley as well as Mary Cassatt. Moreover, a number of private collectors began to interest themselves in the style. By the time of the exhibition of Impressionist paintings at the Columbian Exposition, many of the artists and critics had been won to the new style.[52]

Theodore Robinson, after his conversion to impressionism in 1888, was the one American who worked most consistently as an impressionist; but he also exemplifies the inability of many Americans to assimilate the French style, because his respect for draftsmanship and for the real object before him would not permit him to dissolve the objects into a pattern of color patches.[53] In his view of the Columbian Exposition, the detailing of the man-made forms, particularly the architecture, is rendered with fine, delicate brushes (Pl. V). Only in the areas of natural forms—trees, water and sky—does the artist's touch loosen into the short, choppy strokes of true impressionist technique. It was as if, after all, the artifacts of men deserved a more fastidious rendering than the natural world which supported them. In their sunfilled landscape scenes, Chase, Lilla Cabot Perry and J. Alden Weir also adhered to the facts in the detailing of villas, farmhouses and factories.

In their choice of subjects the impressionists differed from mid-century landscape painters such as Church and Bierstadt; they preferred, as was the case with the tonalists, intimate or domestic subjects—gardens rather than spectacular mountain ranges, pools rather than pounding oceans. Similar to European works, the figures in their compositions are usually genteel ladies at their leisure or children playing, rather than rural farmers or urban workers. The time is usually mid-day and the season often summer, although John Twachtman and Willard Metcalf often preferred the delicately pale but sparkling harmonies of snow, ice and thin blue sky of sunlit, winter days. Since many of the American impressionists spent years studying and working abroad, many scenes are set in Paris, as Henry O. Tanner's *Les Invalides, Paris,* or in the French countryside, as Perry's *Landscape in Normandy* (Figs. 74, 72). After the turn of the century, impressionists such as Hassam turned to the picturesque boulevards of New York City (Fig. 75).

In 1898 a number of artists who considered themselves impressionists joined with a group of figure painters to form "The Ten American Painters." The artists involved were Frank Weston Benson, Joseph Rodefer De Camp, Thomas Dewing, Frederick Childe Hassam, Willard Leroy Metcalf, Robert Reid, Edward Simmons, Edmund Charles Tarbell, John Henry Twachtman, Julian Alden Weir. Their motive for organizing was a reaction to what they felt were the discriminatory hanging practices of the Society of American Artists. They held annual exhibitions until 1918, and when Twachtman died in 1902, Chase was elected to take his place.

Benson, De Camp and Tarbell were Boston figure painters connected with the Museum of Fine Arts School, who taught and influenced a number of younger artists such as William

McGregor Paxton and Lilian Westcott Hale. Their works varied in technique from the smooth, porcelain handling of Paxton's brush to the blond, short impressionist strokes of Tarbell. The subjects were women in gardens or in interiors, occasionally children, but rarely men. The women were transformed into beautiful objects—lyrical forms of harmonious colors played off against a background of complementary shapes and tones, as in Benson's *Girl Playing Solitaire,* De Camp's *Guitar Player,* and Lilian Hale's *L'Edition de Luxe* (Figs. 82, 81, 83). These women idle away their hours playing cards, playing musical instruments, and reading, or, as in Tarbell's *Josephine and Mercie,* writing letters (Fig. 84). Doing little or nothing marked the status of upper class women according to Thorstein Veblen whose sociological analysis of the rich, *The Theory of the Leisure Class* (1899), was brilliantly ironical:

> Propriety requires respectable women to abstain more consistently from useful effort and to make more of a show of leisure than the men of the same social classes. It grates painfully on our nerves to contemplate the necessity of any well-bred woman's earning a livelihood by useful work. It is not "woman's sphere." Her sphere is within the household, which she should "beautify," and of which she should be the "chief ornament."[54]

Household work, when depicted, is done by a person clearly designated as a servant.

The New York artists Robert Reid and Thomas Dewing, using different styles, also performed poetic renderings of women which are closer in spirit to the Boston painters than to the other New York impressionists. Dewing's style was uniquely his own and rarely varied; his interiors show thin, delicately boned women in softly lit, harmonious interiors, as in *Venetian Brocade,* or out of doors enveloped in a muted atmosphere of gentle light, as in *The Garland* (Figs. 79, 78). Flowers are an important motif in Dewing's paintings and his wife, Maria O. Dewing, was a well-respected flower painter. Their friend Abbott Thayer, associated with the mural movement, also painted many easel paintings of young, beautiful women with garlands and flowers as attributes.

Today we recognize that the idealized women of Reid, Dewing, Thayer, and the Boston painters are far removed from the reality of our own experience. Moreover, our knowledge of the history of women's struggles has taught us that there were few women who led such lives of idyllic irresponsibility without

becoming psychically scarred. We respond to the brooding loneliness of the woman, called "girl," in Benson's *Girl Playing Solitaire,* surrounded by beautiful artifacts symbolic of her wealthy station—a Windsor chair (her New England tradition), a Japanese screen (the new internationalism), elegant candlesticks and beautiful dress (American prosperity). She is a reminder of the upper class women hermetically sealed off from the everyday world.[55]

One way of understanding the meaning of these admittedly beautiful women/arrangements is to view them in the context of both aesthetic thought and social attitudes. On the one hand, there was a yearning among many to restore art to its function of elevating the mind and soul through the portrayal of *ideal* subjects. Others touched by the aesthetic movement declared that art should reveal *beauty;* and the academic tradition emphasized the *human figure.* In a secular society, materialistic in its outlook, shocked by the behavior of men at the financial marketplaces and worried about the influx of immigrants, idealized human beauty became fair Anglo-Saxon female types. These paintings of beautiful, undemanding and passive women were intended to soothe, perhaps, an overworked male's sensibilities; and thus were similar to the landscape paintings of the tonalists. Samuel Isham probably assessed the situation correctly when he observed about Americans:

> They have no goddesses or saints, they have forgotten their legends, they do not read the poets, but something of what goddess, saint, or heroine represented to other races they find in the idealization of their womankind. They will have such idealization decorous; there is no room for the note of unrestrained passion, still less for sensuality. It is the grace of children, the tenderness of motherhood, the beauty and purity of young girls which they demand, but especially the last. The American girl is placed upon a pedestal and each offers worship according to his abilities, the artist among the rest.[56]

There was, of course, no thought and no attempt to render the psychology and daily trials of real women, although in a few paintings the sense of longing and loss comes through the image of surface beauty. These women were and are purely decorative—beautiful things captured by the scintillating and facile brushstrokes of a group of successful turn-of-the-century artists who had absorbed the dominant values of their time.

70. Julian Alden Weir. *The Factory Village,* 1897. Oil on canvas, 29 x 38 inches.
 Collection of Mrs. Charles Burlingham.

71

72

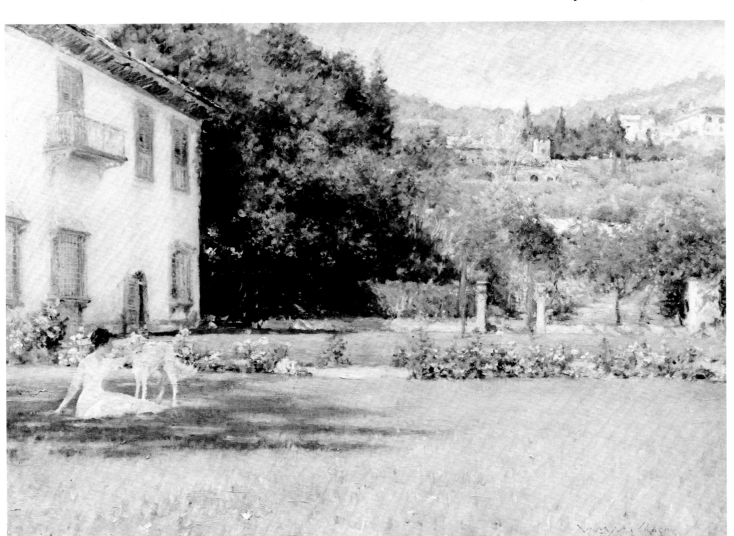

73

71. Theodore Robinson. *Evening at the Lock,*
 1893. Oil on canvas, 21¾ x 32 inches.
 Piedmont Driving Club, Atlanta. Photo-
 graph courtesy of the High Museum of
 Art, Atlanta.

72. Lilla Cabot Perry. *Landscape in Normandy,*
 1891. Oil on canvas, 18 x 22 inches.
 Collection of Mrs. Diana Bonnor Lewis.

73. William Merritt Chase. *Good Friends,*
 c. 1909. Oil on wood, 22⅛ x 30⅞ inches.
 Hirshhorn Museum and Sculpture Gar-
 den, Smithsonian Institution, Washing-
 ton, D.C.

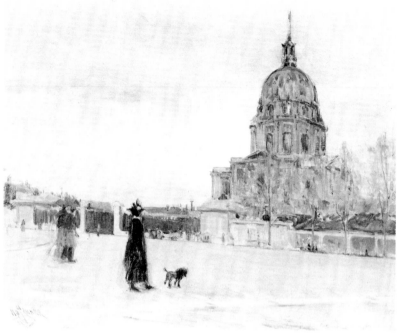

74

74. Henry O. Tanner. *Les Invalides, Paris,*
 1896. Oil on canvas, 13 x 16 inches.
 Collection of Mrs. Diana Bonnor Lewis.

75. Frederick Childe Hassam. *Winter Scene
 in New York,* 1900. Oil on canvas, 23 x 19
 inches. Museum of the City of New
 York.

76. Willard Leroy Metcalf. *The First Snow,*
 1906. Oil on canvas, 26 x 29 inches.
 Museum of Fine Arts, Boston; Bequest
 of Ernest Wadsworth Longfellow.

77. John Henry Twachtman. *Winter Har-
 mony,* c. 1900. Oil on canvas, 25¾ x 32
 inches. National Gallery of Art, Wash-
 ington, D.C.; Gift of the Avalon Foun-
 dation.

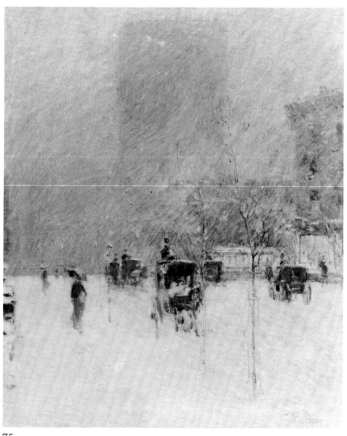

75

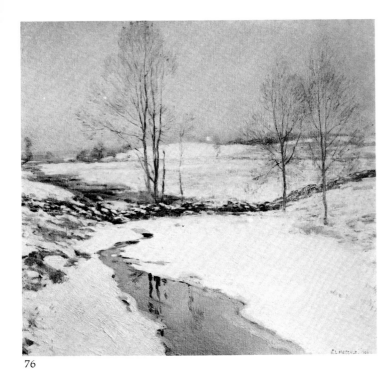

76

77

78

78. Thomas Dewing. *The Garland,* 1899. Oil on canvas, 31½ x 42¼ inches. Clyde M. Newhouse and Newhouse Galleries, New York.

79. Thomas Dewing. *Venetian Brocade,* c. 1905. Oil on canvas, 20 x 25 inches. Washington University Gallery of Art, St. Louis.

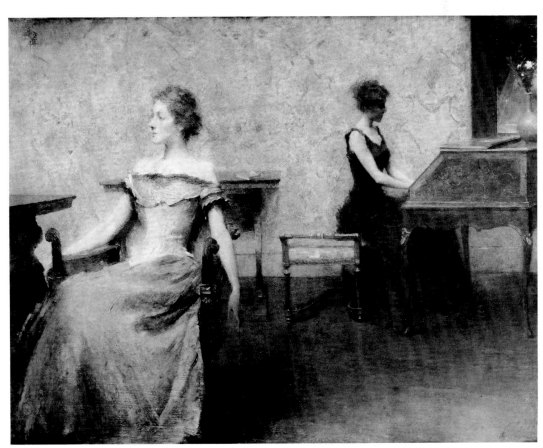

79

80. Robert Reid. *The Mirror,* c. 1910. Oil on
canvas, 37⅞ x 30⅜ inches. National
Collection of Fine Arts, Smithsonian
Institution, Washington, D.C.; Gift of
William T. Evans.

81. Joseph Rodefer De Camp. *The Guitar
Player,* 1908. Oil on canvas, 50½ x 46½
inches. Museum of Fine Arts, Boston;
Charles Henry Hayden Fund.

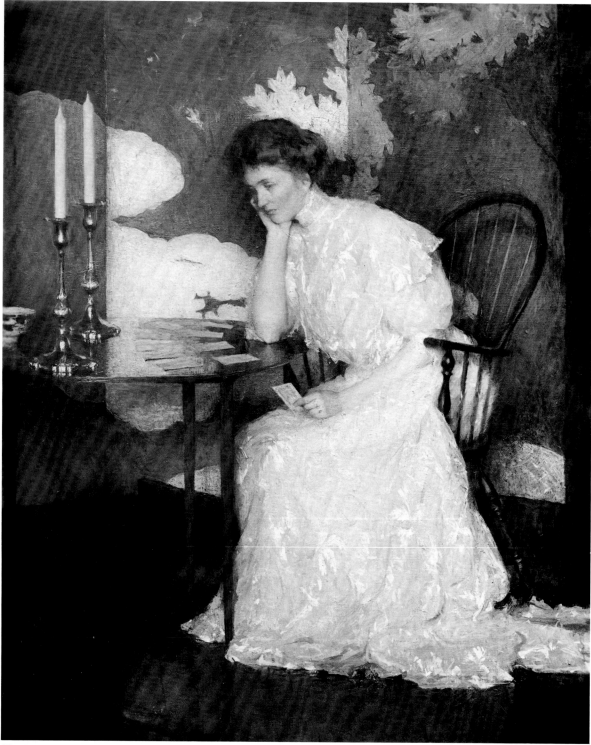

82

83

82. Frank Weston Benson. *Girl Playing Solitaire,* 1909. Oil on canvas, 50 x 40³⁄₁₆ inches. Worcester Art Museum, Worcester, Massachusetts.

83. Lilian Westcott Hale. *L'Edition de Luxe,* 1910. Pastel on canvas, 23 x 15 inches. Museum of Fine Arts, Boston; Gift of Miss Mary C. Wheelwright.

84. Edmund Charles Tarbell. *Josephine and Mercie,* 1908. Oil on canvas, 28¼ x 32¼ inches. Corcoran Gallery of Art, Washington, D.C.

84

85

85. Maria O. Dewing. *Garden in May,* 1895. Oil on canvas, 23 x 32 inches. National Collection of Fine Arts, Smithsonian Institution, Washington, D.C.; Gellatly Collection.

86. Abbott Thayer. *Roses,* 1896. Oil on canvas, 22⅜ x 31⅜ inches. National Collection of Fine Arts, Smithsonian Institution, Washington, D.C.; Gift of John Gellatly.

87. Winsor McCay. *Little Nemo in Slumberland (Slide Down the Banister),* 1909.
 Ink on paper, 28½ x 22½ inches (sheet). Collection of Ray Winsor Moniz.

VII Illustrations and Cartoons

THE PERIOD BETWEEN 1880 and 1910 has been called the "golden age" of American illustration. At that time painters and professional graphic artists designed newspaper, magazine, and book illustrations in such quantity and such high quality that the mural painter Edwin Blashfield could brag:

> If an enlightened foreigner came to America to weigh our art I would take him to the illustrators, with pride in the fact that in them he would find full measure of all-round capacity based upon well-laid foundations, a rich and varied technic, a mastery of means which had not been paid for by any lack of significance.[57]

Blashfield advocated the mutual exchange of ideas among artists of the various pictorial media which would, he thought, particularly benefit easel and mural painting.[58]

Illustrations differ from the so-called "fine-arts" drawing—the pastels, watercolors and prints—in their commercial purpose, their mass audience and their collaborative aspects. First, illustrations are commissioned to elucidate a written text or harmonize with it; as editorial cartoons they may stand in place of a text. Second, they were meant to be reproduced for a mass audience. Third, the editor or publisher often had specific requirements about size, format and style; often editors, writers and the illustrators worked in collaboration to produce the final graphic design.

The history of illustration and cartoons in the United States is closely connected with the growth of weekly journals and newspapers and developments in the technology of printing. A number of illustrated weeklies appeared in the 1850s using wood engravings, most notably *Frank Leslie's Illustrated Newspaper* and *Harper's Weekly.*[59] Artists, such as Winslow Homer who worked for *Harper's Weekly,* would submit drawings which were turned over to engravers who in turn would transfer the image to several small blocks. The blocks were engraved, bolted together and printed with the text.

During the next several decades many rapid advances were made in reproductive techniques. In 1877 *Scribner's Monthly* began photographing the artist's illustration and developing this image directly onto the wood block.[60] The engraver then could cut directly into the block, eliminating one step. Halftone reproduction was developed in the 1880s, whereby the illustration was photographed onto a plate through a screen, thus creating a series of etched dots on the plate. (In this process the engraver himself was eliminated.) The plate was then inked along with the accompanying text. After 1886 the number of halftone illustrations increased in *Harper's New Monthly Magazine, Century Magazine,* and other illustrated magazines, although wood engravings were still popular until about 1893. By the end of the 1890s, however, the halftone was the primary method of reproduction.[61] By that time, line drawings, photographs and paintings specifically commissioned as illustrations were appearing as halftone reproductions.

In the meantime high-speed presses were being developed which made possible thousands of inexpensive publications. Frank Luther Mott has estimated that between 1885 and 1905 there were nearly eleven thousand periodicals published in the United States, with many illustrations.[62]

Political events provided the first subjects of popular illustration in the mid-eighteenth century; in America, anti-British propaganda was the message of many engravings distributed as broadsides. In the mid-nineteenth century political caricature and cartoons could be found in the illustrated weeklies; the most famous graphic art was done by Thomas Nast, who satirized the corrupt politicians of New York City, specifically Boss Tweed, for *Harper's Weekly.* Nast developed some of the symbols of American political life: he invented the Republican Elephant and Tammany Tiger, and popularized the Democratic Donkey.[63] Nast worked at *Harper's Weekly* until the mid-1880s and then left because of disagreement with the management. Neither Nast nor the weekly survived as a political force after the rupture.[64]

In 1876, German-born lithographer Joseph Keppler and Adolph Schwarzmann, a writer, founded a German-language comic weekly called *Puck,* modeled after the English weekly *Punch.* In March 1877, they issued an English edition using the lithographic stones of the German edition.[65] Keppler believed in the importance of weekly staff consultations for the development of politically satirical graphic compositions.[66] These ap-

peared as chromolithographs on the cover, the center-fold and the back page. The cartoons lampooned politicians, attacked the greed of the large trusts, and made humorous caricatures of participants in topical events, yet the weekly was generally sympathetic to the Democratic Party. The artists who worked for *Puck* at various times were Frederick Burr Opper, T. Bernhard Gillam, Eugene Zimmerman, Louis Dalrymple, Samuel D. Ehrhart, Charles Jay Taylor, Louis M. Glackens, William Allen Rogers, Frank A. Nankivell, Rose O'Neill, Joseph Keppler, Jr., and Art Young. Several later went over to *Puck's* rival *Judge*, founded in 1881 as a weekly favorable to the Republicans.

Whereas *Puck* and *Judge* relied on chromolithography to attract its readers, in 1883 another weekly appeared called *Life*, which focused less on political issues and more on social satire. *Life* featured black and white line drawings, and Charles Dana Gibson joined the magazine in 1888 as a contributor. Gibson invented the Gibson Girl and a number of humorous characters and satirized the rich both at home and abroad.

Newspaper illustration also developed at this time as a way to satisfy the expanded public's craving for visual information and therefore to increase circulation. When Joseph Pulitzer of St. Louis bought the New York *World* in 1883, he set a new standard for newspaper journalism characterized by good news coverage, stunts, crusades against the large trusts like the New York Central, the Bell Telephone Company, the Standard Oil Company, and the Pacific Railroad lobbyists, as well as an editorial page that had a high character. But when William Randolph Hearst bought the New York *Morning Journal* in 1895 and shortly thereafter established the *Evening Journal*, an intensive war developed between the two rivals, Hearst and Pulitzer.[67]

Many New Yorkers deplored the new sensational journalism, but the graphic arts benefited. Newspapers now employed artists who had distinctive styles and who could collaborate when it was necessary. Edward Kemble described the way an art department of the *Daily Graphic* operated in those days:

> The marvelous methods of an art department of that period are worth recording. A spacious loft on the top floor of the plant served as the studio. Some ten budding geniuses were seated at tables where their shares in the pictorial features were given them by the art director. Each man was more or less a specialist in his particular line. Gray Parker did horses and social events. Cusaks, a Spaniard, did any old thing and sang snatches from "Carmen" while doing it. Zenope, a Turk, did portraits and delivered monologues of children reciting bits from their Sunday School lessons. C. V. Taylor, long and lanky, with spreading side-whiskers, did cartoons and street scenes. I was cartoonist and character artist. George B. Lucks [*sic*] was a contributor and did wonderful song and

dance acts for us whenever he paid a visit to the sanctum. If the West Point cadets were to parade on the following day, a full page spread had to be done the day before. The reviewing stand was put in by one man, the cadets drawn by the military genius, the mayor and his guests inserted by the portrait man, and then the whole masterpiece was pieced together and made ready for the photographer in an adjoining room. The thing that always bothered us most was the weather forecast. We would wait until the last minute and if a report came from the weather bureau announcing "rain tomorrow," the rain specialist, who was skilled at making an open umbrella from a bird's eye point of view, covered the whole opus with his product. Complete, the plate was made and the paper went to bed, and invariably the day of the parade just reeked with sunshine.[68]

A number of cartoonists, men such as Homer Davenport and William Allen Rogers, specialized in the editorial cartoon. Rogers, who had once worked for *Harper's Weekly* went to work for the New York *Herald* and developed a new bestiary for Wall Street manipulators. Along with the traditional bulls and bears, he created the rhinoceros, which represented the new finance; the octopus, representing the Standard Oil Company; the "muckrake," whose head was an actual rake with a body like a racoon, and the little lambs represented the small shareholder.[69] Theodore Roosevelt appeared in many of these cartoons with his bristling moustache, broad smile, thick eyeglasses, safari outfit and a big stick.

Not all newspaper art was of a political nature. There were the comic one-line illustrated jokes as well. To increase circulation for the New York *World*, Richard Felton Outcault drew a jug-eared urchin with a toothless grin and a long smock whose image was used to promote the paper. One day a printer added a block of yellow color to the kid's smock and he became "The Yellow Kid"—and the namesake for the term "yellow journalism."[70] Outcault went over to work for Hearst's *Journal* and George Luks was hired to perpetuate the Yellow Kid for the *World*.[71] The comic strips entered the newspapers in the 1890s—again to increase circulation. Rudolph Dirks created the *Katzenjammer Kids* in 1896. Other famous strips were Bunny Schultze's *Foxy Grandpa* (1900), Outcault's *Buster Brown* (1902), George McManus's *The Newlyweds* (1904) and Winsor McCay's *Little Nemo* (1905; Fig. 87).[72]

Illustrations also proliferated in the non-comic "quality" magazines—*Century Magazine*, *Scribner's Magazine* and *Harper's Monthly*—which hired artists to illustrate travel essays, short stories, biographies, news stories and general essays. Charles Parsons of Harper & Brothers and A. W. Drake of the *Century* are credited with raising the quality of the illustrations.[73] In those

days, when the motion picture was only in its infancy, the illustrations in magazines, as well as newspapers, were important sources of visual information. The Columbian Exposition was the last major exposition to be extensively covered by illustrators such as T. Dart Walker and Thure de Thulstrup;[74] and the Spanish-American War was the last war to which illustrators such as Frederic Remington, William Glackens, William Allen Rogers, and R. F. Zogbaum went as artist-journalists.[75] Later, photography replaced illustrations for news stories.

From the 1880s on, many of the magazines such as *McClure's Magazine, Century Magazine* and *Scribner's Magazine* began publishing articles which promoted the progressive reform movements of the time. Parts of Jacob Riis's *How the Other Half Lives* (1890) appeared in *Scribner's* in 1889, and Lincoln Steffens's *The Shame of Our Cities* (1904) appeared as articles in *McClure's Magazine* beginning in 1902. Other articles about steerage passengers, the coal fields and the steel mills were illustrated by artists such as Jay Hambidge and André Castaigne.

Howard Pyle and the England-based Edwin Austin Abbey were influential book illustrators who thoroughly researched their historical subjects in order to provide an accurate depiction of those times. Pyle was a teacher as well, and his students included N. C. Wyeth, Violet Oakley, Jessie Willcox Smith, Elizabeth Shippen Green and Alice Barber Stephens.

The best known illustrators developed very individual styles in book and magazine illustration. Florence Scovell Shinn and Arthur G. Dove had a straight comic style. Rose O'Neill, the inventor of the Kewpie doll, had a style which was eccentric and mannered but appealing; Oakley, Smith and Green shared a house together, and all three, along with Stephens, illustrated sentimental romances. Arthur Burdett Frost, who illustrated the *Uncle Remus* tales, and Edward Kemble, who illustrated Mark Twain's *Huckleberry Finn*, were known for their comic exaggerations of rural types and blacks.[76] Children's books were another area which developed a body of illustrators, and William Wallace Denslow's characters for Frank Baum's *Wizard of Oz* and Palmer Cox's Brownies are still remembered by many.

John Sloan, who developed an art nouveau illustrational style for the Philadelphia *Inquirer* in the 1890s, moved toward naturalistic representation in the first decade of the twentieth century. This naturalistic style was, of course, shared by the other Philadelphia artists George Luks, Everett Shinn and William Glackens, who specialized in scenes of the working classes. They were hired by the cheaper, mass-produced magazines such as *McClure's Magazine* and *The Saturday Evening Post*, which supported liberal causes and progressive reform. Those four artists, who became well-known painters and members of The Eight (see Section XII), valued their training as illustrators and particularly the experiences of observing life at first hand. George Luks criticized artists who snubbed the illustrator's profession:

> I have utterly no patience with the fellows whose "style is ruined" if they must make drawings for newspapers or advertisements, whose "art is prostituted" if they must use it to get daily bread. Any style that can be hurt by such experiences is not worth keeping clean. Making commercial drawings and especially doing newspaper work gives an artist unlimited experience, teaches him life, brings him out. If it doesn't, there was nothing in him to bring out, that's all.[77]

The turn toward naturalism and realism was noticeable in some of the other pictorial media at the time as well. Poster designers had shown a similar trend toward naturalism, and many photographers in that first decade came to reject the manipulated pictorial styles, preferring instead the "straight" photograph (see Section VIII). The shift may have been influenced by the realism and naturalism of the photographic halftones in the magazines, but it is also probable that editors preferred a naturalist style in magazines devoted to social reform and to a realistic assessment of the country's problems.

What criteria must we employ to assess those commercial and mass-audience cartoons and illustrations? Those art forms have a long and varied history shaped by developments in technology, expansion in the communications field, quixotic changes of taste, and the judgments of editors concerned with commercial possibilities. Aesthetic guidelines can help, but only partially. In cartoons and caricature the humor resides in two elements: first, the recognition of the subject and the situation, and second, the knowledge of the degree to which the work deviates from or exaggerates the real life subject. In illustration it is the appropriateness of the style and the subject to the content of the text. Questions of whether the drawing is skillful and inventive, or clumsy and monotonous, or whether the design has an immediate visual impact or is diffused and ambiguous, can also be asked.

Often we must ask these questions of the image which survives as a reproduction. Since the original designs were intended for translation into reproductions, many of them, if not lost, were often damaged, marked by printer's notations in blue pencil and corrected with unsightly white paint. Whether image or object, the illustrations are a valuable part of history and often either delightful or profound as art.

88

89

88. Joseph Keppler. *The Same Old Act*, for *Puck*, November 12, 1890. Hand-colored lithographic proof, 13⅜ x 10⅛ inches. Prints Division, The New York Public Library; Astor, Lenox and Tilden Foundations.

89. Eugene Zimmerman. *At It Again*, from *Judge*, September 30, 1905. Chromolithograph, 13¾ x 10 inches. Ben and Beatrice Goldstein Foundation, New York.

90. Charles Jay Taylor. *Another Shotgun Wedding with* Neither *Party Willing*, from *Puck*, December 1, 1897. Chromolithograph, 13½ x 10 inches. Ben and Beatrice Goldstein Foundation, New York.

91. Frederick Victor Gillam. *The Pig*, from *Judge*, 1903. Chromolithograph, 11 x 18 inches. Collection of Mr. and Mrs. Benjamin Eisenstat.

ANOTHER SHOTGUN WEDDING, WITH NEITHER PARTY WILLING.

90

THE PIG.

91

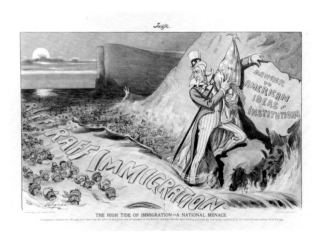

92

93

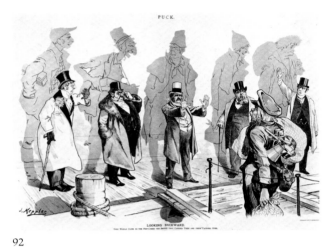

94

95

92. Joseph Keppler. *Looking Backward*, for *Puck*, January 11, 1893. Hand-colored lithographic proof, 13⅜ x 19⅞ inches. Prints Division, The New York Public Library; Astor, Lenox and Tilden Foundations.

93. Louis Dalrymple. *The High Tide of Immigration—A National Menace*, from *Judge*, 1903. Chromolithograph, 11 x 18 inches. Collection of Mr. and Mrs. Benjamin Eisenstat.

94. Charles Dana Gibson. *Life's Sunday Visit to the Metropolitan Museum Suggested as a Good Design for a Tapestry to Be Hung in That Progressive Institution*, from *Life*, 1890.

95. Edward Kemble. *An Evil and the Remedy*, from *Life*, 1901.

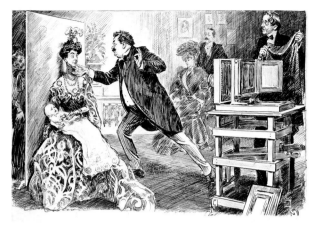

96

97

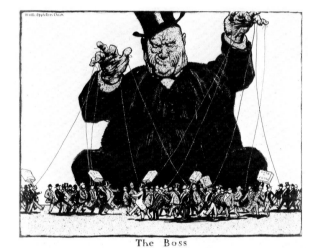

The Boss

98

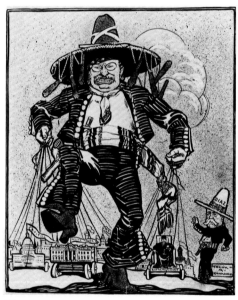

99

96. Charles Dana Gibson. *Grandma Takes the Baby to the Photographers*, 1904. Ink on paper, 19 x 28¾ inches. Library of Congress, Washington, D.C.

97. Charles Dana Gibson. *Mr. A. Merger Hogg Is Taking a Few Days Much-Needed Rest at His Country Home*, from *Life*, 1903. Photograph courtesy of the Library of Congress, Washington, D.C.

98. Walter Appleton Clark. *The Boss*, for *Collier's Weekly*, November 10, 1906. Ink on paper. Photograph courtesy of the Library of Congress, Washington, D.C.

99. Frank A. Nankivell. *Theodore Roosevelt and Diaz*, for *Puck*, October 18, 1910. India ink, pencil and tempera on paper; 22⅝ x 19¹/₁₆ inches. Free Library of Philadelphia.

100

101

102

100. William Allen Rogers. *He Doesn't Study Us: He Only Hunts Us*, for the New York *Herald*, May 25, 1907. Ink on paper, 15 x 19¾ inches (sheet). Prints Division, The New York Public Library; Astor, Lenox and Tilden Foundations.

101. William Allen Rogers. *What Are You Going To Do About It?*, for the New York *Herald*, January 25, 1910. Ink on paper, 14¹¹⁄₁₆ x 20³⁄₁₆ inches. Prints Division, The New York Public Library; Astor, Lenox and Tilden Foundations.

102. William Allen Rogers. *I'll Sweep Your Streets if No One Else Will*, for the New York *Herald*, December 27, 1906. Ink on paper, 15¹¹⁄₁₆ x 19⅞ inches. Prints Division, The New York Public Library; Astor, Lenox and Tilden Foundations.

103. William Allen Rogers. *The Upheaval*, for *Harper's Weekly*, February 4, 1905. Ink on paper, 16⅝ x 14½ inches (sheet). Prints Division, The New York Public Library; Astor, Lenox and Tilden Foundations.

103

104

105

106

104. Louis M. Glackens. *In the German Jam Closet*, for *Puck*, November 30, 1908. India ink and colored pencil on paper, 15¾ x 14 inches. Free Library of Philadelphia.

105. Richard Felton Outcault. *Yellow Kid*, 1896. Ink over pencil on paper, 10¹¹⁄₁₆ x 7⁹⁄₁₆ inches. Prints Division, The New York Public Library; Astor, Lenox and Tilden Foundations.

106. Gus Dirks. *The Latest News from Bugsville*, c. 1900. Ink and watercolor on paper, 12¾ x 21¼ inches. Graham Gallery, New York.

107

108

109

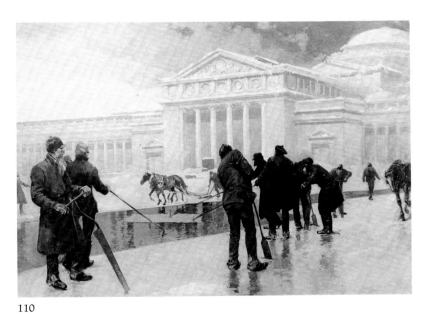

110

107. Joseph Keppler. *Puck World's Fair Souvenir* (Cover Design), 1893. Watercolor over pencil on paper, 14⅜ x 10½ inches. Prints Division, The New York Public Library; Astor, Lenox and Tilden Foundations.

108. Charles Dana Gibson. *The Artist's Studio*, n.d. Ink on paper, 22 x 16 inches. Collection of Joel S. Post.

109. Thure de Thulstrup. *Sculptor's Studio, Columbian Exposition*, for *Harper's Weekly*, April 12, 1892. Black, white and gray gouache on paper, 23 x 13⅜ inches. Cooper-Hewitt Museum of Decorative Arts and Design, Smithsonian Institution, New York.

110. T. Dart Walker. *Harvesting Ice on the Waterways of the Exposition Grounds at Chicago*, 1893. Gouache and Chinese white on illustration board, 12⅞ x 19⅜ inches. Anonymous lender.

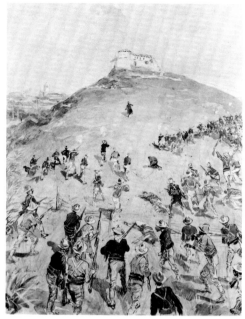

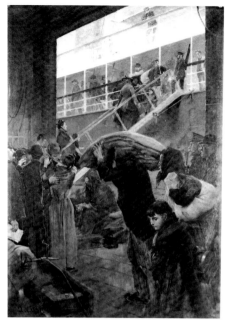

111 112 113

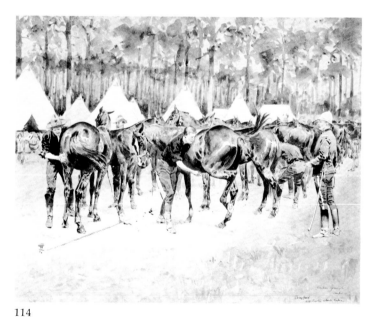

111. William J. Glackens. *The Charge at El Caney,* for *McClure's Magazine,* October 1898. Ink, wash and Chinese white on paper, 17 x 13¼ inches. Collection of Victor D. Spark.

112. André Castaigne. *Gone,* 1893, for *Century Magazine,* April 1894. Monochrome oil on canvas, 29⅛ x 20⅝ inches. Library of Congress, Washington, D.C.

113. Jay Hambidge. *Christmas on the East Side—A Prayer of Thanksgiving That He Lives in a Free Country,* for *Century Magazine,* December 1897. Ink and white gouache on paper, 26⅛ x 17¼ inches. Free Library of Philadelphia.

114. Frederic Remington. *Picket Line, Tampa, Florida,* 1898. Ink and wash on paper, 22 x 28 inches. Graham Gallery, New York.

114

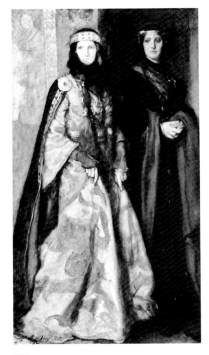

115

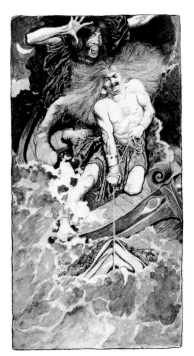

116

117

118

115. Edwin Austin Abbey. *Goneril and Regan*, for *King Lear*, 1902. Oil on canvas, 30¼ x 17½ inches. Yale University Art Gallery, New Haven; The Edwin Austin Abbey Memorial Collection.

116. Howard Pyle. *Fishing of Thor and Hymer*, c. 1901. Watercolor on paper, 7¾ x 4⅛ inches. Delaware Art Museum, Wilmington.

117. Howard Pyle. *Sir Kay Interrupts Ye Meditations of Sir Percival*, c. 1903. Ink on paper, 9¼ x 6¼ inches. Delaware Art Museum, Wilmington.

118. T. Dart Walker. *Home from Europe—The Customs Ordeal on the Pier*, 1894. Gouache, gray wash and Chinese white on illustration board; 13¼ x 21⅜ inches. Anonymous lender.

119. Jessie Willcox Smith. *Mother and Child*, c. 1908. Mixed media on paper, 24 x 18 inches. Collection of Mr. and Mrs. Benjamin Eisenstat.

120. Rose O'Neill. *Popularity à la Mode*, for *Puck*, June 26, 1901. Ink on paper, 21½ x 15⅛ inches. Collection of Mrs. John Sloan.

121. Elizabeth Shippen Green. *He Knew That He Was Not Dreaming*, for *Harper's Monthly Magazine*, August 1907. Charcoal and watercolor on illustration board, 13 x 14⅝ inches (image). Library of Congress, Washington, D.C.

122. Alice Barber Stephens. *Please Wait a Moment*, for *McClure's Magazine*, December 1906. Pastel on board, 15⅛ x 17⅛ inches. Library of Congress, Washington, D.C.

119

120

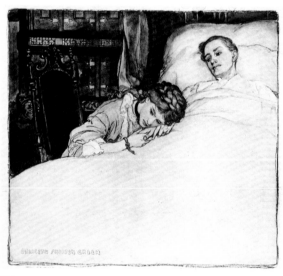

121

122

123

124

123. Florence Scovell Shinn. *On the Fences and Walls Throughout All Ohio,* from *Mr. Perkins of Portland,* 1899. Ink on paper, 16¼ x 14½ inches. Free Library of Philadelphia.

124. Edward W. Kemble. *Cold Weather at the Zoo: Cast Off Clothing Thankfully Received,* c. 1900. Ink on paper, 14¼ x 11 inches. Collection of Mr. and Mrs. Benjamin Eisenstat.

125. Arthur Burdett Frost. *The Monroe Doctrine,* 1904. Gouache on paper, 17¾ x 24½ inches. New Jersey State Museum, Trenton.

126. John S. Pughe. *Down in Chickentown,* for *Puck,* February 1900. Ink on paper, 10 x 21¼ inches. Collection of Mr. and Mrs. Benjamin Eisenstat.

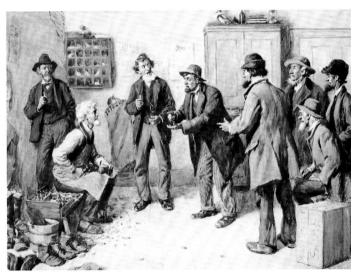

125

126

127

127. William Wallace Denslow. *You Ought to Be Ashamed of Yourself*, for *The Wizard of Oz*, 1900. Ink over pencil on paper, 19⅞ x 14 inches. Prints Division, The New York Public Library; Astor, Lenox and Tilden Foundations.

128. Palmer Cox. *The Brownies, Tally Ho*, for *Another Brownie Book*, 1890. Pencil and India ink on paper, 12¾ x 9½ inches. Cooper-Hewitt Museum of Decorative Arts and Design, Smithsonian Institution, New York.

129. John Sloan. *On the Court at Wissahickon Heights*, for the Philadelphia *Inquirer*, 1892. Ink on paper, 9¾ x 6⅝ inches. Collection of Mrs. John Sloan.

130. John Sloan. *She Blew a Ring of Smoke*, 1895. Ink on paper, 10½ x 6¾ inches. Collection of Mrs. John Sloan.

131. John Sloan. *Don't You Want the Umbrella?*, for *The Steady*, 1904. Crayon on paper, 18 x 12 inches. Collection of Mrs. John Sloan.

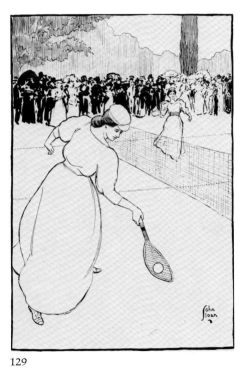

129

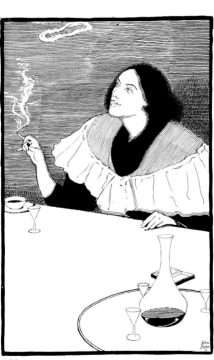

130

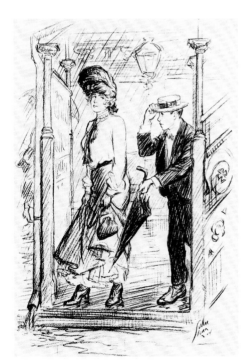

131

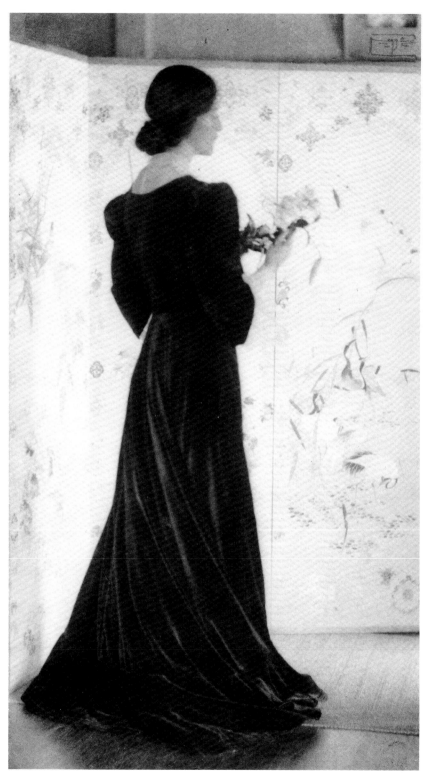

132. Eva Watson Schütze. *Woman in a Velvet Dress*, 1905. Platinum print,
 8 x 4⅝ inches. Collection of Paul F. Walter.

VIII Pictorial Photography and the Photo-Secession

AT THE TURN OF THE CENTURY "pictorial photography" defined those photographs which attempted to achieve the same qualities as the currently admired paintings. There was the anecdotal genre which focused on picturesque studies of farmers, historical genre which sought to emulate seventeenth-century Dutch painting, nature studies advocated by Peter H. Emerson in his influential book *Naturalist Photography* (1889) and, in America especially, soft-focus and tonal photographs inspired by the paintings and theories of Inness and Whistler.

Pictorial photography was promoted by serious amateurs who banded together into camera clubs in order to share ideas, to raise standards and to promote photography as an acceptable and serious art form. In their view, the best photography was capable of producing artistic results because the formal criteria for determining what was quality in a photograph were the same as those applied to painting. To Charles Caffin, whose book *Photography as a Fine Art* (1901) vigorously championed the cause of artistic photography, the aims of both painting and photography were identical: "The goal of the best photographers, as of all true artists, is not merely to make a picture, but to record in their print and transmit to others the impression which they experience in the presence of the subject...."[78]

Whatever the claims of these photographers, there was resistance, particularly among conservative painters, to the acceptance of photography as art. Since George Eastman had invented the roll-film camera (the Kodak) in 1888 and thousands of amateurs were making snapshots of family and vacation spots, critics held that photography was a mere pastime. Some refused to view professional commercial photography as anything other than hack work, based on endless repetition of worn out formula poses and arrangements. Others saw the camera's mechanical nature as antithetical to the creation of beauty and artistic effects.

To answer such criticisms, Caffin distinguished "utilitarian" photography from "aesthetic" photography: "The goal of the one being a record of facts, and of the other an expression of beauty." Examples of the former are photographs of buildings and engineering works, news scenes for newspapers, tourist snapshots and most portraits. According to Caffin, in all such utilitarian photographs, "the operator relies upon the excellence of his camera, and in developing and printing aims primarily at exact definition."[79]

The "aesthetic" photograph is one "whose motive is purely aesthetic: to be beautiful. It will record facts, but not as facts; it will even ignore facts if they interfere with the conception that is kept in view." Caffin, however, admits an intermediate type of photograph, "which, while first of all useful as records of works of art, are treated with so much skill and feeling for the beauty of the originals that they have an independent value as being themselves things of beauty." In this class are the photographs of artworks and the more sensitive portraits. In summing up the three classes, Caffin concludes: "In the first class the photographer succeeds by mechanical and scientific means, in the two latter he must also have sympathy, imagination, and a knowledge of the principles upon which painters and photographers alike rely to make their pictures."[80]

In 1901, Caffin singled out Alfred Stieglitz as a leader of the photographers who were bringing aesthetic considerations to photography. Stieglitz had gone to Germany in 1881 to study engineering, but with the encouragement of his photochemistry professor Hermann Vogel, in whose class he began making photographs, he had taken up the camera in earnest. He had even won, in 1887, an important prize from Peter Emerson—awarded by *The Amateur Photographer,* London. When Stieglitz returned from Europe in 1890 he was determined to promote standards of excellence in photography. During the next twenty years Stieglitz and the men and women who were his colleagues and followers—Gertrude Käsebier, Clarence H. White, Frank Eugene, Alvin Langdon Coburn, Joseph T. Keiley and Edward Steichen—exerted a decisive influence on the development of the medium in America.

In the early 1890s Stieglitz involved himself with various amateur photographic clubs and, from 1893 to 1896, was editor of the newsletter *American Amateur Photographer.* In 1897 he persuaded the New York Camera Club to allow him to produce an elegant quarterly with articles on photographers, reviews of exhibitions, essays on new techniques, halftones of a number of photographs, and two hand-pulled photogravures; the advertis-

ing to be included would support the enterprise. The first issue of *Camera Notes* appeared in July 1897.

Stieglitz believed that only excellent work would bring recognition to photography. Although he set high standards for the quarterly, he was open to many possibilities. He showed the work of artists who earned their living with their commercial photography, such as Frances B. Johnston, as well as of those who were talented amateurs, such as F. Holland Day. He also selected both "manipulated" and "straight" photographs for reproduction.

Manipulated photographs were the results of a photographer's self-conscious attempt to achieve artistic effects by altering the negative (by scratching and rubbing its surface) or retouching the print during the darkroom process. Artists such as Steichen and Eugene and the Europeans Robert Demachy and Heinrich Kühn were known for their prints which often looked similar to etchings. What they all hoped for was an artistic mood, often of reverie and introspection—a mood which they felt could not be achieved by sharp detail.[81]

The straight photographers were those who aimed at artistic effects solely through the selection of subject, props, setting, placement of lights, composition and focusing. Although interested in art they were not interested in imitating the effects of painting or etching; they preferred the clear, crisp image which they considered natural to photography. Many pages of *Camera Notes* dealt with the controversies of whether or how much a photograph should be manipulated.

Stieglitz himself rarely tampered with the fundamental processes as they were known then. He was an innovator in terms of subject matter—finding art where others had not looked. By preferring the straight photograph, he was beginning to reject the aesthetics of pictorial photography. His personal attitude, as reported in 1901, was that "the photographer should rely upon means really photographic; that is to say, upon those which grow out of and belong to the technical process."[82]

In 1902, Stieglitz mounted a photographic exhibition for the National Arts Club. He included the photographers whose work he had published in *Camera Notes* and had seen in previous exhibitions, and called it "an Exhibition of Photography Arranged by the Photo-Secession." When questioned about the title by Charles de Kay, the founder and director of the National Arts Club, Stieglitz replied: "Photo-Secession implies a seceding from the accepted idea of what constitutes a photograph. Besides which, in Europe—in Germany and Austria—splits have occurred in art circles, the moderns calling themselves Secessionists. So Photo-Secession hitches up with the art world."[83]

In 1903, Stieglitz, who had left *Camera Notes* because of disagreement with other Camera Club members, began his own quarterly, *Camera Work*. The standard of the reproductive photogravures was unusually high. Over the years he introduced new photographers to the group—artists such as Anne Brigman, George Seeley, and finally Paul Strand. The quarterly was also an important forum for the airing of aesthetic issues. In 1905 Stieglitz and Steichen opened a gallery for the Photo-Secession at 291 Fifth Avenue in order to show their work, and in 1907, watercolors and then paintings and sculpture were added to the exhibitions in order to show modern photography in the context of developments in the other media. The gallery, known as "291," soon became the locus for the exhibition of modern art in America.

Straight photography, in the meantime, was slowly becoming the dominant trend. In 1904 Hartmann reviewed the accomplishments of pictorial photography and predicted its demise:

> The pictorial quality of the photographic print has reached a very high standard. The monotonous platitude of the average photographic print has been broken. And whoever sees a Steichen print must confess that it possesses high artistic qualities. And now as the pictorial photographer has accomplished his task, a reaction in favor of work produced by less artificial means will probably set in.[84]

Caffin, agreeing in 1909, saw the manipulated pictorial print as a necessary step in the maturing of photography as an art form: "In the case of painting, we have seen the 'Art for Art's sake' principle justify itself, do its stint of service and then die of inanition. I propose to raise the question whether the work of the Secession does not need a little fresh nutriment, if it is to avoid a similar fate."[85]

Although pictorial photographers worked up to the 1920s, times were changing; artificiality and mannerisms were rejected by Stieglitz as well as other artists. Hartmann's earlier praise for Stieglitz was to become the standard by which to judge new work:

> Nobody masters the contradictions of photographic art as well as he. He combines refinement of detail with poetical beauty, and understands how to render his realism poetical and decorative, by the simple, and yet so rarely united, means of an artistic temperament and a perfect technique.[86]

As in the other media of art what came to be valued was honesty and directness. To Stieglitz beauty was truth to the poetry of reality and to the means of expression.

133

133. Alice Boughton. *Sand and Wild Roses*, from *Camera Work*, April 1909. Photogravure, 8⅜ x 6¼ inches (image). The Witkin Gallery, Inc., New York.

134. Anne Brigman. *The Bubble*, 1905. Photograph, 7½ x 9½ inches. The Oakland Museum; Gift of Mr. and Mrs. W. M. Nott.

134

135

136

137

135. Clarence H. White. *Nude (The Mirror)*, 1909. Platinum print, 9½ x 7⅝ inches. The Museum of Modern Art, New York; Purchase, 1971.

136. Alfred Stieglitz and Clarence H. White. *Torso*, 1907. Platinum print, 9½ x 8¼ inches. The Museum of Modern Art, New York; Extended loan from the Estate of Lewis F. White.

137. F. Holland Day. *Untitled (Nude Boy in Stream)*, 1907. Platinum print, 7⅞ x 4¾ inches (image). Library of Congress, Washington, D.C.

138

139

140

141

138. Gertrude Käsebier. *Mrs. Beatrice Baxter Ruyl and Infant*, 1905. Platinum print, 7¼ x 9⅝ inches. The Museum of Modern Art, New York; Gift of Mrs. Hermine M. Turner.

139. Rudolf Eickemeyer, Jr. *Two Boys*, 1906. Platinum print, 9⁵⁄₁₆ x 5⅛ inches. Hudson River Museum, Yonkers, New York.

140. Joseph T. Keiley. *Portrait: Miss DeC.*, 1908. Platinum print, 3¼ x 4⅜ inches. The Metropolitan Museum of Art, New York; Alfred Stieglitz Collection.

141. Clarence H. White. *Untitled (Woman on Loveseat)*, c. 1899. Platinum print, 7¾ x 6 inches. The Museum of Modern Art, New York; Gift of Mr. and Mrs. Clarence H. White, Jr., 1976.

142. George Seeley. *Autumn,* from *Camera Work,* no. 29, January 1910. Photogravure, 8 x 6⅜ inches. Philadelphia Museum of Art; Gift of Carl Zigrosser.

143. Edward Steichen. *Self Portrait with Brush and Pencil*, 1901. Gum-bichromate print, 8¼ x 6⅜ inches. Collection of Eugene M. Schwartz.

144

145

144. Edward Steichen. *The Pool*, from *Camera Work*, April 1903. Photogravure, 8 x 6¹/₁₆ inches (image). Ex Libris, New York.

145. Clarence H. White. *Winter Landscape, Newark, Ohio*, c. 1900. Platinum print, 8⅛ x 6¼ inches. The Museum of Modern Art, New York; Gift of Mr. and Mrs. Clarence H. White, Jr., 1971.

146. Clarence H. White. *Spring—A Triptych*, 1898. Platinum prints; center panel: 16⅛ x 8⅛ inches, side panels: 15 x 2⅜ inches. The Museum of Modern Art, New York; Mrs. Douglas Auchincloss Fund.

146

147. Gertrude Käsebier. *Joe Black Fox, a Sioux Indian from Buffalo Bill's Wild West Show*, c. 1895–1905.
Platinum print, 8 x 6⅛ inches. Robert Schoelkopf Gallery, New York.

IX Portrait Photographs

Shortly after the publication in 1839 of Daguerre's process for fixing an image on a copper plate through photographic means, many realized its potential for portraiture. In fact, the early daguerreotypes were almost always portraits—substitutes for the expensive painted miniatures of the early nineteenth century.

As photography developed, various kinds of photographic portraits appeared, both unique and reproducible. Each ambrotype and tintype, like the daguerreotype, was a unique image. Other portraits developed on salt or albumen paper from paper or glass negatives were capable of being reproduced endlessly. In the 1860s the pocket-size *carte de visite* (visiting card) photograph became popular, especially after photographs of Queen Victoria and her family were distributed in 1860.[87] Another type of commercial portrait photograph was the slightly larger (about 4 x 2½ inches) "cabinet card," which allowed for more ambitious compositions and settings. After 1869, retouching became widely used to improve upon the facial features of sitters, to firm up details of the setting, and to admit a greater number of tones.

By the late nineteenth century, mass production of cheap and sharp portraits was in full swing and many commercial photographic firms had been established which specialized in the genre, such as Pach Brothers of New York and Brown Brothers of Philadelphia. The Byron Company of New York specialized in other kinds of commercial photography but did occasional portraits of business and social leaders and their families. Every major city—and plenty of frontier towns as well—had a number of commercial portrait photographers.

At the same time, there were the art-conscious photographers and the pictorialists (see Section VIII) who reacted against the "average photographer," described by Charles Caffin, "who turns on the full light, producing a bald, hard, uniformly-lighted picture, unsuggestive, merely obvious, and too often commonplace."[88] The other, more particular photographers began experimenting with techniques and processes which would produce a more expressive portrait. The refinement of the "permanent" printing methods which produced carbon or platinum prints aided their search. In this latter method, the photograph was printed on paper impregnated with platinum salts which produced a chemically stable print—less affected by air, moisture or acids. Often photographers who had been trained as painters, such as Alice Boughton, Gertrude Käsebier and Edward Steichen, were attracted to the aesthetic qualities of the platinum print with its range of delicate silver-gray tones.

Once in control of the processes and the craft, the art-conscious photographers were challenged by the problem of how to make a "likeness" which was also artistic—to be true to the sitter's appearance and sensitive to the individuality of character, but also to produce an interesting photographic object. The training of these painters-turned-photographers made them aware of compositional problems, but it also made them more conscious of the limitations of the medium and of the brevity of the photographic sitting. Alice Boughton's remarks on these difficulties, first published in 1905, are worth quoting at length:

> The photographer should be intuitive, to be able to get in touch with his subject, just as the painter; to study character every moment while not ostensibly doing so, and to be ready when the right instance presents itself.... The painter usually has several sittings, sees his subject under varying conditions in different moods, has a chance, in short, to become acquainted with the personality he is to portray. The photographer, on the other hand, has one moderately short session, and for that reason, too, he must sharpen his wits.
>
> He should realize at once how different persons should be done; which require delicate treatment and which can stand strong contrasts. Sometimes a light scheme of whites and greys, by the very closeness of the values, can suggest the etheral quality of a delicate child, or a young girl, or frail old age. Heavy blacks and browns are for persons with color and brunettes, and are strong masses for men. In between come a countless number of gradations, from the subtlety of fine drawing to the Rembrandtesque distribution of lights and shades. The photographer also must understand pose and lighting....
>
> That there shall be one centre of interest is necessary, and that the parts should not apparently be out of focus....

If the photographer has sufficient insight to perceive the interest and character of the sitter, the result may be a real achievement....[89]

Gertrude Käsebier, who insisted upon referring to herself as a commercial photographer,[90] received the greatest number of accolades as a portraitist of the time. She had a number of photographs reproduced as photogravures in *Camera Notes*, published between 1897 and 1902, and was the first artist to appear in Stieglitz's *Camera Work* when the inaugural issue appeared in 1903. Arthur Dow praised her portraits in 1899:

> She looks for some special evidence of personality in her sitter, some line, some silhouette, some expression of movement; she searches for character and for beauty in the sitter. Then she endeavors to give the best presentation by the pose, the lighting, the focusing, the developing, the printing—all the processes and manipulations of her art which she knows so well.[91]

During Käsebier's career she made portraits of society belles, artists, educators, and actors. She was sensitive to the medium but also aware of the special conditions of photographing for the mass-circulated magazines, where halftone reproduction would be used. Through her efforts and those of others, the standard of photographic portraiture was raised to a position where Caffin could assert in 1901 that, "In this country today, the portraits by the best photographers attain a higher average of all-round excellence than those by the best painters."[92]

To ask whether there is a qualitative difference between the portraits which were made commercially and those made as self-conscious artistic endeavors intended for eventual exhibition in galleries and museums may be less relevant than to search for the degree of awareness of the photographer in the making of a portrait, which is, after all, a representation of an individual as an individual, not as a type. One artist may prefer, or have only the time, to record naturalistically the physiognomy of the sitter, including details of social status. But slice-of-life naturalism is impossible in a posed portrait. Sitters are not usually neutral. Once aware of the camera focused on their own individuality, they either become frozen with self-consciousness, feign nonchalance or arrange their facial expressions and their limbs to conform with their self-image.

Another artist may be struck by the design possibilities of facial features, and arranges the human face to make a decorative composition. But a sitter's personality may include the desire to be part of an artistic arrangement, thereby elevating his own life to the claims of art. Pushed to extremes, artificiality and mannerism become the aesthetic content of such portraits.

A third photographer may intend a humanistic interpretation of people. This artist sees a face that has been shaped by a specific personal history full of the triumphs, the failures, and the daily experience of living, and may also see present concerns mirrored there—the fantasies, the pretensions and the human compassion. This photographer acknowledges the active role of the sitter and seeks an expressive synthesis of personal response to the unique personality of the subject. The important premise seems to be that the photographer be conscious of self, sitter and the limits and possibilities of the artistry. The most memorable photographs of that era are those in which the photographer was aware of all three.

148. Alvin Langdon Coburn. *Mark Twain*, 1908. Photogravure, 9⅛ x 6⅜ inches. International Museum of Photography at George Eastman House, Rochester, New York.

149. Thomas Eakins (attributed). *Walt Whitman*, n.d. Silver print, 4¾ x 3⅞ inches. Philadelphia Museum of Art; Bequest of Mark Lutz.

148

149

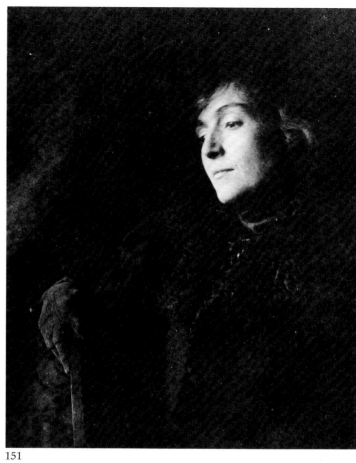

151

150

150. Edward Steichen. *J. P. Morgan,* 1903. Modern print made by Rolf Petersen from original negative, 16¾ x 13½ inches. The Museum of Modern Art, New York; Gift of the Photographer, 1964.

151. F. Holland Day. *Portrait of Mrs. Potter Palmer,* c. 1890. Platinum print, 5⅝ x 4¹¹/₁₆ inches. The Metropolitan Museum of Art, New York; Alfred Stieglitz Collection.

152. Edward Steichen. *Isadora Duncan,* c. 1910. Photograph, 7⅞ x 9⅞ inches. The Museum of Modern Art, New York; Gift of Edward Steichen.

153. Gertrude Käsebier. *Evelyn Nesbit,* c. 1903. Gelatin silver print, 8⅛ x 6⅛ inches. International Museum of Photography at George Eastman House, Rochester, New York.

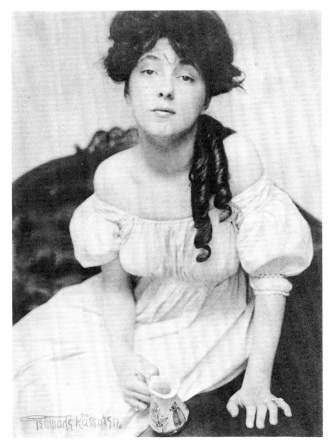

153

152

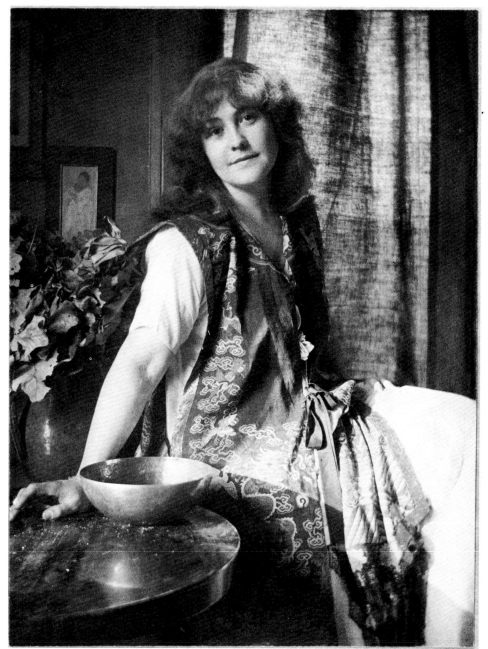

154

154. Gertrude Käsebier. *Rose O'Neill: Illustrator and Originator of the "Kewpie" Doll, Posed in the Photographer's New York City Studio,* 1900. Platinum print, 8 x 6 inches. International Museum of Photography at George Eastman House, Rochester, New York.

155. Gertrude Käsebier. *Portrait of F. Holland Day,* n.d. Platinum print, 4¾ x 4¾ inches. The Museum of Modern Art, New York; Gift of Miss Mina Turner.

156. Frank Eugene. *Alfred Stieglitz,* from *Camera Work,* January 1909. Photogravure, 7 x 5 inches (image). The Museum of Modern Art, New York; Gift of Edward Steichen.

155

156

157

158

160

159

157. Gertrude Käsebier. *Robert Henri*, n.d. Gum-bichromate print, 12^{11}/$_{16}$ x 9¼ inches. The Museum of Modern Art, New York; Gift of Hermine M. Turner, 1963.

158. Gertrude Käsebier. *John Sloan*, 1907. Photograph, 8⅛ x 6¼ inches. Collection of Mrs. John Sloan.

159. Frank Eugene. *Princess Rupprecht and Her Children*, from *Camera Work*, April 1910. Photogravure, 6⅞ x 4¾ inches (image). Philadelphia Museum of Art; Gift of Carl Zigrosser.

160. James Van DerZee. *Music Teacher and Wife at Whittier*, n.d. Modern print made from original glass negative, 8 x 10 inches. Courtesy of The James Van DerZee Institute, Inc., New York.

161

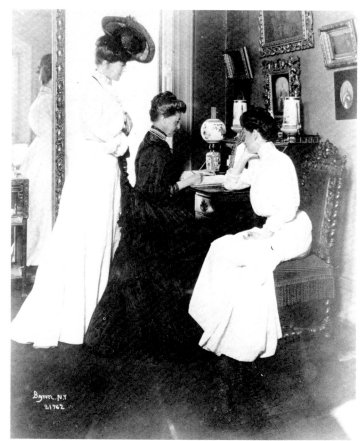

162

163

161. Addison Scurlock. *Grant's Rear Guard*, c. 1905. Modern print made by the photograper's grandson, Robert Scurlock, from original negative, 8 x 10 inches. Courtesy of Scurlock Studios, Washinton, D.C.

162. The Byron Company. *Mrs. James Gore King Duer and Her Daughters, Alice Duer Miller and Caroline King Duer*, 1906. Solio print, 9⅜ x 7⁹⁄₁₆ inches (image). Museum of the City of New York.

163. The Byron Company. *Children's Party*, 1906. Solio print, 10½ x 13¼ inches (image). Museum of the City of New York.

164. The Byron Company. *Richard Hall at Work on His Portrait of Cathleen Neilson, the Future Mrs. Reginald Claypool Vanderbilt*, 1903. Solio print, 8⅜ x 10¼ inches (image). Museum of the City of New York.

164

165. Arnold Genthe. *Shop in Chinatown*, 1896–1906. Photograph, 10⅜ x 13⅛ inches.
The Museum of Modern Art, New York; Gift of Albert M. Bender, 1940.

X Social Photography: Documentary and Topical

AT THE TURN OF THE CENTURY a number of photographers photographed people in the environments in which they found them. Some of these photographers worked for philanthropic agencies; others were employed by commercial firms and were paid by clients—businesses, city agencies, colleges, newspapers and publishers—who often specified certain scenes and activities. Some photographs were used for purposes of promotion or documentation. Still others were reproduced and sold commercially as postcards or stereographs. Many commercial photographers were involved either aesthetically or personally with their subjects. Often they were there simply to record as objectively as possible the activity or view.

There were others photographing the life and scenery of America who were not commissioned for their efforts. Some were amateurs with no pretensions to art or accurate documentation, their goal being the collection of snapshot reminders of friends and holiday excursions. More serious amateurs and professional photographers such as Alice Austen did work for their own pleasure, although in some instances their photographs were sold.

Whether commissioned or taking photographs for their own pleasure, or (as was the case with Lewis Hine) finding a situation in which they could get paid for photographing the subjects of their interest, what united these photographers was their intention to focus on the world outside the studio. If we see artistic merit in the results, it is often a byproduct of their primary concern to record the appearance and significance of real people and scenes. These turn-of-the-century social photographers of documentary and topical scenes also shared a lack of interest in pictorialism as a style or aestheticism as a philosophy, although they may all have been concerned with photography as a precise craft with artistic potential. Finally, few of this group working before 1910 anticipated that the eventual destination of their works would be the walls of art galleries or the cabinets of museum photographic departments.

In general the status of commercial photography during those years was low in the estimation of established art critics such as Charles Caffin who remarked that the commercial photographer's "objective is a definite financial profit; he cannot afford to experiment, and adopts a certain process which in the long run produces the best average of results and sticks to it."[93] Nevertheless, even the most mediocre of these original photographs can hardly fail to elicit some response. The antiquarian in each of us marvels at the age of the object—at the ability of old photographic paper to retain an image—and we respond to its fragility, realizing that as light made the image appear, greater and prolonged exposure to light can bleach out the same image. (The more permanent processes, such as silver prints and platinum prints, because of their expense, were not used as often by commercial photographers.) The historian sees the photographs as a part of history—images documenting clothing, housing conditions and land development specific to a historical time and place. The sentimentalist views these photographs as reminders of a time when life was different, presumably more innocent, than our present times.

But among the commercial and amateur photographers outside the art establishment were those who nevertheless made stunning *objects* and memorable *images*: carefully processed objects which have a richness of tonal values, a delicacy of color and a subtlety of surface; and images in which subject matter and design requirements mutually enhance each other to reveal the photographer's distinct point of view. In these better efforts, and better solutions, one finds what may be called artistry.

The art historian or critic with a formalist bias sees in these more exceptional topical photographs the roots for our present-day straight photography—photography which finds in the empirical world the shapes and textures with which to construct an interesting two-dimensional design. The historian or writer who values subject matter as an essential part of the artist's expressive content has the obligation to explain any special relevance which the subject may have.

However, as Jonathan Green has pointed out in his introduction to *Camera Work: A Critical Anthology* (1973): "During the last half of the nineteenth century, there was no recognized esthetic that would certify the straight photograph as an expressive object,"[94] even though Stieglitz as well as Hine certainly realized that potential. Therefore, we might claim as our obligation the necessity to construct guidelines with which to view and

differentiate between the various kinds of early straight photographs in order to reach an understanding with them.

Indeed, we may find it useful to revive the traditional distinctions between realism and naturalism used in the nineteenth century in discussions of painting when attempting to understand these social or documentary or topical photographs as art. Although the words have been used interchangeably, realism has gained acceptance as the term to categorize any art representing or imitating forms that exist or could exist in the world outside the artist's head. The distinction has been blurred, perhaps because the question of the artist's intentions—his or her personal stance—has been dismissed as irrelevant. But when the differences were considered, the rule of thumb went somewhat as follows: If the artist self-consciously proclaimed a point of view, a social message, a concern with ideology, then the work was considered realist.[95] If, on the other hand, the artist denied moral and political commitment and claimed slice-of-life objectivity as a goal (either because the patron/client requested it or because objectivity had become the artist's personal world outlook) then that art was called naturalism. To be a naturalist often meant to be detached and scientific and even formal in one's approach to the subject.

The naturalist or objective photographers were those such as the Byron Company photographers, of whom Edward Steichen remarked:

> Their only speciality was making photographs, photographs without opinion, comment, slant or emotion. If the word objective has any meaning in relation to photography here it is. There is no pretense or artifice, no willful accent or suppression. Composition is based on including everything within the camera's angle and photographing so that everything is plainly visible. The photographs are objective because the places, the things and the people photographed have a chance to speak for themselves without interference.[96]

But can the works really be called "objective" when the scenes were commissioned by, or the firm hoped to sell to, the telephone company which would require an image of business efficiency and contented workers? William Rau photographed railroad tracks of the Pennsylvania Railroad, making them seem pristinely beautiful, orderly and not disruptive of the environment. Frances B. Johnston's photographs for Hampton Institute promoted the educational advantages of the college; thus, the house in *A Hampton Graduate's Home* is not simply the living quarters of people, but a portrait of middle-class prosperity and well being. As in other areas of art making, patronage often determined the point of view and was an ingredient in the result.

Jacob Riis, a newspaper reporter and author of *How the Other Half Lives* (1890) and other books and articles on the living conditions of the poor in New York City, turned to photography because of its ability to document with accuracy, and thereby dramatize, the conditions he was campaigning against. He caught the attention of Theodore Roosevelt, later police commissioner, who referred to Riis as "the most useful citizen of New York."[97] When *How the Other Half Lives* first appeared in *Scribner's* in December 1889, the illustrations were line drawings made by Kenyon Cox and others after Riis's photographs. The illustrations with their suppression of detail softened the image of dire poverty and squalor—translating the tenement dwellers into images of picturesque beggary which was contrary to Riis's intentions. In the meantime, however, advances were made in the reproduction of photographs, and the 1890 book contained halftones of the photographs.

Because Riis does have a point of view—to reform rather than sugarcoat the effects of tenement living and sweatshop working conditions, his images fall into the tradition of realism. His photographs depict real slum children and their activities; real Indians who work in sweatshops along with everyone else; and a real Jewish man awaiting the end of the Sabbath before he breaks bread. The faces sometimes smile, perhaps at a joke or at the photographer with his elaborate equipment, but often the faces, etched by years of hard work, simply stare out at us. Although Riis's writing is often punctuated with evidence of bigotry toward ethnic and racial groups, his moral outrage is primarily directed at uncovering the squalor, disease, child mortality and depravity bred in the tenement districts.

Lewis Hine, a teacher at the Ethical Culture School in the early 1900s, turned to photography at the suggestion of the superintendent of the school who appears to have wanted students to learn about the people of the city through photography. One of Hine's first projects was to photograph immigrants arriving at Ellis Island. These photographs and others which followed, including the ones done for the National Child Labor Committee, show Hine as the concerned photographer—exposing the reality of laboring children in order to reform those conditions. He does not universalize these children. They are not picturesque types nor are they symbols of capitalist oppression, rather they are specific individuals who work in deplorable conditions which lack proper sanitary facilities, safety precautions, light and ventilation. Their wages are miserable and they are unable to attend school—therefore condemning themselves to a cycle of poverty of which Hine was acutely aware:

> For many years I have followed the procession of child workers winding through a thousand industrial communities, from the canneries of Maine to the fields of Texas. I have heard their tragic stories, watched their cramped lives

and seen their fruitless struggles in the industrial game where the odds are all against them.[98]

In 1907 he became associated with Paul and Arthur Kellogg, editors of *Charities and the Commons,* a journal of social reform and made the photographs for the ambitious undertaking called the Pittsburgh Survey, a compendium of essays, statistics, photographs by Hine and drawings by Joseph Stella.

Hine was not a photographic naturalist, but was aware that art could become a tool to provoke consciousness; "this sharpening of the vision to a better appreciation of the beauties about one, I consider the best fruit of the whole work."[99] In reality he found in the beauty of human endeavor and human struggle—a truth beyond prettiness. But the photography must be absolutely straight in order to convince the viewer of the truth; Hine wrote to Elizabeth Causland in 1938 that, "All along I had to be double sure that my photo-data was 100% pure—no retouching or fakery of any kind. This had its influence on my continued use of straight photography which I preferred from the first."[100] Hine was a compassionate realist, a partisan for humanity and reform.

Since the 1850s a number of photographers have used the camera to record Indian life. Their motives were various. Some were anthropologists attempting to delineate accurately the bone structure and physiognomy of Indian types; some were romantic painters or illustrators who used photographs as studies for their work in other media; others, often amateurs, saw in the Indians and their ways a picturesqueness which

contrasted to the "civilized" ways of the Euro-American heritage. During the 1890s, the uncontested notion that the Indian was a "vanishing race" motivated a number of photographers to renew an interest in Indian subject matter.[101]

In 1896 the anthropologically minded Edward S. Curtis began the ambitious project of recording in words and through photographs information on the Indians of North America. In 1906, he enlisted the patronage of J. Pierpont Morgan and he completed the project, which ran to forty illustrated volumes, in 1930.[102] His photographs, as valuable as they may be as documents of Indian life, nevertheless often stress the poignancy of the "doomed noble savage" and his picturesque ways.

Other photographers visited Indian reservations. Adam Clark Vroman saw the formal beauty of pueblo architecture, pots, rugs and artifacts; Frank A. Rinehart, a commercial photographer from Omaha, represented the appearances of reservation life with its contradictions of new technology, for example, telegraph poles, and tribal ways, represented by the wigwams.

Regardless of the motives of the social photographer, or the outlook of those who paid for the work (although this is often crucial to the attitude of the photographer), the photographic images can be sorted into those which stress the beauty of formal arrangements, those which show people as types, whether picturesque or noble, and those which stress the individuality and specificity of the figures in a real setting. Our preferences will depend upon our own shifting moods, needs and ideologies—whether for formalism, universalism or realism.

166. Edward S. Curtis. *Woman Reaping,* n.d. Platinum print, 12⅜ x 16⁵⁄₁₆ inches. The St. Louis Art Museum; Purchase and funds given by Martin Schweig Memorial Fund for Photography.

166

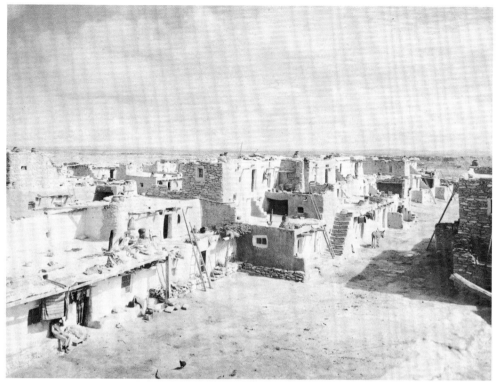

167

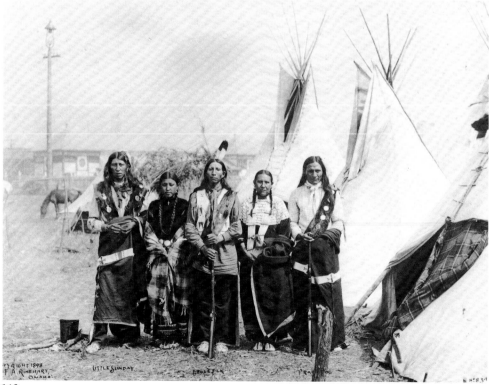

168

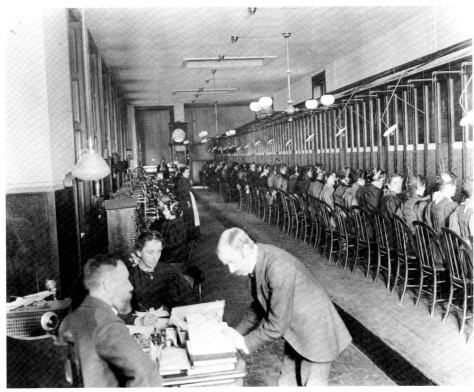

169

167. Adam Clark Vroman. *Plaza at Shungo-pavy*, c. 1902. Platinum print, 6 x 8⅛ inches (image). Collection of Samuel J. Wagstaff.

168. Frank A. Rinehart. *Sioux—Little Sunday, Eagle Elk, Prairie Dog*, 1898. Platinum print, 7¹/₁₆ x 9¼ inches. The Witkin Gallery, Inc., New York.

169. The Byron Company. *Telephone Exchange, Cortlandt Street*, 1896. Solio print, 7⁷/₁₆ x 9⅜ inches (image). Museum of the City of New York.

170. Frank Currier. *Interior of a Kitchen*, 1901. Photograph, 7½ x 9⅝ inches. The Museum of Modern Art, New York; Gift of Ernst Halberstadt, 1944.

170

171

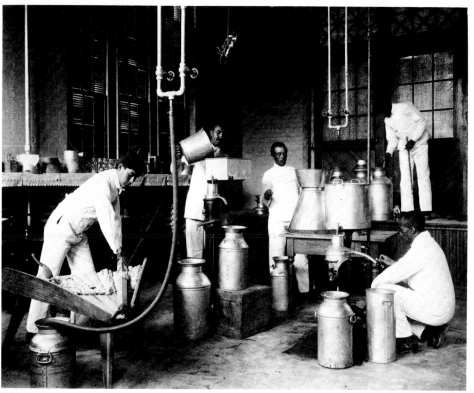

172

171. Frances B. Johnston. *A Hampton Gradu-
ate's Home*, 1899-1900, from *The Hampton
Album*. Platinum print, 7½ x 9½ inches.
The Museum of Modern Art, New
York; Gift of Lincoln Kirstein, 1965.

172. Frances B. Johnston. *Agriculture. Butter
Making*, 1899-1900, from *The Hampton
Album*. Platinum print, 7½ x 9½ inches.
The Museum of Modern Art, New
York; Gift of Lincoln Kirstein, 1965.

173. Lewis Hine. *Washing Up in a Small Steel
Mill, Pittsburgh*, 1907-08. Photograph, 7
x 5 inches. Collection of Naomi and
Walter Rosenblum.

174. Lewis Hine. *Railroad Yards Near Pitts-
burgh*, 1907-08. Photograph, 5 x 7 inches.
Collection of Naomi and Walter Ro-
senblum.

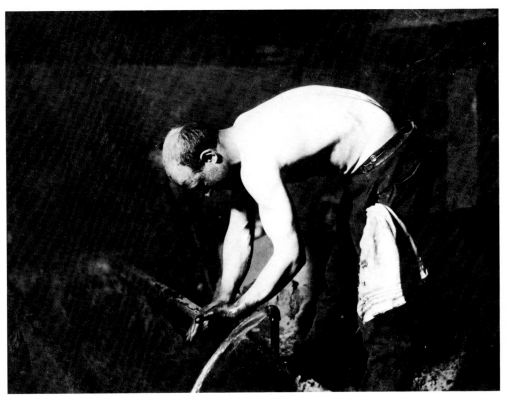

173

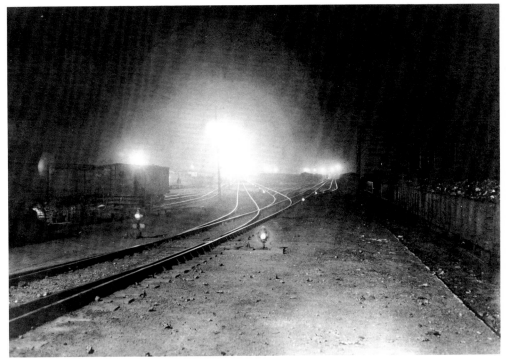

174

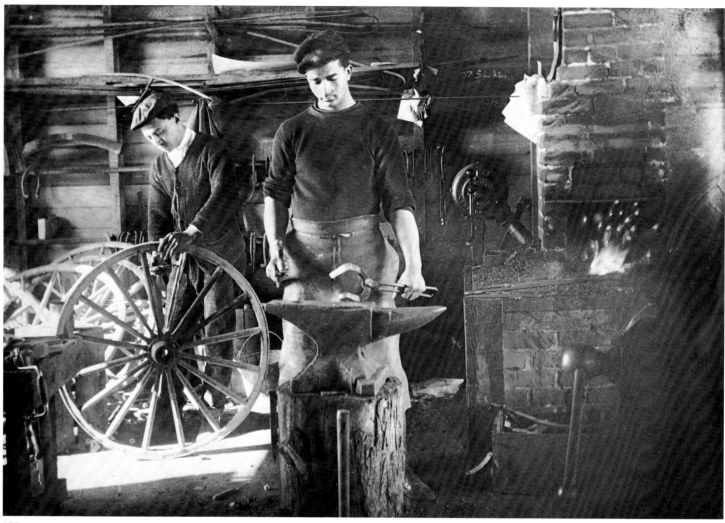

175

175. James Van DerZee. *Blacksmith, Virginia,* 1908. Photograph, 8 x 10 inches. The James Van DerZee Institute, Inc., New York.

176. Lewis Hine. *Painting Glassware,* c.1910. Photograph, 5 x 7 inches. Collection of Naomi and Walter Rosenblum.

177. Lewis Hine. *Workers at Warren, Rhode Island, Manufacturing Company, June 1909.* Modern print made from original negative in the Library of Congress, 8 x 10 inches. Collection of Naomi and Walter Rosenblum.

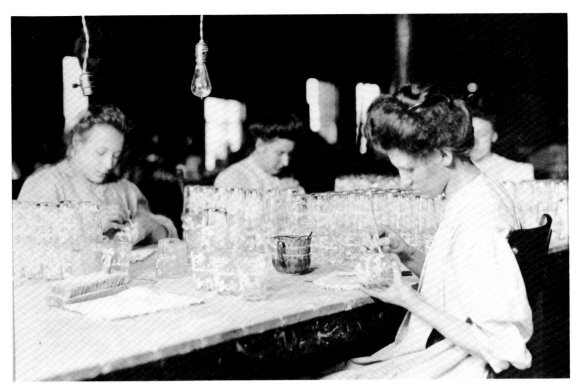

176

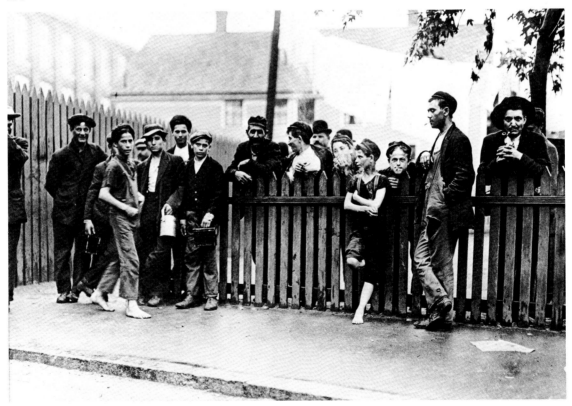

177

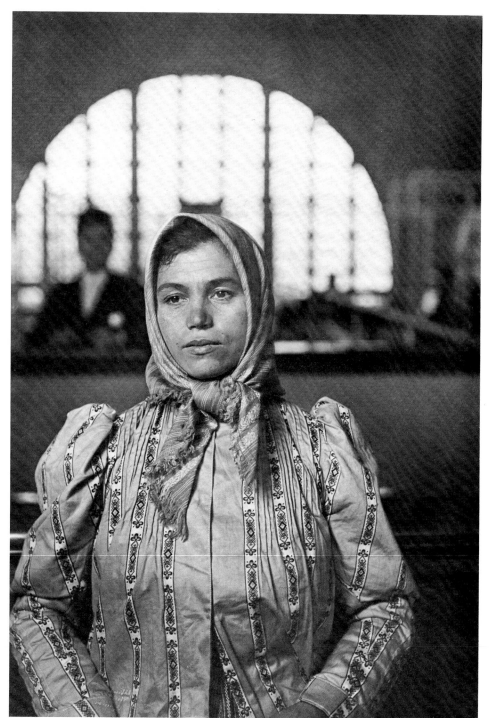

178

178. Lewis Hine. *Slovak at Ellis Island,* 1904.
Photograph, 6⅜ x 4⅝ inches. Collection
of Naomi and Walter Rosenblum.

179. Lewis Hine. *Child Mill Worker, South
Carolina Mill,* 1908. Photograph, 7⅝ x
9⅜ inches. Collection of Naomi and
Walter Rosenblum.

180. Jacob Riis. *Iroquois Indians at 511 Broome
Street,* early 1890s. Print made by Alex-
ander Alland from original negative, 4 x
5 inches. Museum of the City of New
York.

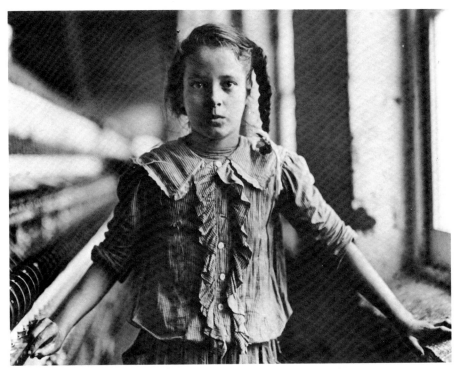

179

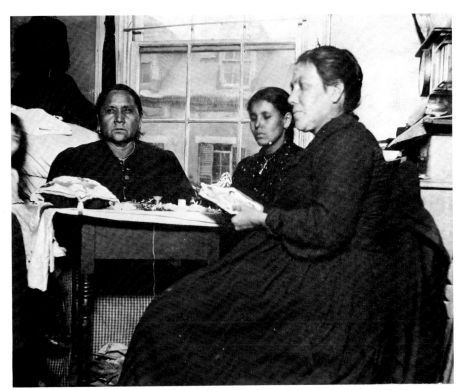

180

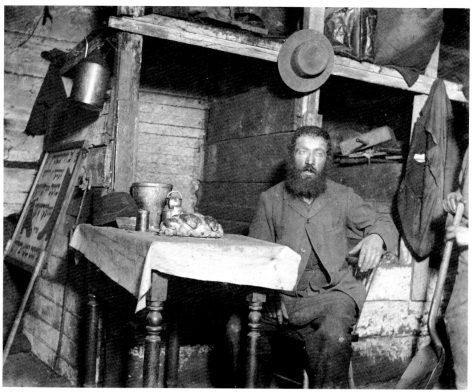

181

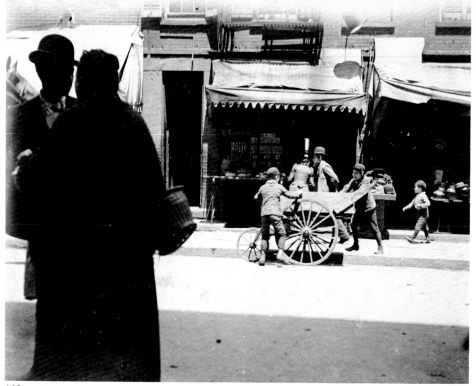

182

181. Jacob Riis. *Ready for the Sabbath Eve in a Coal Cellar on Ludlow Street*, 1895. Print made by Alexander Alland from original negative, 4 x 5 inches. Museum of the City of New York.

182. Jacob Riis. *What the Boys Learn There*, early 1890s. Print made by Alexander Alland from original negative, 4 x 5 inches. Museum of the City of New York.

183. Jacob Riis. *Minding the Baby, Cherry Hill*, n.d.. Print made by Alexander Alland from original negative, 4 x 5 inches. Museum of the City of New York.

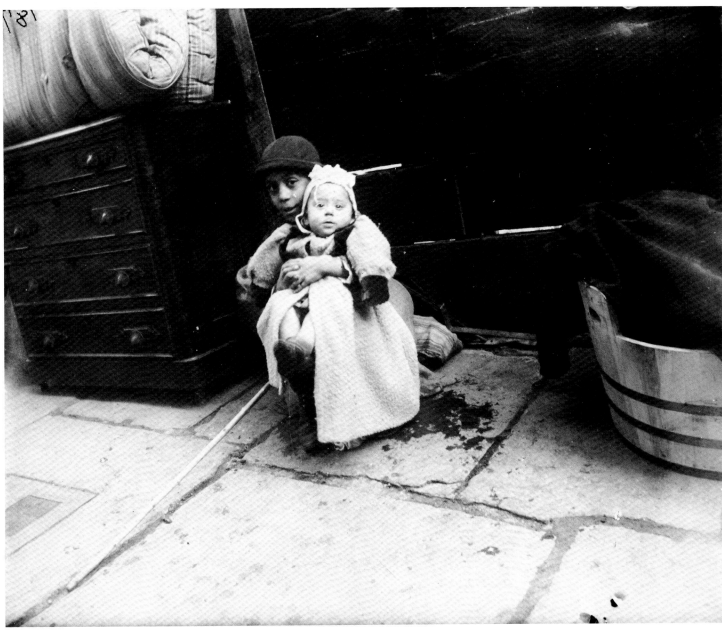

183

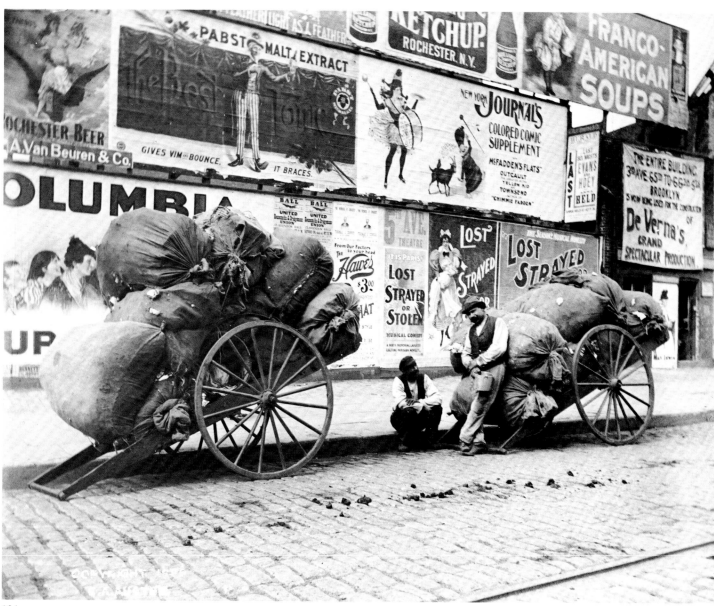

184

Main Line along The Susquehanna near Steelton

185

184. Alice Austen. *Rag Pickers and Hand Carts at 23rd Street and Third Avenue*, 1896. Modern print made from original negative, 8 x 10 inches. Courtesy of The Staten Island Historical Society, New York.

185. William Rau. *Main Line Along the Susquehanna Near Steelton #6*, 1890s. Photograph, 17 x 21¼ inches (image). Collection of Samuel J. Wagstaff.

186. William Rau. *The Susquehanna West of Steelton #5*, 1890s. Photograph, 17¼ x 21¼ inches (image). Collection of Samuel J. Wagstaff.

The Susquehanna west of Steelton.

186

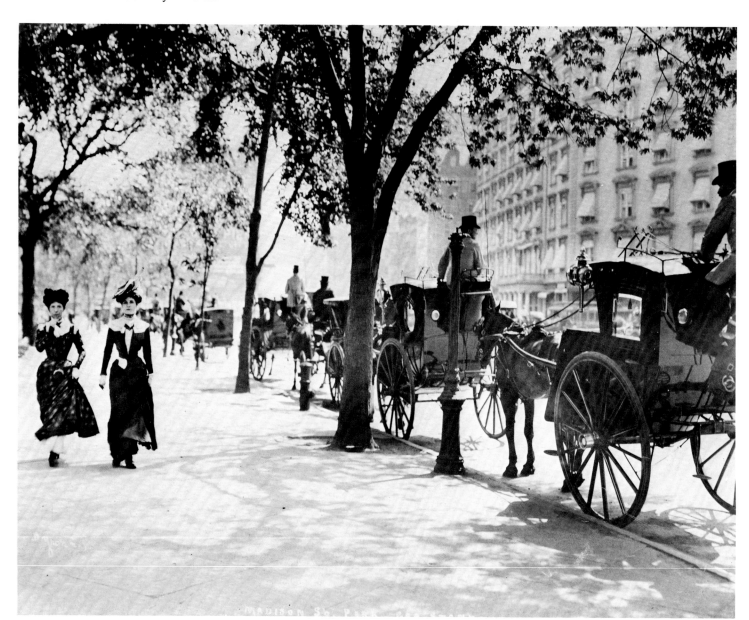

187. The Byron Company. *Madison Square Park Cabstand,* 1901. Solio print, 7¼ x 9⁷⁄₁₆ inches (image). Museum of the City of New York.

XI The City, Industry and Urban Life

THE CONCEPTS OF "beauty" and "truth" are never fixed; they are, rather, interpreted by men and women living in particular times and places. Toward the end of the nineteenth century, many artists found a source for their art in the city, with its unique forms and symbols, with its industrial and commercial activity, and with its masses of hurrying people. To these artists, the *reality* of the technological and communications explosion and the *truth* of the effects of industrialization on the everyday lives of individuals contained more possibilities for the creation of great art than idealized Grecian women, pastoral landscapes and art nouveau arrangements.

There was a movement, indeed, an urgency, by artists, writers, and critics to persuade artists to wake up to these possibilities of a new subject matter and a new content. An author in the magazine *Brush and Pencil* of September 1897 said: "Art must step out of the picture gallery and go into the streets."[103] And Sadakichi Hartmann voiced the attitudes of many when he observed that "the best art is that which is most clearly the outcome of the time of its production, and the art signifying most in respect to the characteristics of its age, is that which ultimately becomes classic."[104] The consensus of the writers of the period was that the characteristics of the age were growth, expansion and activity.

However, city scenes had not been neglected by earlier artists. From 1800 on publishers of engravings, such as William Birch of Philadelphia, had issued topographical views of city streets, and the painters Francis Guy, John Lewis Krimmel and John Ritto Penniman had excelled at the genre in the early nineteenth century; later in the century William Hahn and Childe Hassam painted city scenes. Hartmann even suggested that the genre may be distinctly "American": "The painting of street scenes is, strange to say, one of the oldest branches of our art. The appreciation of common sense and the love for reality, which were always characteristics of the American, may have something to do with it."[105]

City scenes certainly reflected local pride in the achievements and beauties of growing towns and busy ports, but what has been thought of as "American" often turns out to be simply "nineteenth century." In France, during and after the rebuilding of Paris by Baron Haussmann, the illustrator Constantine Guys and later Edouard Manet, Edgar Degas, Claude Monet and Camille Pissarro, among others, had turned their attention to city scenes. The interest in the city was a reflection of nineteenth-century population shifts and industrialization on an international scale. Yet the majority of the paintings focused on the middle classes and their "modern" life style which consisted of promenading along the boulevards, relaxing in the parks and enjoying refreshments at outdoor cafes. The leisure life of the working classes did not seem to engage the artists as yet.

Certainly popular art played a role in generating interest in scenes of the city, industry and urban life. Reciprocally, the new sociology of progressive reform and expanded technology encouraged articles which needed illustrations. Editors of the illustrated magazines and newspapers began publishing articles about living habits, of the wealthy as well as the poor, in the modern city, and they drew attention to the new construction and industrial processes. Thus, the subjects of the illustrations of the magazines of the 1880s and 1890s ranged from topical views of parks and residential thoroughfares crowded with strollers to scenes of tenement dwellers sleeping on roofs in the summer to escape the sweltering heat of airless rooms. Also common were views of factories and bridges under construction as well as scenes of steel workers and coal workers engaged in the heavy labor of their industry. The illustrators who specialized in such views and scenes were Harry Fenn, Thure de Thulstrup, William Allen Rogers and Jay Hambidge, among others.[106] Other pictorial sources were the many photographic postcards and stereographic views of city scenes. In short, there was not only the city itself as an inspiration for turn-of-the-century artists, but also lithographic views, illustrations and commercial photographs.

American artists who shaped that raw material of city life—the bridges, the skyscrapers, the elevated trains, the billowing smokestacks and steam vents, the electric lights at night and the crowds of anonymous people, rich and poor, hurrying along the avenues—can be divided into three groups. Some dwelled on the building activity of the city, others on the formal shapes and others on urban people.

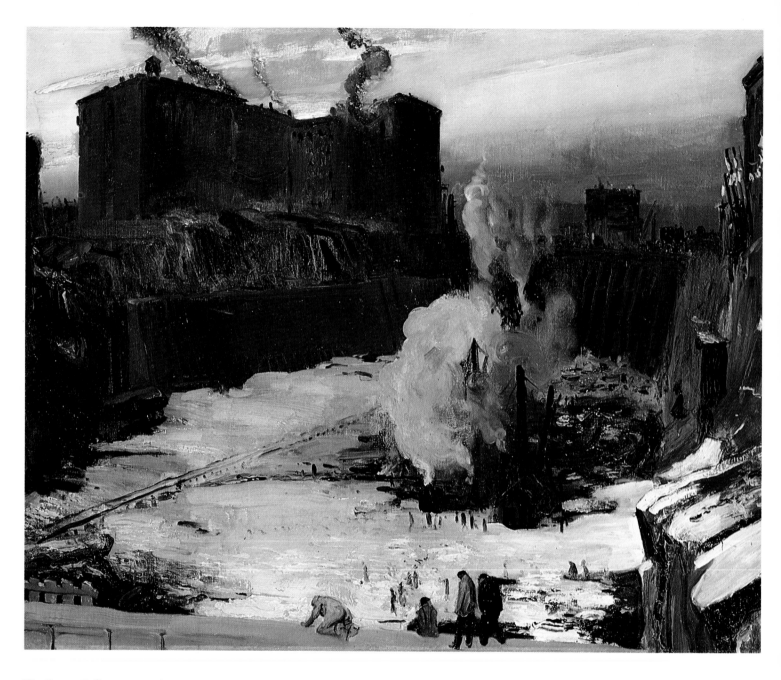

VI. George Bellows. *Pennsylvania Station Excavation*, 1909. Oil on canvas, 30¼ x 38¼ inches.
The Brooklyn Museum, New York; A. Augustus Healy Fund.

John Sloan's *The Schuylkill River* and George Luks's *Round-houses at Highbridge* represent the industrial movement along the rivers and waterfronts, where clouds of smoke from factories and trains create the gray skies which hang over the urban landscape (Figs. 189, 188). The actual construction of buildings, skyscrapers and tunnels became the subject of George Bellows's *Pennsylvania Station Excavation* and Alvin Coburn's portfolio of photogravures published in 1910 (Pl. VI, Fig. 190). In his foreword to that portfolio, *New York*, H.G. Wells observed that, "it is the machine and enterprise that prevail. These New York bridges, with their huge vigour of span, their resolute outward leap, testify again to the tremendous pressures, the immense urgency of this rock-borne capital."[107]

Photographers of the Detroit Publishing Company took photographs of the Flatiron Building during its construction in 1902 (Figs. 192, 193). In the contrast between the older, low buildings and the tall skyscrapers being erected, artists felt the germination of a new America. Alfred Stieglitz recalled the moment when he understood the Flatiron Building as symbolic of the future:

> Watching the structure go up, I felt no desire to photograph the different stages of its development. But with the trees of Madison Square covered with fresh snow, the Flat Iron impressed me as never before. It appeared to be moving toward me like the bow of a monster ocean steamer—a picture of new America still in the making....[108]

In defending the building to his father, who found it hideous, Stieglitz went on to draw the analogy that "the Flat Iron is to the United States what the Parthenon was to Greece," and criticized his father who "had not observed the steelwork going up....He had neither watched the men working nor noted the amazing simplicity of the tower, its lightness combined with solidity." There is a generation's difference between the responses of the two men.

Birge Harrison, Edward Steichen, Joseph Pennell and Stieglitz focused on the shapes of the city. Harrison's *Fifth Avenue at Twilight*, Steichen's *Flatiron Building—Evening* and Stieglitz's early photograph *The Glow of Night* of 1897, suggest the poetic moods of the city when daylight disappears and muted color tones are pierced by electric lights (Figs. 199, 191, 194). However, the straight edges of the skyscrapers and the orderly recession of shapes in Stieglitz's *The City of Ambition*, a photograph of 1910, provide an image of clarity and rational order; Stieglitz's photograph is also prophetic of the direction photographers were to take toward a straight view of reality (Fig. 196).

By the first decade of the century, artists working in all the media found urban people to be appealing subjects for their art. In summer and winter, adults and children, rich and poor were viewed in moments of quiet isolation and in moments of social exchanges. If the photographers, illustrators and painters did not draw direct inspiration from each other, they were motivated by identical scenes which they witnessed in real life. William Glackens's *Central Park: Winter* of about 1905, is close in spirit, composition and pose to the Byron photograph *Recent Vision of Jollity in Central Park,* of 1898 (Figs. 201, 200).[108A]

Artists turned as well to the immigrants who made up a large portion of the population of New York in the first decade of the twentieth century. André Castaigne and Jay Hambidge did illustrations of the immigrants in transit to this country for articles which appeared in *McClure's Magazine* and *Scribner's Magazine*. A Byron photographer focused on the individual faces of fatigued immigrants sunning themselves on the S.S. Pennland in 1893 (Fig. 204). Stieglitz was also drawn to photograph steerage passengers; he, however, was struck more by the totality of the visual scene rather than by the fact that the subjects were aliens being shipped back to Europe (Fig. 205).[109]

Everett Shinn's *Lunch Wagon*, drawn in pastel, is reminiscent of Stieglitz's night scenes where incandescent street lights blink through the inky darkness and reflect on flat pavements (Fig. 202). Hartmann considered Shinn, "the foremost representative of the suggestive sketch. His memory sketches of street scenes are instinct with vitality, movement, and reality. He is fascinated by the picturesqness of our streets, the vastness and hurry of the stream of humanity, the unceasing roar and traffic, the ever-changing effects of city life, and represents them with the facility of a virtuoso...."[110] Shinn expanded subject matter to include all aspects of working-class life; his *Sixth Avenue Elevated After Midnight* of 1899 is one of the first pastels to depict isolated and lonely passengers on the speeding elevated train (Fig. 203).

From 1904 to 1910 John Sloan did a number of etchings of the lives of working class people engaged in activities recognized by all as typical of city life, but also new in the history of the fine arts—incidents inspired more by the popular illustrations than by high art. In such etchings as *Fun, One Cent* he captures the buoyant spirit of young girls on the street (Fig. 206). In *Turning Out the Light* and *Night Windows* the day has ended and people must rest themselves for the next day (Figs. 207, 208).

Not only did Shinn and Sloan expand subject matter, but they used the media of pastel and etching which had been associated with genteel subjects and quiet moods. The city with its forms, activities and diversity of people left no area of art making untouched.

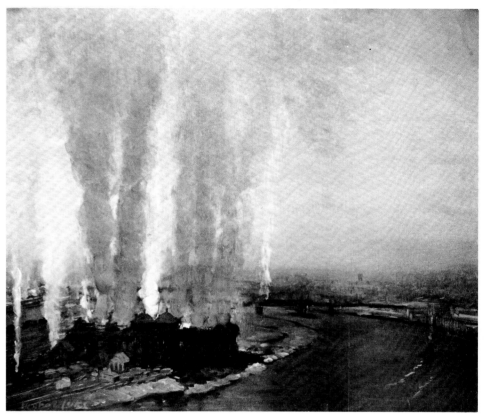

188

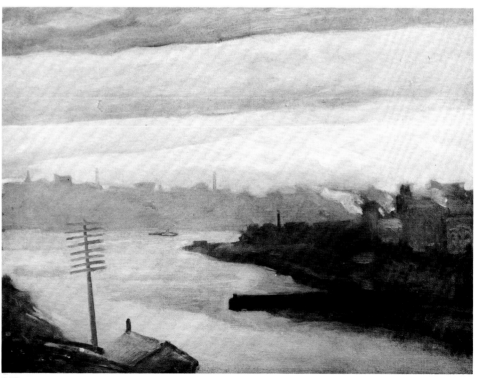

189

188. George Luks. *Roundhouses at Highbridge*, 1909–10. Oil on canvas, 30⅜ x 36⅛ inches. Munson-Williams-Proctor Institute, Utica, New York.

189. John Sloan. *The Schuylkill River*, 1900–02. Oil on canvas, 24 x 32 inches. Kraushaar Galleries, New York.

190. Alvin Langdon Coburn. *Brooklyn Bridge*, from *New York*, 1910. Photogravure, 8⅝ x 6 inches. Philadelphia Museum of Art; Gift of Mr. and Mrs. Adrian Siegel.

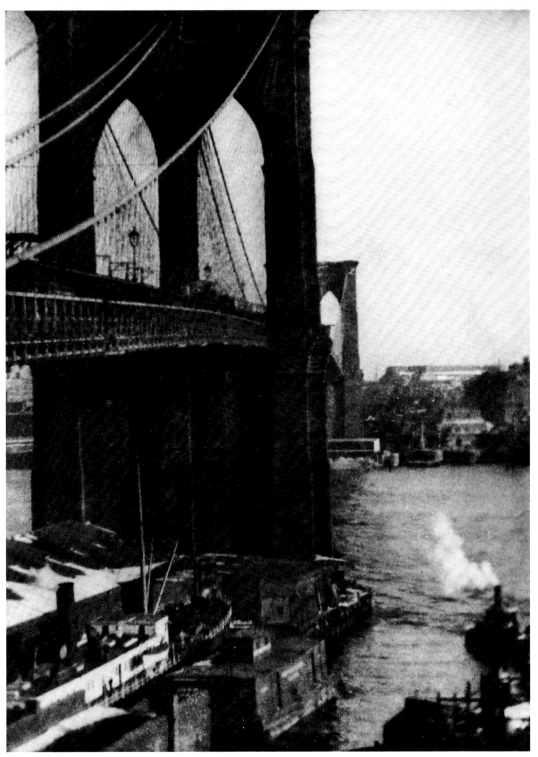

190

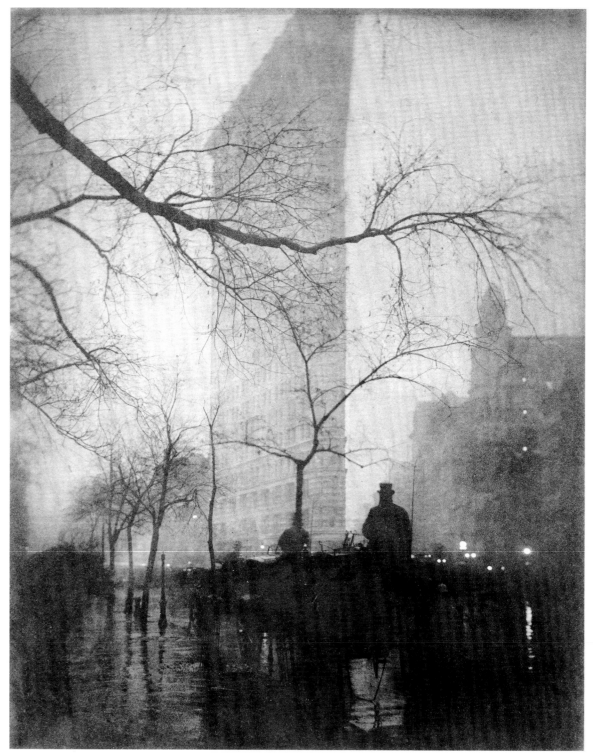

191

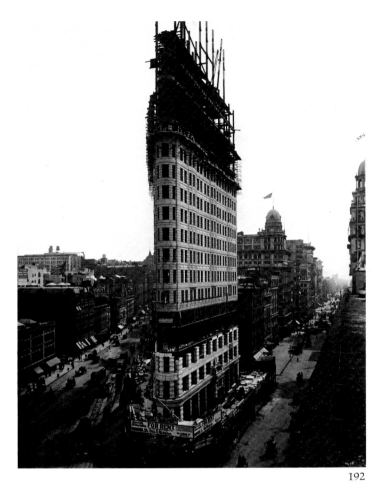

192

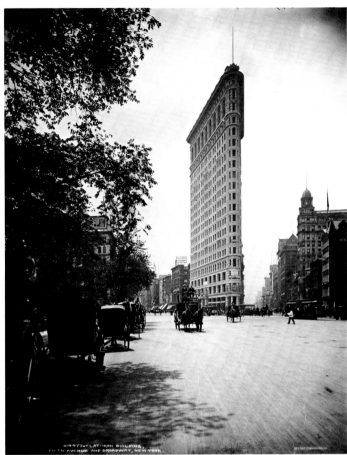

193

191. Edward Steichen. *The Flatiron Building—Evening,* 1905. Photograph. The Metropolitan Museum of Art, New York; The Alfred Stieglitz Collection.

192. Detroit Publishing Company. *The Flatiron Building Being Built,* c. 1902. Modern print made from original glass negative, 10 x 8 inches. Courtesy of the Library of Congress, Washington, D.C.

193. Detroit Publishing Company. *The Flatiron Building,* n.d. Modern print made from original glass negative, 10 x 8 inches. Courtesy of the Library of Congress, Washington, D.C.

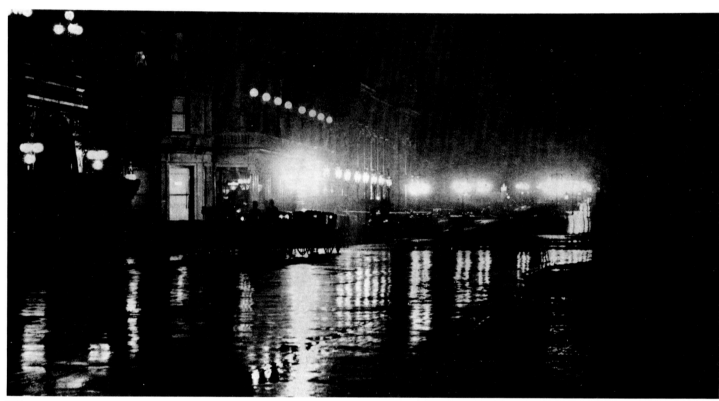

194

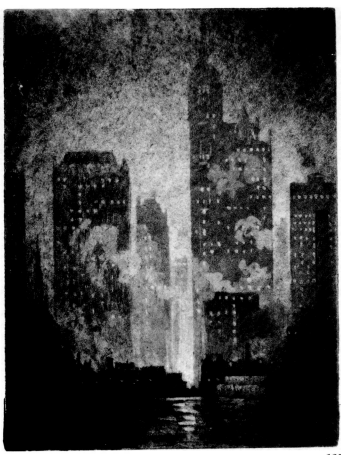

195

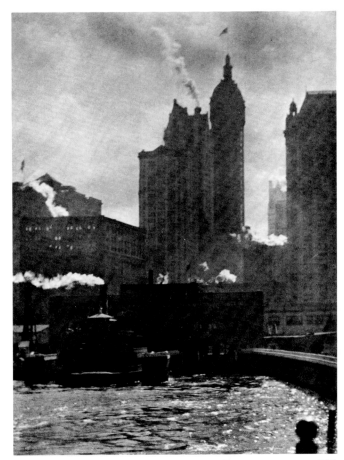

196

194. Alfred Stieglitz. *The Glow of Night,* 1897. Photogravure, 4¾ x 9¼ inches. The Museum of Modern Art, New York.

195. Joseph Pennell. *From Cortlandt Street Ferry,* 1908. Etching, 13 x 9¾ inches. The Metropolitan Museum of Art, New York; Harris Brisbane Dick Fund, 1917.

196. Alfred Stieglitz. *The City of Ambition,* 1910. Photogravure, 13⅜ x 10¼ inches. The Museum of Modern Art, New York; Purchase, 1949.

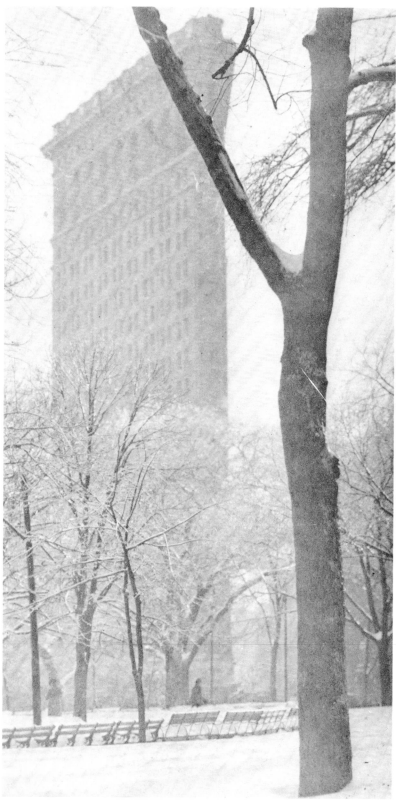

197

197. Alfred Stieglitz. *The Flatiron*, 1903. Photogravure, 12⅞ x 6⅝ inches. The Museum of Modern Art, New York; Purchase, 1949.

198. Alfred Stieglitz. *Winter, Fifth Avenue, New York*, 1893. Photogravure, 8½ x 6⅛ inches. The Museum of Modern Art, New York; Transferred from the Library.

199. Birge Harrison. *Fifth Avenue at Twilight*, n.d. Oil on canvas, 30 x 23 inches. The Detroit Institute of Arts; City Appropriation.

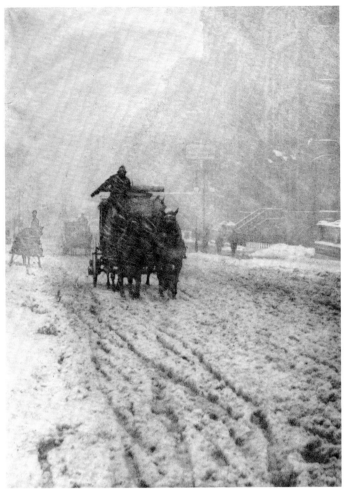

198

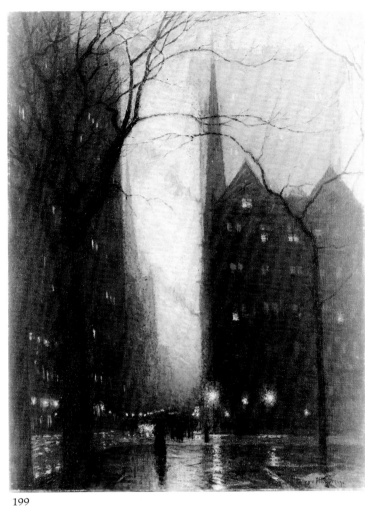

199

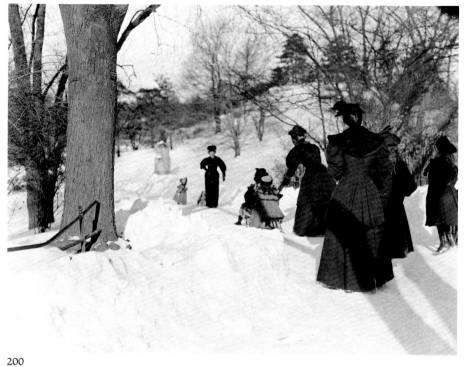

200

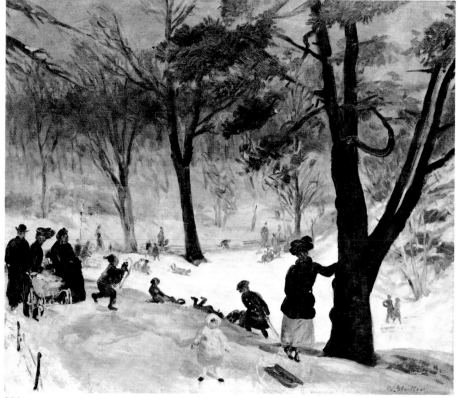

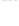

201

200. The Byron Company. *Recent Vision of Jollity in Central Park,* 1898. Solio print, 7¼ x 9⅛ inches. Museum of the City of New York.

201. William J. Glackens. *Central Park: Winter,* c. 1905. Oil on canvas, 25 x 30 inches. The Metropolitan Museum of Art, New York; George A. Hearn Fund, 1921.

202. Everett Shinn. *Lunch Wagon, Madison Square,* 1904. Pastel on paper, 8½ x 13 inches. Collection of Arthur G. Altschul.

203. Everett Shinn. *Sixth Avenue Elevated After Midnight,* 1899. Pastel on paper, 8 x 12⅜ inches. Collection of Arthur G. Altschul.

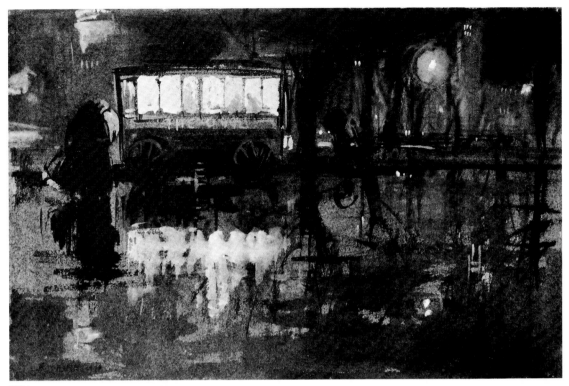

202

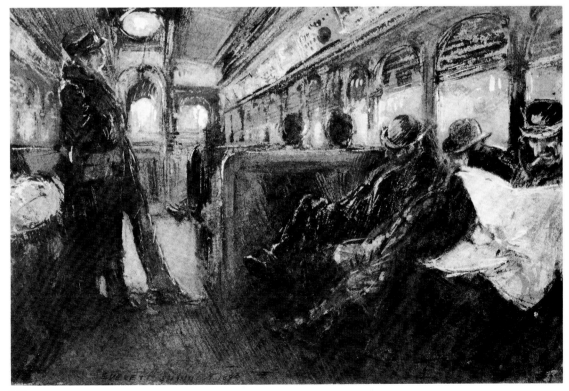

203

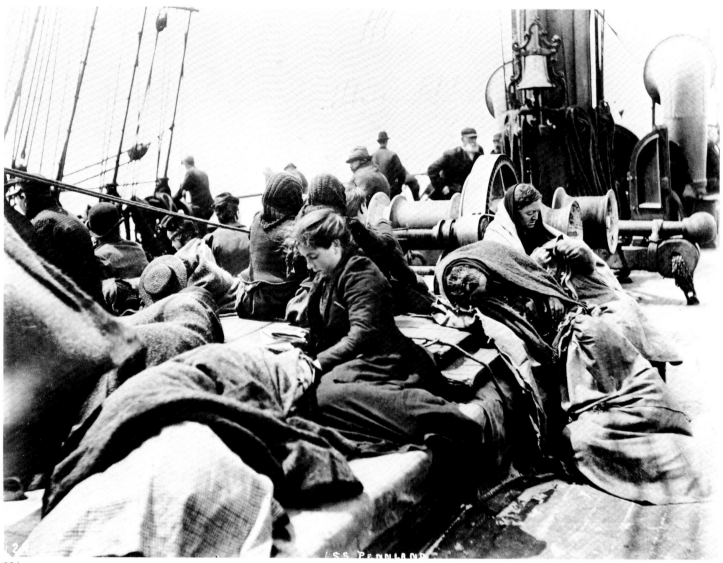

204

204. The Byron Company. *Steerage Deck of the S.S. Pennland of the Red Star Line*, 1893. Solio print, 7 x 9½ inches. Museum of the City of New York.

205. Alfred Stieglitz. *Steerage*, 1907. From *291*, 1915. Photogravure, 13⅛ x 10⅜ inches (image). Collection of Robert Mapplethorpe.

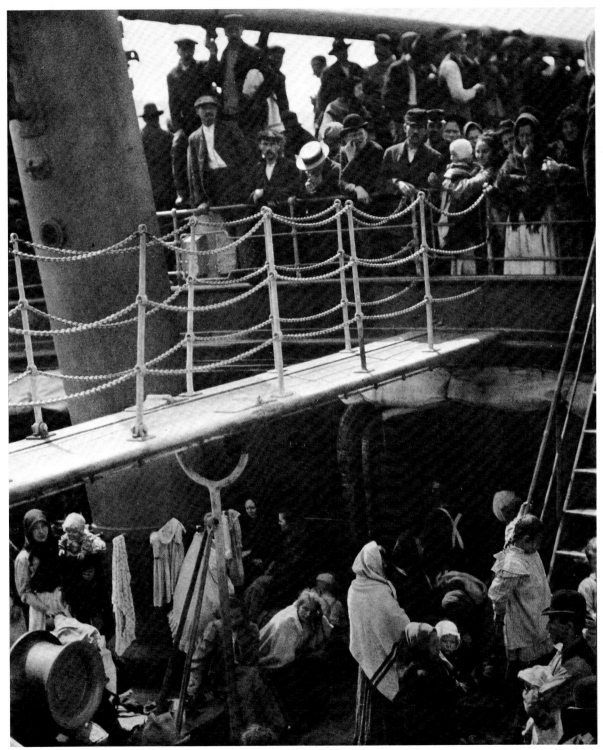

205

206

206. John Sloan. *Fun, One Cent,* 1905. Etching,
4¾ x 6¾ inches (plate). Whitney Muse-
um of American Art, New York.

207. John Sloan. *Turning Out the Light,* 1905.
Etching, 4¾ x 6¹³/₁₆ inches (plate). Whit-
ney Museum of American Art, New
York.

208. John Sloan. *Night Windows,* 1910. Etch-
ing, 5⅛ x 6¹³/₁₆ inches (plate). Whitney
Museum of American Art, New York.

207

208

XII The Eight

ON FEBRUARY 3, 1908, an exhibition opened at the Macbeth Galleries in New York of paintings by eight artists—Robert Henri, Everett Shinn, William Glackens, George Luks, John Sloan, Maurice Prendergast, Ernest Lawson and Arthur B. Davies. Histories of art mark the exhibition as the first event in twentieth-century America when a group of independent artists publicly declared their intentions to break with the forces of academicism and tradition.[111] Without minimizing its importance, we must remember that it was only one in a series of events where breakaway groups organized exhibitions of their own rejected or ignored work. Their motives were to show their paintings under circumstances more favorable than were provided by the established art tastemakers. The significance of the exhibition for The Eight (as they came to be called) was that they proved that critics and art public alike were responsive and favorable to their independent and anti-academic styles.

The principal organizer was Robert Henri, a man who inspired a generation of painters. As a youth with a flair for art, he had pasted into a scrapbook not only reproductive engravings after then popular academic masters, but also numerous cartoons by Gillam, Opper and others from *Puck* and *Judge*.[112] His art training was typical of serious, young American artists born in the 1860s: first, a stint at the Pennsylvania Academy of the Fine Arts absorbing the realist tradition, and then travel and study in Europe where he immersed himself in the study of the seventeenth-century masters Velázquez, Ribera, Hals and Rembrandt, and took notice of nineteenth-century trends. He returned to Philadelphia in 1896 to teach, but was abroad again from 1898 to 1900. As the century turned he settled in New York City, painting and teaching studio courses, first at a private school for girls, and, from 1902 to 1909, at the New York School of Art.

Henri did cityscapes in a painterly style, emphasizing long fluid brushstrokes; the generally subdued colors are livened with touches of white, bright reds and yellows. His spontaneous direct portraits capture the momentary expression of a sitter's face; Henri was unconcerned with presenting the emblems and attributes of social status or with probing into the introspective moods of the sitter.

Much of his energy went into teaching and encouraging his younger friends and colleagues, particularly Sloan, Glackens, Luks and Shinn, whom he had known since the days of teaching in Philadelphia. Sloan later recalled:

> In Philadelphia in the nineties, there was a group of newspaper artists, plain and rather normal young men making their livings as craftsmen—and we became painters because Robert Henri had that magic ability as a teacher which inspires and provokes his followers into action. He was a catalyst; he was an emancipator, liberating American art from its youthful academic conformity, and liberating the individual artist from repressions that held back his natural creative ability.[113]

By 1904 they had all followed Henri to New York where they continued their careers as illustrators while making realist paintings in their spare time.

Glackens and Shinn painted scenes of the city and also scenes of the vaudeville theater. Luks focused on the faces of street people and had a penchant for exuberant children. Sloan, perhaps the most inventive of the group, extended the range of subject matter to include picnics, election celebrations, movie house audiences and automobile passengers.

The other three artists of The Eight, Prendergast, Lawson and Davies, were not realists, although each had developed an individualized style outside the academic mainstream. Prendergast painted tapestry-like watercolors and oils in a post-impressionist style. Lawson worked in a technique in which thick paint was scraped and dragged across stained canvases producing landscapes which looked impressionistic. Davies's thinly painted visions of arcadian landscapes were unacademic with their formless nudes and vague perspectives.

Assisted by Sloan and Davies, Henri was the experienced, driving force behind The Eight's exhibition.[114] He had organized several showings of his own work, and because of his reputation as a promoter of the newer art, he had begun to receive invitations to organize group exhibitions. In 1902, he organized a small exhibition for the Allan Gallery; in 1904, he organized

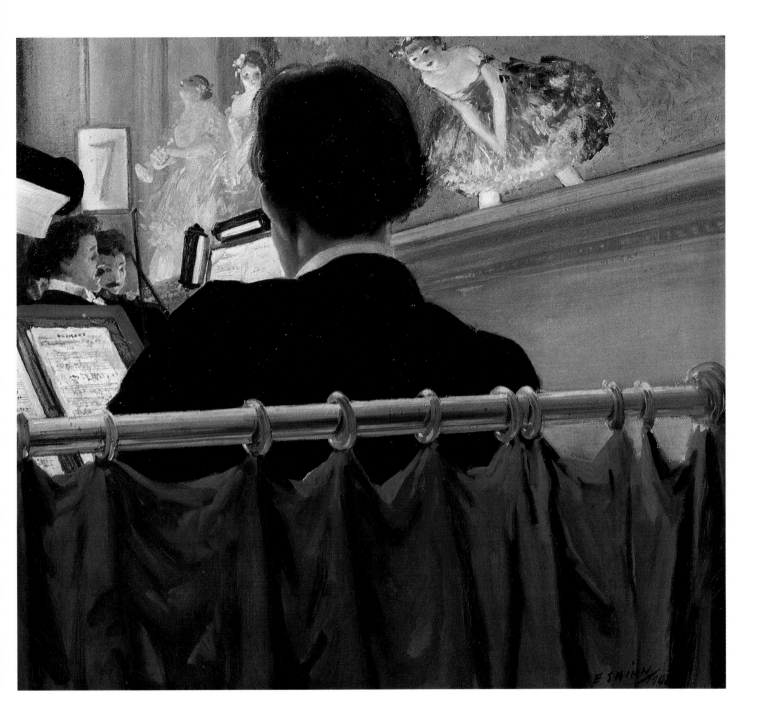

VII. Everett Shinn. *The Orchestra Pit, Old Proctor's Fifth Avenue Theatre,* c. 1906–07. Oil on canvas, 17⁷/₁₆ x 19½ inches. Collection of Arthur G. Altschul.

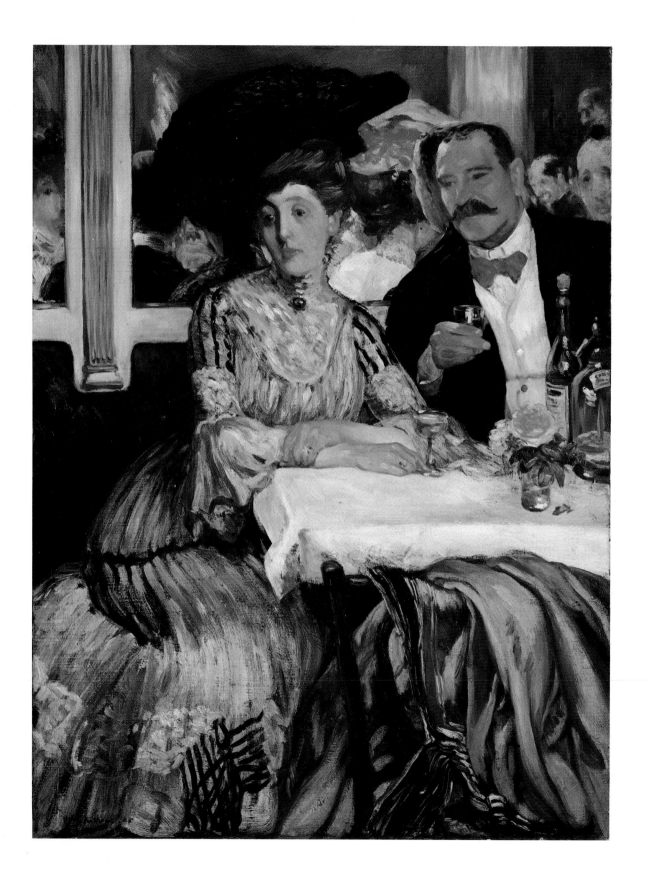

another at the National Arts Club, the same organization which had sponsored Stieglitz's Secession Exhibition in 1902. During this time he had little impulse to secede from the art establishment. In fact, in 1906, he participated along with Samuel Isham and Kenyon Cox in the negotiations to have the Society of American Artists reunite with the National Academy of Design, its parent organization from which it had split in 1878. Henri's involvement in those negotiations stemmed from his optimism that by working within the art establishment he could bring recognition to the younger realists.

Henri was elected to membership in the National Academy of Design in the spring of 1906, and was asked to be on the jury for the spring exhibition of 1907. He found, however, that he was unable to liberalize the entrenched conservatives of the Academy's jury, who refused a number of paintings submitted by Luks, Shinn, Glackens, Carl Sprinchorn and Rockwell Kent. Henri resigned from the jury and withdrew two of his own paintings. In April the Academy refused to elect to membership Davies, Lawson and Jerome Myers whom he had supported. Henri's response to the incident was quoted in the New York Mail of April 11: "This action... shows that the academy is hopelessly against what is real and vital in American art. What the outsiders must now do is hold small or large group exhibitions, so that the public may see what the artists who have something important to say are doing."[115]

Earlier that April, Henri had held a meeting with Luks, Davies, Glackens, Sloan and Lawson to discuss an independent exhibition. Shinn attended the next organizing meeting; and by mid-May of 1907, Prendergast had also joined the group. It was arranged that each of the eight would have twenty-five feet of wall space at the Macbeth Galleries and was responsible for his own choices. To the press, Henri said of the group: "They have been working for years developing and producing on the same lines in which they are now found each from the other very different in his way—no unity in any cult of painting—similar only in that they all agree that *life* is the subject and that view and expression must be individual."[116] Many years later, Sloan was to reminisce about the realists of the group: "We came to realism in revolt against sentimentality and artificial subject-matter and the cult of 'art for art's sake.'"[117]

Of the personalities in the first decade of the twentieth century who spoke out against the art-for-art's-sake credo, Robert Henri was certainly the most vociferous and most convincing. To Henri art should concern itself with the artist's individual response to the most vital aspects of life:

...Always art must deal with *life*, and it becomes important as the ideas of the artist are significant. Art to every man must be his personal confession of life as he feels it and knows it. The lack of human quality in painting or sculpture means the lack of that vitality which makes for permanence. Why is it...that the New York public prefers the Horse Show with its compelling attraction to the average lecture or the ordinary Academy exhibit? It is the human quality of it. It is life at a brilliant, beautiful and intoxicating moment instead of some pedantic point of view about unreal things. And so it seems that the basis of future American art lies in our artists' appreciation of the value of the human quality all about them, which is nothing more or less than seeing the truth, and then expressing it according to their individual understanding of it.[118]

Henri urged his students to observe carefully and then paint from memory, so that the most salient expressive features would thus be captured. He was, then, similar to the tonalists when he insisted that the impression of a scene was the most important—that unessential details should be avoided. A contemporary critic said of Henri in words which could have described Inness or Tryon, "He has stood face to face with Nature, and then painted as he feels. He carries away with him only the impression of what he considers worth remembering, and in placing it on a canvas employs his brains as well as his brush."[119] Henri, however, focused his attention on the contemporary human situation.

Interested in the facts and objects of daily life, the realists had no patience with the optical effects of the impressionist style, nor were they interested in color and line for their own sake. Henri maintained that:

Colors... [and] lines are beautiful when they are significant. It is what they signify that is beautiful to us, really. The color is the means of expression. The reason that a certain color in life, like the red in a young girl's cheek, is beautiful, is that it manifests youth, health; in another sense, that it manifests her sensibility....[120]

To Henri, the artist should not even concern himself with "whether the thing he wishes to express is a work of art or not, whether it is literature or not, he should only care that it is a

VIII. William J. Glackens. *Chez Mouquin*, 1905. Oil on canvas, 48³/₁₆ x 36¼ inches.
The Art Institute of Chicago; Friends of American Art Collection.

statement of what is worthy to put into permanent expression."[121]

Significance had been of concern to the academic muralists Kenyon Cox and Edwin Blashfield; the difference was that significance for the realists was found in their individual, specific feelings toward humanity and life, whereas to the muralists significance meant the uplifting and abstract ideals of patriotism, civic duty and religious virtue.

The academic artists were also being challenged by the changing concepts of beauty and truth. Academic beauty defined as a harmony of the internal parts was too formalist and seemed either boring or irrelevant in the new twentieth century. The tradition of realism in American literature expanded considerably in the 1890s and after, when Stephen Crane, Frank Norris, Theodore Dreiser and Hamlin Garland pushed realism toward more inclusive themes which included working class life. The painter-realists may or may not have read them, but they could not have been unconscious of their ideas.[122] Caffin observed:

> Shall the painter confine his study to idealising life, or at least to presenting only its comely aspects, or may he have the whole run of life for his field, as the writer has; trusting to the sincerity of his purpose and the beauty of his technique to justify the ugliness of his theme? Whatever may be our individual answer to this question, let us recognise that the work of Sloan and a few others, such as Robert Henri, C. W. Hawthorne, William G. Glackens, Jerome Myers, and George Luks, is a natural and wholesome reaction from the vogue of frippery, tameness, and sentimentality.[123]

The scenes and portraits of Henri and his realist friends have been recently criticized because they were not in advance of their time.[124] In terms of style, they were using a dark, painterly technique which had been popular in Munich some thirty years earlier; in terms of subject matter, they have been castigated because they did not select themes with a political, revolutionary content. However, it is important to remember them in the context of their time. They did reject the so-called new styles, Impressionism and Art Nouveau, and consciously returned to an energetic and spontaneous handling, the technique of Frans Hals, which they felt was appropriate to their realist subjects. In terms of their politics, only Sloan, for a brief period before 1917, was engaged in the socialist movement. But neither Sloan nor the others were revolutionaries; they were humanists whose sympathies were with the social reformers and who felt that great art depended upon similar concerns. Henri stated: "Men who have achieved great art felt the tremendous need of raising their voices for or against the condition of life that existed, for out of a full heart comes the desire to express."[125] With the social reformers, they believed that merely to expose or express conditions would enlighten decent and rational men and women to see the justness of the democratic promise of America as the land of liberty and equality. In the American liberal tradition of Ralph Waldo Emerson and Walt Whitman, Henri and the realists championed personal liberty and individualism rather than seeking collective solutions to achieve equality in society.[126]

As Caffin observed, in their art they rejected tameness and sentimentality. They portrayed the urban working classes neither as mindless automatons engaged in grim, backbreaking labor nor as idealized heroes working in harmony with their machines. Rather, the realists, but especially Sloan, depicted them as real people in those moments when they were themselves—in their own homes and with their friends, enjoying brief moments of relaxation. The early twentieth-century realists portrayed a dream which ignored the struggle for bare subsistence, which forgot about imperialism, and which proposed a new vision of honest human feeling and sincere camaraderie.

209. William J. Glackens. *Hammerstein's Roof Garden*, c. 1903. Oil on canvas, 30 x 25 inches.
Whitney Museum of American Art, New York.

210

210. Robert Henri. *Laughing Child,* 1907. Oil on canvas, 24 x 20 inches. Whitney Museum of American Art, New York.

211. George Luks. *The Spielers,* 1905. Oil on canvas, 36 x 26 inches. Addison Gallery of American Art, Phillips Academy, Andover, Massachusetts.

212. John Sloan. *Election Night in Herald Square,* 1907. Oil on canvas, 25⅜ x 31¾ inches. Memorial Art Gallery of the University of Rochester, New York; R.T. Miller, Jr., Fund.

211

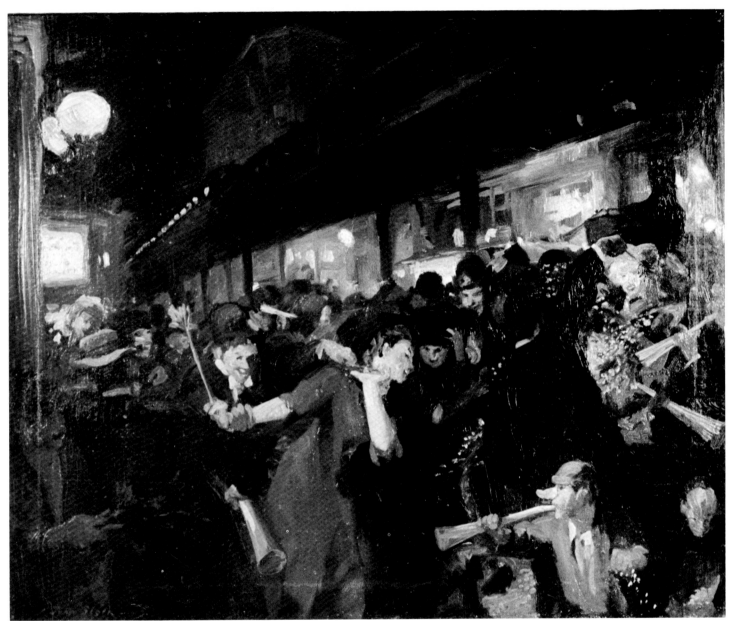

212

213

214

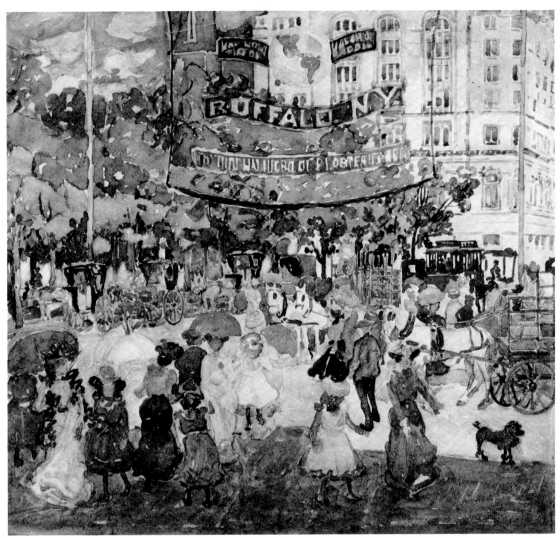

215

213. Arthur B. Davies. *Many Waters,* 1907–
 08. Oil on canvas, 17 x 22 inches. The
 Phillips Collection, Washington, D.C.

214. Ernest Lawson. *Winter on the River,* 1907.
 Oil on canvas, 33 x 40 inches. Whitney
 Museum of American Art, New York.

215. Maurice Prendergast. *Madison Square,*
 1901. Watercolor on paper, 15 x 16½
 inches. Whitney Museum of American
 Art, New York; Bequest of Joan Whit-
 ney Payson.

Epilogue

In this era of American expansion, 1890–1910, artists of many different tendencies and working in many branches of picture making struggled to secure recognition, to find patrons and to reach an audience sympathetic with their aims. Some were painters, others were photographers and illustrators, but all were touched by and had opinions about the coexisting art movements: aestheticism, academic idealism, tonalism, pictorialism, impressionism and realism.

Artists gravitated toward one of two poles. Those searching for *beauty* gravitated toward *aestheticism*—the belief in art for art's sake, in the independence of art from nature and human values, and in the priority of formal relations of line, mass, color and tone. Those searching for *truth* gravitated toward *realism*—the belief in a subject matter and a content responsive to social issues. For two decades these two contending attitudes about the role of art in life and the role of life in art coexisted while they competed for hegemony. In this, they reflected the debate then current in the political and social spheres: that is, were progress and reform desirable, were they possible, were they antithetical?

As 1910 approached, it seemed that aestheticism in all its forms was in eclipse. The academic and decorative styles of the muralists, with their canons of classical beauty and their belief in ideal, universal values, were exhausted. The tonalism and pictorialism depicting nature's moods had also waned as more and more artists turned to the city and city life as sources for subject matter.

The art which emerged as the dominant trend in those years before 1910 was realism, just as photography also edged toward the "straight" view of life. What the realists did—especially Henri, Sloan, Shinn, Glackens, Luks, Bellows and their friends—was to campaign for an art more in tune with the lives of working people, just as Theodore Roosevelt championed the need for social reform. Bennard Perlman, writing on Henri in 1962, drew the obvious connection:

> [The early 20th-century Realists] attacked the domineer-ing attitudes of the art academies in a manner that paralleled the trust-busting of Theodore Roosevelt. The Realists were joined in their crusade by a vigorous coterie of art students, and by literary men who sought to expose political corruption and to spearhead general social and economic reforms.[127]

The realists appealed to a new audience and a liberal patron-age[128] who were also full of optimism that in spite of the economic slumps, social change was possible, poverty could be eradicated and educational opportunities might open up to a greater number of people.

But Henri's realism had its limitations, limitations analogous to those of the movement led by Roosevelt. In both, the contradictions asserted themselves in the pull between the reformist ideals for social equality and justice, and the entre-preneurial spirit of rugged individualism. In both spheres the individualist ethos prevailed. Henri's art, for all its appeal and optimism, in the final analysis reveals an artist committed more to his individual responses to life than to the rendering of life in *all* its complexity and flux.

After 1910, events changed the mood of optimism in the country. It became clear that the imperial powers of Europe were moving inevitably toward war, which broke out in 1914. After much contention and debate among the political and industrial leaders and against the resistance of a great part of the population, the pro-expansionist forces prevailed and, in 1917, led the country into war. Attention was necessarily drawn away from internal social problems and economic conditions and toward concern with external threats. When the Russian Revo-lution of 1917 raised the spectre of Bolshevism, public leaders became hesitant about reform and its implications; immigrants and social reformers soon found themselves accused of foment-ing revolution.

Many artists found it more and more difficult in this period to project an image of optimism. They became disillusioned about social progress and alienated from the political and business leaders of the country. At that very time European artists were experimenting with new art forms which either celebrated the artist's personal emotional response to color (Fauvism) or coolly investigated formal relationships (Cubism). This European modern art had been introduced to New York artists at the

"291" Gallery; the general public became aware of the new art at the Armory Show of 1913, which traveled to Boston and Chicago. It is no coincidence that many American artists were drawn away from realism and to the modern styles at the time of disillusionment and pessimism—a time when Marius De Zayas, the witty and somewhat decadent writer in the later issues of *Camera Work*, could pronounce in 1912: "Our epoch is chaotic, neurotic, inconsequent, and out of equilibrium."[129]

Modernism became a retreat for many artists—not into nature but rather into the detached world of formal aesthetic relationships or into the individual emotional response to color. In other words, art for art's sake was reborn in modernism.

The various art trends which had their beginnings in the nineteenth century are still struggling for dominance in the art world. Although it seems for the moment that modernism is leading, many photographers and painters are more and more reasserting the primacy of subject matter and are insisting on the recognition of the extra-aesthetic meanings in their art. Once again the partisans of realism are moving to challenge the partisans of art for art's sake.

Notes

Introduction

1. Quoted in Norman A. Graebner, Gilbert C. Fite and Philip L. White, *A History of the American People* (New York: McGraw-Hill, 1970), p. 837. The following sources were specifically useful for the information and statistics in this section: Erik Barnouw, *Tube of Plenty: The Evolution of American Television* (New York: Oxford University Press, 1975); William Bridgwater and Seymour Kurtz, eds., *The Columbia Encyclopedia*, 3rd ed. (New York: Columbia University Press, 1963); Philip S. Foner, *History of the Labor Movement in the United States*, vol. III: *The Policies and Practices of the American Federation of Labor, 1900-1909* (New York: International Publishers, 1964); Oliver Jensen, ed., *The Nineties* (New York: American Heritage Publishing Co., 1967); Samuel Eliot Morison, *The Oxford History of the American People* (New York: Oxford University Press, 1965); Richard B. Morris, ed., *Encyclopedia of American History* (New York: Harper & Row, 1970); Gilbert Osofsky, *Harlem: The Making of a Ghetto, Negro New York 1890-1930* (New York: Harper Torchbooks, 1968); Mary P. Ryan, *Womanhood in America: From Colonial Times to the Present* (New York: New Viewpoints, 1975); Time-Life Books, *This Fabulous Century, 1900-1910*, I (New York: Time-Life Books, 1969); Barbara W. Tuchman, *The Proud Tower: A Portrait of the World Before the War, 1890-1914* (New York: Macmillan Company, 1962).

2. Sadakichi Hartmann, *A History of American Art*, new rev. ed. in two vols. (New York: Tudor Publishing Company, 1934), II, pp. 225-26. [First published in 1901. Revisions consist of one last chapter. All quotations cited here were first published in 1901.]

3. Clara Erskine Clement, *Women in the Fine Arts: From the Seventh Century B.C. to the Twentieth Century A.D.* (Boston and New York: Houghton, Mifflin, 1904), p. xxxvii.

4. *Ibid*, p. xxxix.

5. Hartmann, *History of American Art*, I, pp. 191-92.

6. Charles H. Caffin, *The Story of American Painting* (New York: Frederick A. Stokes Co., 1907), pp. 359-60.

7. Samuel Isham, *The History of American Painting*, new ed. with supplemental chapters by Royal Cortissoz (New York: Macmillan Company, 1936), p. 500. [First published in 1905. All quotations cited here were in that edition.]

8. George Santayana, *The Sense of Beauty: Being an Outline of Aesthetic Theory* (New York: Charles Scribner's Sons, 1896), p. 22, quoted in Peter Bermingham, *American Art in the Barbizon Mood* (Washington, D.C.: Smithsonian Institution Press, 1975), p. 95.

9. Arthur Dow, "Mrs. Gertrude Käsebier's Portrait Photographs," *Camera Notes*, 3 (July 1899): 22.

10. James Abbott McNeill Whistler, *The Gentle Art of Making Enemies* (New York: John W. Lovell, 1890), pp. 127-28.

11. Caffin (*Story of American Painting*, p. 173) was critical of academic idealism and said as follows: "[The 'ideal' picture] involves the use of the nude or of figures wrapped in draperies, for the most part, supposed to be 'classical.' This class of motive is based upon the assumption that the painter's duty and privilege is to improve upon the imperfections of the human form and to give the figure an ideal perfection. Therefore the world of real men and women will not do; the painter must invent some fancy of his own. As a rule, he does not so much invent as follow along some well-worn ruts that have led for centuries to the same goal."

12. Kenyon Cox, *Concerning Painting: Considerations Theoretical and Historical* (New York: Charles Scribner's Sons, 1917), p. 60.

13. *Ibid.*, p. 10.

14. Caffin, *Story of American Painting*, pp. 258, 261.

15. In the essays which follow, pictorial arts are defined as "pictures"—paintings, photographs, drawings and prints done on a flat support such as canvas, paper or, in the case of murals, on the wall. Artists selected for discussion are those who have been trained in the academies and art studios of established artists, or on the job in newspaper and magazine graphics departments or in commercial photographic firms. Subjects which are not covered in the exhibition or the catalogue, but which have been investigated in other exhibitions are: American Indian painting, folk painting, architectural renderings, studies for sculpture and the decorative arts, postcards, stereographic photographs, trade cards and advertising art.

16. Frederick Antal, "Remarks on the Method of Art History," *The Burlington Magazine*, 91 (February 1949): 49-52; (March 1949): 73-75, later anthologized in *Classicism and Romanticism with Other Studies in Art History* (London: Routledge & Kegan Paul, 1966), pp. 179-80.

17. The author has in preparation a more extensive study of the pictorial arts of the period 1890-1910.

I. The Mural Movement

18. Robert S. Gallagher, "Chicago," in *The Nineties*, p.14.

19. Caffin, *Story of American Painting*, pp. 313-14.

20. Pauline King, *American Mural Painting: A Study of the Important Decorations by Distinguished Artists in the United States* (Boston: Noyes, Platt & Company, 1902), p. 63.

21. In the Woman's Building, designed by a woman architect, Sophia Hayden, and decorated by many women artists, a spectator could view major murals by

Mary Cassatt, Mary MacMonnies and others. See King, *American Mural Painting,* pp. 87–92.

22. Florence N. Levy compiled an extensive list of murals which was published in "Mural Painting in the United States," *American Art Annual* 9 (1911): 12–33. I am grateful to Richard Murray for calling this to my attention.

23. Caffin (*Story of American Painting,* p. 123) observed that the French Academy "with its *Ecole des Beaux Arts,* has been officially maintained in order to preserve a standard of excellence and a system of teaching. Both are based upon the preeminence of line over colour, of drawing over painting. Such an out-and-out doctrinaire as Ingres asserted that 'Form is everything, colour nothing.' Whether the doctrine be applied to landscape or figure painting, it implies the superiority of art over nature, and the need of modifying the forms of nature that they may be made to emulate the perfection of classic models." See also, Lois Marie Fink and Joshua C. Taylor, *Academy: The Academic Tradition in American Art* (Washington, D.C.: Smithsonian Institution Press, 1975), p. 14, regarding the academic ideal in the 16th century which was maintained throughout the 19th century.

24. G*******, "The Prairie on Fire," *The Garland for 1830: Designed as a Christmas and New-Year's Present* (New York: Josiah Drake, 1830), p. 152.

25. Edwin H. Blashfield, *Mural Painting in America* (New York: Charles Scribner's Sons, 1913), pp. 175–76.

26. Edwin H. Blashfield, "A Definition of Decorative Art," *Brochure of the Mural Painters, a National Society* (New York: The Mural Painters, 1916), pp. 9–10. This brief essay sums up the points he made in his book

27. Hartmann, *History of American Art,* II, p. 234.

28. Caffin, *Story of American Painting,* p. 329.

II. Tonalists, Realists

29. The most thorough recent discussion of this group of artists can be found in Bermingham, *Barbizon Mood.*

30. Wanda M. Corn's excellent study, *The Color of Mood: American Tonalism, 1880–1910* (San Francisco: M. H. De Young Memorial Museum and the California

Palace of the Legion of Honor, 1972), relates the tonalist paintings with the work of the pictorial photographers of the turn of the century. [See also Section IX.]

31. Quoted in Isham, *History of American Painting,* p. 256.

32. Charles H. Caffin, *American Masters of Painting: Being Brief Appreciations of Some American Painters* (New York: Doubleday, Page & Company, 1902), p. 46.

33. Hartmann, *History of American Art,* I, p. 189.

III. Portraits in Oil

34. Sadakichi Hartmann, "Portrait Painting and Portrait Photography," *Camera Notes* 3 (July 1899): 4

35. *Ibid.*

36. *Ibid.,* p. 6.

37. Caffin, *American Masters of Painting,* p. 61.

38. John C. Van Dyke, *American Painting and Its Tradition* (New York: Charles Scribner's Sons, 1919), pp. 257–58.

IV. The Genteel Media

39. Dianne H. Pilgrim has written a thorough account of the pastel revival in "The Society of Painters in Pastel: The Revival of Pastels in 19th Century America," (essay submitted to the Department of Art History, Graduate Center, City University of New York, 1973).

40. "Whistler's Water Colors and Prints," *Art Age* 9 (March 1889): 60, quoted in Pilgrim, "Society of Painters in Pastel," p. 8.

41. References to the watercolor societies can be found throughout Theodore E. Stebbins, Jr., *American Master Drawings and Watercolors: A History of Works on Paper from Colonial Times to the Present* (New York: Harper & Row, 1976).

42. Frank Weitenkampf, *American Graphic Art* (New York: Henry Holt and Company, 1912), pp. 38–39.

43. At the end of the century, there was also a minor revival of the woodcut by artists such as Arthur W. Dow, Helen Hyde and B. J. Olssen-Nordfeldt, who were influenced by Japanese woodcuts. See Weitenkampf, *Graphic Art,* pp. 175–76.

44. *Ibid.,* p. 49.

V. Art Posters

45. Hartmann, *History of American Art,* II, pp. 131–32.

46. Sources for the historical information are: *Will Bradley, His Graphic Art: A Collection of His Posters, Illustrations, Typographic Designs, and Decorations,* ed. Clarence P. Hornung, intro. by Clarence P. Hornung and Roberta W[addell] Wong (New York: Dover Publications, 1974); Carolyn Keay, *American Posters of the Turn of the Century* (New York: St. Martin's Press, 1975); Kunstbibliothek Staatliche Museen Preussischer Kulturbesitz, Berlin, *Das Frühe Plakat in Europa und den U.S.A.: Ein Bestandskatalog,* introductory essays by Heinz Spielmann and Ruth Malhotra (Berlin: Gebr. Mann Verlag, 1973); Victor Margolin, *American Poster Renaissance* (New York: Watson-Guptill, 1975); Roberta [Waddell] Wong, *American Posters of the Nineties* (Lunenburg, Vt.: Stinehour Press, 1974).

47. According to Roberta Waddell, in conversation, Penfield's first poster was March 1893, rather than April, as is frequently stated.

48. See Frank Luther Mott, *A History of American Magazines* (Cambridge, Mass.: Belknap Press, 1957) IV, pp. 386–87. The "little magazines" were also called "dinky books," according to Waddell, in conversation.

49. See Mary Black, *American Advertising Posters of the Nineteenth Century: From the Bella C. Landauer Collection of The New-York Historical Society* (New York: Dover Publications, 1976).

50. Quoted in [Waddell] Wong, *American Posters,* p. 12.

51. Quoted in Weitenkampf, *Graphic Art,* p. 330.

VI. Impressionism, The Ten

52. Hamlin Garland, in *Crumbling Idols* (Chicago and Cambridge: Stone & Kimball, 1894), devotes one chapter to Impressionism. In that essay (pp. 134-35) he described twice visiting the Chicago Exposition, once with "a man who cared nothing for procedure" and again with a painter: "Both these men shook their heads at Inness, Diaz, Corot, Troyon, Rousseau, and Millet. The painter said, a little sadly, as if surrendering an illusion, 'They do not represent nature to me any more. They're all too indefinite, too

weak, too lifeless in shadow. They reproduce beautifully, but their color is too muddy and cold.'

"The other man was not even sad. He said, 'I don't like them—that's all there is about it. I don't see nature that way. Some of them are decorative, but they are not nature. I prefer Monet or Hassam or the Norwegians.'" This passage has also been quoted in Bermingham, *Barbizon Mood,* p. 88.

53. This stylistic contradiction was first noted by John I. H. Baur in *Theodore Robinson 1852–1896* (Brooklyn: The Brooklyn Museum, 1946), p. 27. (Reprinted in John I. H. Baur, *Three Nineteenth Century American Painters* [New York: Arno Press, 1969].)

54. Thorstein Veblen, *The Theory of the Leisure Class: An Economic Study of Institutions* (New York: The New American Library, 1953), p. 126. [First published in 1899.]

55. The Worcester Art Museum staff informed the author in 1974 that the painting has always been exhibited as *Girl Playing Solitaire.* Women in many of these paintings are frequently referred to as "girl."

56. Isham, *History of American Painting,* pp. 468, 471.

VII. Illustrations and Cartoons

57. Blashfield, *Mural Painting,* p. 188.

58. *Ibid.*

59. See Weitenkampf, *Graphic Art,* pp. 211–19.

60. *Ibid.,* p.126.

61. Robert Taft, *Photography and the American Scene: A Social History, 1839–1889* (New York: Dover Publications, 1964), p. 440. [First published in 1938.]

62. Mott, *American Magazines,* IV, pp. 11–12.

63. Ralph E. Stikes, *The Indignant Eye: The Artist as Social Critic in Prints and Drawings from the Fifteenth Century to Picasso* (Boston: Beacon Press, 1969), p. 316.

64. William Murrell, *A History of American Graphic Humor, 1865–1938* (New York: Cooper Square Publishers, 1967), p. 83. [First published in 1938 by the Whitney Museum of American Art.]

65. Richard S. West, "An Historical Narrative: Puck, the Political Cartoon Weekly," *Cartoonews* (1976).

66. Murrell, *Graphic Humor,* p. 65.

67. Quoted in Frank Luther Mott, *American Journalism: A History of Newspapers in the United States through 250 Years: 1690 to 1940* (New York: Macmillan, 1941), p. 434.

68. E[dward] W. Kemble, "Illustrating Huckleberry Finn," *The Colophon,* part 1 (February 1930): [51–52].

69. According to Mott (*American Magazines,* IV, p. 207): "The exposure of political corruption in city, state, and national government by magazines, which assumed the proportions of a 'movement,' came to a climax about 1905–06, and was tagged 'muckraking' by President Theodore Roosevelt."

70. Mott, *American Journalism,* p. 525.

71. *Ibid.,* p. 522.

72. Don Denny and Judith O'Sullivan, *The Art of the Comic Strip* (College Park: University of Maryland Art Gallery, 1971), p. 88.

73. See Linda S. Ferber in *A Century of American Illustration* (New York: The Brooklyn Museum, 1972), p. 17, and Weitenkampf, *Graphic Art,* p. 221.

74. See Phyllis Peet, "Americans at Leisure," in *The American Personality: The Artist-Illustrator of Life in the United States, 1860–1939* (Los Angeles: University of California, 1976), p. 42.

75. Mott, *American Journalism,* pp. 533–34.

76. Regarding racial stereotypes in the cartoons of Kemble, see Francis Martin, Jr., "Edward Windsor Kemble, A Master of Pen and Ink," *American Art Review* 3 (January-February 1976): 54–67.

77. George Luks quoted in Edward H. Smith, "George Luks, Painter and Anti-Genius," *The World Magazine,* April 27, 1919, which in turn is quoted in Edgar John Bullard, III, "John Sloan and the Philadelphia Realists as Illustrators, 1890–1920" (Master's thesis, University of California, Los Angeles, 1968), p. 132.

VIII. Pictorial Photography

78. Charles H. Caffin, *Photography as a Fine Art: The Achievements and Possibilities of Photographic Art in America* (New York: Doubleday, Page & Company, 1901), p. 88.

79. *Ibid.,* p. 9.

80. *Ibid.,* pp. 9–10.

81. Steichen, particularly, was known to have done such tricks as splashing water on the lens and kicking the tripod at the moment when he snapped the shutter.

82. Paraphrased in Caffin, *Photography as a Fine Art,* p. 34.

83. Quoted in Dorothy Norman, *Alfred Stieglitz: An American Seer* (New York: Random House, 1973), p. 48.

84. Sadakichi Hartmann, "Aesthetic Activity in Photography," *Brush and Pencil* 14 (April 1904): 39.

85. Charles H. Caffin, "Some Impressions from the International Photographic Exposition, Dresden," *Camera Work,* no. 28 (October 1909): 39.

86. Sadakichi Hartmann, "A Walk Through the Exhibition of the Photographic Section of the American Institute," *Camera Notes* 2 (January 1899): 89.

IX. Portrait Photographs

87. The *carte de visite* portrait was made by a multilens camera which could expose four to eight duplicate images on a single glass plate. The duplicate images were cut up and pasted upon cards about 4 x 2½ inches. Millions of *carte de visite* photographs of celebrities were mass produced—it is estimated that during the presidential campaign of 1860 some 100,000 *carte de visite* photographs of Lincoln were issued.

88. Caffin, *Photography as a Fine Art,* p. 62.

89. Alice Boughton, "Photography, a Medium of Expression," reprinted in *Camera Work,* no. 27 (July 1909): 35.

90. Caffin, *Photography as a Fine Art,* p. 55.

91. Dow, "Käsebier's Portrait Photographs," p. 22.

92. Caffin, *Photography as a Fine Art,* p. 16.

X. Social Photography

93. Caffin, *Photography as a Fine Art,* p. 118.

94. Jonathan Green, ed., *Camera Work: A Critical Anthology* (New York: Aperture, 1973), p. 18.

95. For a study of 19th-century attitudes toward realism, see Linda Nochlin, *Realism* (Baltimore: Penguin Books, 1971).

96. Edward Steichen, "Foreword," in Grace M. Mayer, *Once Upon a City* (New York: Macmillan Company, 1958), p. ix.

97. Quoted from Charles A. Madison, "Preface to the Dover Edition," in Jacob A. Riis, *How the Other Half Lives: Studies Among the Tenements of New York* (New York: Dover Publications, 1971), p. vii.

98. Lewis W. Hine in the Child Labor Bulletin of 1914, quoted by Walter Rosenblum, in "Foreword," *America & Lewis Hine: Photographs 1904–1940* (New York: Aperture, 1977), p. 12.

99. Alan Trachtenberg, "Essay," *America & Lewis Hine,* p. 121

100. *Ibid.,* p. 100.

101. Throughout the 19th century it was a common attitude held by white men that the American Indian was going to "vanish." For a study of that attitude, see Roy Harvey Pearce, *The Savages of America: A Study of the Indian and the Idea of Civilization,* 2d ed. rev. (Baltimore: Johns Hopkins Press, 1965).

102. Joseph Epes Brown, *The North American Indians: A Selection of Photographs by Edward S. Curtis* (New York: Aperture, 1972), unpaged.

XI. The City

103. *Brush and Pencil* 1 (September 1897): 14, quoted in Mott, *American Magazines,* IV, p. 145.

104. Sadakichi Hartmann, "A Plea for the Picturesqueness of New York," *Camera Notes* 4 (October 1900): 91–92.

105. Hartmann, *History of American Art,* I, pp. 252–53.

106. Some dozen illustrators who seemed to specialize in urban and industrial scenes are discussed in Emily Bardack Kies, "The City and the Machine: Urban and Industrial Illustration in America, 1800–1900" (Ph.D. dissertation, Columbia University, 1971).

107. H. G. Wells, "Foreword," Alvin Langdon Coburn, *New York* (London: Duckworth; New York: Brentano's, 1910), p. 10.

108. Quoted in Norman, *Stieglitz,* p. 45.

108A. Grace M. Mayer has previously noted the similarity in *Once Upon a City.*

109. See Norman, *Stieglitz,* pp. 75–77.

110. Hartmann, *History of American Art,* II, pp. 277–78.

XII. The Eight

111. Giles Edgerton [Mary Fanton Roberts] in "The Younger American Painters: Are They Creating a National Art?," (*The Craftsman* 13 [February 1908]: 531, maintains that the group was not a "secession from the Academy, because Robert Henri is an Academy member and Glackens an associate...." Her article was written with the cooperation of Henri, according to William Innes Homer with the assistance of Violet Organ, *Robert Henri and His Circle* (Ithaca, N.Y.: Cornell University Press, 1969), p. 136.

112. Homer, *Henri,* p.19.

113. Quoted from Sloan's notes in Homer, *Henri,* p. 76.

114. A thorough history of the events leading up to the exhibition can be found in Homer, *Henri,* pp. 127–46.

115. Quoted in Homer, *Henri,* p. 128.

116. Quoted in Homer, *Henri,* p. 131.

117. Quoted in Van Wyck Brooks, *John Sloan: A Painter's Life* (New York: Dutton, 1955), p. 56. [Sloan made the remark in 1950.]

118. Quoted in Edgerton, "Younger American Painters," pp. 524–25.

119. Byron Stephenson, "The Gilder," *Town Topics,* April 3, 1902, quoted in Homer, *Henri,* p. 109.

120. Robert Henri, "Progress in Our National Art Must Spring from the Development of Individuality of Ideas and Freedom of Expression: A Suggestion for a New School," *The Craftsman* 15 (January 1909): 394.

121. *Ibid.,* p. 393.

122. Sloan denied that they had any direct influence on the paintings of the realists. See Homer, *Henri,* p. 84.

123. Caffin, *Story of American Painting,* p. 378.

124. See Amy Goldin, "The Eight's Laissez Faire Revolution," *Art in America* 61 (July-August 1973): 42–49.

125. Henri, "Progress," p. 392.

126. For the influence of these thinkers on Henri, see Joseph J. Kwiat, "Robert Henri and the Emerson-Whitman Tradition," *PMLA* vol. 71, no. 4, 1 (September 1956): 617–36.

Epilogue

127. Bennard B. Perlman, *The Immortal Eight: American Painting from Eakins to the Armory Show (1870–1913)* (New York: Exposition Press, 1962), p. 23.

128. It should be noted that Gertrude Vanderbilt Whitney, who had studied with Auguste Rodin in France, encouraged the emerging realists through purchases of their works and creating art organizations which would encourage them. She bought four paintings from the first exhibition of The Eight which are now in the collection of the Whitney Museum: Henri's *Laughing Child* (1907), Luks's *Woman with Goose* (1907), Lawson's *Winter on the River* (1907) and Shinn's *Revue* (1908). She started: in 1914, the Whitney Studio; from 1915–18, the Friends of the Young Artists; from 1918–1928, the Whitney Studio Club. Finally she founded, in 1930, the Whitney Museum of American Art, which opened its doors to the public on November 18, 1931.

129. M[arius] De Zayas, "The Sun Has Set," *Camera Work,* no. 39 (July 1912): 21.

Selected Bibliography

Introduction

BARNOUW, ERIK. *Tube of Plenty: The Evolution of American Television.* New York: Oxford University Press, 1975.

BAUR, JOHN I. H. *Revolution and Tradition in Modern American Art.* New York: Frederick A. Praeger, 1967.

BROWN, HENRY COLLINS. *In the Golden Nineties.* Hastings-on-Hudson: Valentine's Manual, 1928.

CAFFIN, CHARLES H. *The Story of American Painting.* New York: Frederick A. Stokes Co., 1907.

CLEMENT, CLARA ERSKINE. *Women in the Fine Arts: From the Seventh Century B.C. to the Twentieth Century A.D.* Boston and New York: Houghton, Mifflin, 1904.

COX, KENYON. *Concerning Painting: Considerations Theoretical and Historical.* New York: Charles Scribner's Sons, 1917.

FONER, PHILIP S. *History of the Labor Movement in the United States.* Vol. III: *The Policies and Practices of the American Federation of Labor, 1900–1909.* New York: International Publishers, 1964.

GRAEBNER, NORMAN A., FITE, GILBERT C., and WHITE, PHILIP L. *A History of the American People.* New York: McGraw-Hill, 1970.

HARTMANN, SADAKICHI. *A History of American Art.* [1901]; new rev. ed. in two vols., New York: Tudor Publishing Company, 1934.

ISHAM, SAMUEL. *The History of American Painting.* [1905]; New York: Macmillan Company, 1936.

JENSEN, OLIVER, ed. *The Nineties.* New York: American Heritage Publishing Co., 1967.

JONES, HOWARD MUMFORD, and LUDWIG, RICHARD M. *Guide to American Literature and Its Background Since 1890.* 4th ed. Cambridge: Harvard University Press, 1972.

LAFARGE, JOHN. *Considerations on Painting: Lectures Given in the Year 1893 at the Metropolitan Museum of New York.* New York: Macmillan and Co., 1895.

MORISON, SAMUEL ELIOT. *The Oxford History of the American People.* New York: Oxford University Press, 1965.

MORRIS, RICHARD B., ed. *Encyclopedia of American History.* New York: Harper & Row, 1970.

MUMFORD, LEWIS. *The Brown Decades: A Study of the Arts of America, 1865–1895.* [1931]; 2nd rev. ed., New York: Dover Publications, 1955.

NOCHLIN, LINDA. *Realism.* Baltimore: Penguin Books, 1971.

NOVAK, BARBARA. *American Painting of the Nineteenth Century: Realism, Idealism, and the American Experience.* New York: Praeger Publishers, 1969.

OSOFSKY, GILBERT. *Harlem: The Making of a Ghetto, Negro New York 1890–1930.* New York: Harper Torchbooks, 1968.

QUICK, MICHAEL. *American Expatriate Painters of the Late Nineteenth Century.* Dayton: The Dayton Art Institute, 1976.

RICHARDSON, EDGAR P. *Painting in America: From 1502 to the Present.* New York: Thomas Y. Crowell Company, 1965.

RIIS, JACOB A. *How the Other Half Lives: Studies Among the Tenements of New York.* [1890]; New York: Dover Publications, 1971.

RYAN, MARY P. *Womanhood in America: From Colonial Times to the Present.* New York: New Viewpoints, 1975.

SANTAYANA, GEORGE. *The Sense of Beauty: Being the Outline of Aesthetic Theory.* New York: Charles Scribner's Sons, 1896.

SCHNAPPER, M. B. *American Labor: A Pictorial Social History.* Washington, D.C.: Public Affairs Press, 1972.

TIME-LIFE BOOKS. *This Fabulous Century, 1900–1910,* I. New York: Time-Life Books, 1969.

TUCHMAN, BARBARA W. *The Proud Tower: A Portrait of the World Before the War, 1890–1914.* New York: Macmillan Company, 1962.

VAN DYKE, JOHN C. *American Painting and Its Tradition.* New York: Charles Scribners' Sons, 1919.

———. *Art for Art's Sake; Seven University Lectures on the Technical Beauties of Painting.* New York: Charles Scribner's Sons, 1894.

———. *What is Art?: Studies in the Technique and Criticism of Painting.* New York: Charles Scribner's Sons, 1910.

VEBLEN, THORSTEIN. *The Theory of the Leisure Class: An Economic Study of Institutions.* [1899]; New York: New American Library, 1953.

WHISTLER, JAMES ABBOTT McNEILL. *The Gentle Art of Making Enemies.* New York: John W. Lovell, 1890.

ZIFF, LARZER. *The American 1890s: Life and Times of a Lost Generation.* New York: Viking Compass Edition, 1973.

I. The Mural Movement

BLASHFIELD, EDWIN H. *Mural Painting in America.* New York: Charles Scribner's Sons, 1913.

CLEMENT, CLARA ERSKINE. "Later Religious Painting in America." *New England Magazine,* new series vol. 12 (April 1895): 130-54.

FINK, LOIS MARIE, and TAYLOR, JOSHUA C. *Academy: The Academic Tradition in American Art.* Washington, D.C.: Smithsonian Institution Press, 1975.

GERDTS, WILLIAM H. *The Great American Nude: A History of Art.* New York: Praeger Publishers, 1974.

KING, PAULINE. *American Mural Painting: A Study of the Important Decorations by Distinguished Artists in the United States.* Boston: Noyes, Platt & Company, 1902.

National Society of Mural Painters. *Brochure of the Mural Painters, a National Society.* New York: The Mural Painters, 1916.

_____. "Mural Painting in the United States." *American Art Annual* 9 (1911): 12–33.

II, III. Tonalists, Realists; Portraits in Oil

BERMINGHAM, PETER. *American Art in the Barbizon Mood.* Washington, D.C.: Smithsonian Institution Press, 1975.

BREESKIN, ADELYN D. *Mary Cassatt: A Catalogue Raisonné of the Oils, Pastels, Watercolors, and Drawings.* Washington, D.C.: Smithsonian Institution Press, 1970.

CAFFIN, CHARLES H. *American Masters of Painting: Being Brief Appreciations of Some American Painters.* New York: Doubleday, Page & Company, 1902.

CIKOVSKY, NICOLAI, JR. *George Inness.* New York: Praeger Publishers, 1971.

CORN, WANDA M. *The Color of Mood: American Tonalism, 1880–1910.* San Francisco: M. H. DeYoung Memorial Museum and the California Palace of the Legion of Honor, 1972.

GARDNER, ALBERT TEN EYCK. *Winslow Homer, American Artist: His World and His Work.* New York: Bramhall House, 1961.

GOODRICH, LLOYD. *Thomas Eakins: His Life and Work.* New York: Whitney Museum of American Art, 1933.

_____. *Winslow Homer.* New York : Whitney Museum of American Art, 1973.

HARRISON, BIRGE. *Landscape Painting.* New York: Charles Scribner's Sons, 1909.

HENDRICKS, GORDON. *The Life and Works of Thomas Eakins.* New York: Grossman Publishers, 1974.

HILL, FREDERICK D. "Cecilia Beaux, the Grande Dame of American Portraiture," *Antiques* 105 (January 1974): 160–68.

HILLS, PATRICIA. *The Painters' America: Rural and Urban Life, 1810–1910.* New York: Praeger Publishers, 1974.

HUBER, CHRISTINE JONES. *The Pennsylvania Academy and Its Women: 1850–1920.* Philadelphia: Pennsylvania Academy of the Fine Arts, 1973.

JONES, HARVEY L. *Mathews: Masterpieces of the California Decorative Style.* Oakland: The Oakland Museum, 1972.

MATHEWS, MARCIA M. *Henry Ossawa Tanner: American Artist.* Chicago: University of Chicago Press, 1969.

ORMOND, RICHARD. *John Singer Sargent.* New York: Harper & Row, 1970.

SCHENDLER, SYLVAN. *Eakins.* Boston: Little, Brown and Company, 1967.

WILMERDING, JOHN. *Winslow Homer.* New York: Praeger Publishers, 1972.

IV. The Genteel Media

ACKLEY, CLIFFORD S. *American Prints 1813–1913.* Boston: Museum of Fine Arts, 1975. [Contains a bibliography.]

BREESKIN, ADELYN D. *The Graphic Work of Mary Cassatt: A Catalogue Raisonné.* New York: H. Bittner, 1948.

BREITENBACH, EDGAR. "Graphic Arts" in "American Graphics and Painting in the Late Nineteenth Century." *Archives of American Art Journal,* vol. 9, no 3 (1969): 1–11.

JOHNSON, ROBERT FLYNN. *American Prints 1870–1950.* Baltimore: The Baltimore Museum of Art, [1974]. [Contains a bibliography.]

PILGRIM, DIANNE H. "The Society of Painters in Pastel: The Revival of Pastels in 19th Century America." Essay submitted to the Department of Art History, Graduate Center, City University of New York, 1973.

STEBBINS, THEODORE E., JR. *American Master Drawings and Watercolors: A History of Works on Paper from Colonial Times to the Present.* With the assistance of John Caldwell and Carol Troyen. New York: Harper & Row, 1976. [Contains an extensive bibliography.]

SWEET, FREDERICK A. *James McNeill Whistler.* Chicago: The Art Institute of Chicago, 1968.

WEITENKAMPF, FRANK. *American Graphic Art.* New York: Henry Holt and Company, 1912.

V. Art Posters

HAWKES, ELIZABETH H. *The Poster Decade: American Posters of the 1890s.* Wilmington: Delaware Art Museum, 1977.

HORNUNG, CLARENCE P., ed. *Will Bradley, His Graphic Art: A Collection of His Posters, Illustrations, Typographic Designs, and Decorations.* Introduction by Clarence P. Hornung and Roberta W. Wong. New York: Dover Publications, 1974.

KEAY, CAROLYN. *American Posters of the Turn of the Century.* New York: St. Martins's Press, 1975.

Kunstbibliothek Staatliche Museen Preussischer Kulturbesitz, Berlin. *Das Frühe Plakat in Europa und den U.S.A.: Ein Bestandskatalog.* Introductory essays by Heinz Spielmann and Ruth Malhotra. Berlin: Gebr. Mann Verlag, 1973.

MARGOLIN, VICTOR. *American Poster Renaissance.* New York: Watson-Guptill, 1975.

SLOAN, HELEN FARR. *The Poster Period of John Sloan.* Lock Haven, Pa.: Hammermill Paper Co., 1967.

WONG, ROBERTA [WADDELL]. *American Posters of the Nineties.* Lunenburg, Vt.: Stinehour Press, 1974.

VI. Impressionism, The Ten

BAUR, JOHN I. H. *Theodore Robinson 1852–1896.* Brooklyn: The Brooklyn Museum, Brooklyn Institute of Arts and Sciences, 1946.

BOYLE, RICHARD J. *American Impressionism.* Boston: New York Graphic Society, 1974.

DAVIDSON, CARLA. "Boston Painters, Boston Ladies." *American Heritage* 23 (April 1972): 4–17.

DOMIT, MOUSSA M. *American Impressionist Painting.* Washington, D.C.: National Gallery of Art, 1973.

GARLAND, HAMLIN. *Crumbling Idols.* Chicago and Cambridge: Stone & Kimball, 1894; Cambridge, Mass.: Belknap Press, 1960.

HOOPES, DONELSON F. *The American Impressionists.* New York: Watson-Guptill, 1972.

JOHNSTON, SONA. *Theodore Robinson, 1852–1896.* Baltimore: The Baltimore Museum of Art, 1973.

LANES, JERROLD. "Boston Painting 1880–1930." *Artforum* 10 (January 1972): 49–51.

MURPHY, FRANCIS. *Willard Leroy Metcalf: A Retrospective.* Biographical essay by Elizabeth DeVeer. Springfield, Mass.: Museum of Fine Arts, 1976.

PILGRIM, DIANNE H. *American Impressionist and Realist Paintings and Drawings from the Collection of Mr. and Mrs. Raymond J. Horowitz.* New York: The Metropolitan Museum of Art, 1973.

ROOF, KATHERINE METCALF. *The Life and Art of William Merritt Chase.* New York: Charles Scribner's Sons, 1917.

YOUNG, DOROTHY WEIR. *The Life & Letters of J. Alden Weir.* Edited with an introduction by Lawrence W. Chisolm. New Haven: Yale University Press, 1960.

VII. Illustrations and Cartoons

BLAISDELL, THOMAS C., JR., SELZ, PETER, and Seminar. *The American Presidency in Political Cartoons: 1776-1976.* Berkeley: University Art Museum, University of California, 1976.

Brandywine River Museum. *The Art of American Illustration.* Chadds Ford, Pa.: Brandywine Conservancy, 1976.

The Brooklyn Museum. *A Century of American Illustration.* Essays by Linda S. Ferber and Robin Brown. New York: The Brooklyn Museum, 1972.

DOWNEY, FAIRFAX. *Portrait of an Era As Drawn by C. D. Gibson: A Biography.* New York: Charles Scribner's Sons, 1936.

ELZEA, ROWLAND. *The Golden Age of American Illustration, 1880-1914.* Wilmington: Delaware Art Museum, 1972.

The Grunwald Center for the Graphic Arts. *The American Personality: The Artist-Illustrator of Life in the United States, 1860-1939.* Los Angeles: University of California, 1976. [Extensive bibliography.]

HEARN, MICHAEL PATRICK. "The Animated Art of Winsor McCay." *American Artist* 39 (May 1975): 28-33, 63-65.

KEMBLE, E.W. "Illustrating Huckleberry Finn." *The Colophon,* part 1 (February 1930): [45-52].

KIES, EMILY BARDACK. "The City and the Machine: Urban and Industrial Illustration in America, 1880-1900." Ph.D. dissertation, Columbia University, 1971.

MARTIN, FRANCIS, JR. "Edward Windsor Kemble, A Master of Pen and Ink." *American Art Review* 3 (January–February 1976): 54-67.

MAYER, ANNE E. *Women Artists in the Howard Pyle Tradition.* Chadds Ford, Pa: Brandywine River Museum, 1975.

MOTT, FRANK LUTHER. *American Journalism: A History of Newspapers in the United States through 250 Years: 1690 to 1940.* New York: Macmillan Company, 1941.

_____. *A History of American Magazines, IV: 1885-1905.* Cambridge: The Belknap Press of the Harvard University Press, 1957.

MURRELL, WILLIAM. *A History of American Graphic Humor 1865-1938.* New York: Cooper Square Publishers, 1967.

O'SULLIVAN, JUDITH. *The Art of the Comic Strip.* Introductory note by Don Denny. College Park: University of Maryland Art Gallery, 1971.

PENNELL, JOSEPH. *The Graphic Art, Modern Men and Modern Methods.* Chicago: University of Chicago Press for the Art Institute of Chicago, 1921.

PITZ, HENRY C. *The Brandywine Tradition.* Boston: Houghton Mifflin Company, 1969.

_____. *A Treasury of American Book Illustration.* New York: American Studio Books and Watson-Guptill Publications, 1947.

REED, WALT, ed. *The Illustrator in America, 1900-1960's.* New York: Reinhold Publishing Corporation, 1966.

ROBINSON, JERRY. *Cartoon & Comic Strip Art.* New York: Graham Gallery, 1972.

ROGERS, WILLIAM ALLEN. *A World Worth While: A Record of "Auld Acquaintance."* New York: Harper & Brothers Publishers, 1922.

The Society of Illustrators. *200 Years of American Illustration.* New York: The Society of Illustrators, 1976. [Exhibition checklist.]

STIKES, RALPH E. *The Indignant Eye: The Artist as Social Critic in Prints and Drawings from the Fifteenth Century to Picasso.* Boston: Beacon Press, 1969.

TYLER, RON. *The Image of America in Caricature & Cartoon.* Fort Worth: Amon Carter Museum of Western Art, 1976.

Yale University Art Gallery. *Edwin Austin Abbey.* New Haven: Yale University Art Gallery, 1973.

VIII, IX, X. Photography

BOUGHTON, ALICE. "Photography, a Medium of Expression." *Camera Work,* no. 27 (July 1909): 33-36.

BROWN, JOSEPH EPES. *The North American Indians: A Selection of Photographs of Edward S. Curtis.* New York: Aperture, 1972.

CAFFIN, CHARLES H. *Photography as a Fine Art: The Achievements and Possibilities of Photographic Art in America.* New York: Doubleday, Page & Company, 1901.

_____. "Progress in Photography with Special Reference to the Work of Eduard J. Steichen." *The Century Magazine* 75 (February 1908): 483-98.

Camera Notes. All issues: vol. 1, no. 1 (July 1897)—vol. 6, no. 4 (March 1903).

Camera Work. All issues: no. 1 (January 1903)—no. 32 (October 1910).

DANIEL, PETE and SMOCK, RAYMOND. *A Talent for Detail: The Photographs of Miss Frances Benjamin Johnston (1889-1910).* New York: Harmony Books, 1974.

DOTY, ROBERT, ed. *Photography in America.* Introduction by Minor White. New York: Published for the Whitney Museum of American Art by Ridge Press and Random House, 1974.

_____. *Photo Secession; Photography as a Fine Art.* Monograph no. 1. Rochester, N.Y.: George Eastman House, 1960.

DOW, ARTHUR. "Mrs. Gertrude Käsebier's Portrait Photographs." *Camera Notes* 3 (July 1899): 22-23.

EDGERTON, GILES [ROBERTS, MARY FANTON]. "The Lyric Quality in the Photo-Secession Art of George H. Seeley." *The Craftsman* 13 (December 1907): 298-303.

_____. "Photography as One of the Fine Arts; The Camera Pictures of Alvin Langdon Coburn as a Vindication of this Statement." *The Craftsman* 12 (January 1907): 394-403.

GREEN, JONATHAN, ed. *Camera Work: A Critical Anthology.* New York: Aperture, 1973.

HAMILTON, EMILY J. "Some Symbolic Nature Studies from the Camera of Annie W. Brigman." *The Craftsman* 12 (September 1907): 660-66.

HARTMANN, SADAKICHI. "Aesthetic Activity in Photography." *Brush and Pencil* 14 (April 1904): 24-40.

_____. "Portrait Painting and Portrait Photography." *Camera Notes* 3 (July 1899): 3-6.

HEYMAN, THERESE THAU. *Anne Brigman: Pictorial Photographer/Pagan/Member of Photo-Secession.* Oakland: The Oakland Museum, 1974.

HILEY, MICHAEL. "The Photographer as Artist: A Turn of the Century Debate." *Studio* 190 (July 1975): 4–11.

HOMER, WILLIAM INNES. "Eduard Steichen As Painter and Photographer,1897-1908." *The American Art Journal* 6 (November 1974): 45–55.

_____. *Alfred Stieglitz and the American Avant-Garde.* Boston: New York Graphic Society, 1977.

MADDOX, JERALD C. "Photography in the First Decade." *Art in America* 61 (July–August 1973): 72–79.

MAHOOD, R. I., ed. *Photographer of the Southwest: Adam Clark Vroman, 1856-1916.* Introduction by Beaumont Newhall. Los Angeles: Ward Ritchie Press 1961.

MICHAELS, BARBARA L. "Rediscovering Gertrude Käsebier." *Image* 19 (June 1976): 20–32.

NAEF, WESTON. *The Painterly Photograph: 1890-1914.* New York: The Metropolitan Museum of Art, 1973.

NORMAN, DOROTHY. *Alfred Stieglitz: An American Seer.* New York: Random House, 1973.

NOVOTNY, ANN. *Alice's World: The Life and Photography of an American Original: Alice Austen, 1866-1952.* Old Greenwich, Conn.: Chatham Press, 1976.

ROSENBLUM, NAOMI and WALTER. "The Art Historian and the Photographic Image." *Art Journal* 36 (Winter 1976/77): 139–42.

ROSENBLUM, WALTER; ROSENBLUM, NAOMI; TRACHTENBERG, ALAN; and ISRAEL, MARVIN. *America & Lewis Hine: Photographs 1904-1940.* New York: The Brooklyn Museum in association with Aperture, 1977.

STEICHEN, EDWARD. *A Life in Photography.* Garden City, N.Y.: Doubleday & Company, 1963.

TAFT, ROBERT. *Photography and the American Scene: A Social History, 1839-1889.* [1938]; New York: Dover Publications, Inc., 1964.

THORNTON, GENE. *Masters of the Camera: Stieglitz, Steichen & their Successors.* New York: The Ridge Press and Holt, Rinehart and Winston, 1976.

XI. The City

COBURN, ALVIN LANGDON. *New York.* Foreword by H. G. Wells. London: Duckworth & Co.; New York: Brentano's, 1910.

CORN, WANDA M. "The New New York." *Art in America* 61 (July–August 1973), 58–65.

HARTMANN, SADAKICHI. "A Plea for the Picturesqueness of New York." *Camera Notes* 4 (October 1900): 91–92.

KOUWENHOVEN, JOHN ATLEE. *The Columbia Historical Portrait of New York.* Garden City, N.Y.: Doubleday, 1953.

MAYER, GRACE M. *Once Upon A City.* Foreword by Edward Steichen. New York: Macmillan Company, 1958.

VAN DYKE, JOHN C. *The New New York: A Commentary on the Place and the People.* New York: Macmillan Company, 1909.

WELLS, H. G. *The Future in America: A Search After Realities.* London: Chapman & Hall, Ltd. 1906.

XII. The Eight

ANDERSON, DENNIS R. *Ernest Lawson: Retrospective.* New York: ACA Galleries, 1976.

BROOKS, VAN WYCK. *John Sloan: A Painter's Life.* New York: Dutton, 1955.

BULLARD, EDGAR JOHN, III. "John Sloan and the Philadelphia Realists and Illustrators, 1890-1920." Master's thesis, University of California, Los Angeles, 1968.

Delaware Art Center. *The Fiftieth Anniversary of the Exhibition of Independent Artists in 1910.* Wilmington: Delaware Art Center, 1960.

EDGERTON, GILES [MARY FANTON ROBERTS]. "The Younger American Painters: Are They Creating a National Art?" *The Craftsman* 13 (February 1908): 512–22.

Gallery of Modern Art including the Huntington Hartford Collection. *George Bellows: Paintings, Drawings, Lithographs.* Foreword by Margaret Potter. Introduction by Charles H. Morgan. New York: The Foundation for Modern Art, 1966.

GLACKENS, IRA. *William Glackens and the Ash Can Group: The Emergence of Realism in American Art.* New York: Crown Publishers, 1957.

GOLDIN, AMY. "The Eight's Laissez Faire Revolution." *Art in America* 61 (July–August 1973): 42–49.

HENRI, ROBERT. *The Art Spirit.* Philadelphia: Lippincott, 1930.

HOMER, WILLIAM INNES. *Robert Henri and His Circle.* With the assistance of Violet Organ. Ithaca, N.Y.: Cornell University Press, 1969.

KWIAT, JOSEPH J. "Robert Henri and the Emerson-Whitman Tradition," *PMLA*, vol. 71, no. 4, pt. 1 (September 1956): 617–36.

Museum of Art, Munson-Williams-Proctor Institute. *George Luks, 1866-1933.* Texts by Ira Glackens and Joseph S. Trovato. Utica, N.Y.: Munson-Williams-Proctor Institute, 1973.

New Jersey State Museum. *Everett Shinn, 1873-1953.* Introductions by Charles T. Henry, Ira Glackens, and Bennard B. Perlman. Annotated Chronology by Edith DeShazo. Trenton: New Jersey State Museum, 1973.

PERLMAN, BENNARD B. *The Immortal Eight: American Painting from Eakins to the Armory Show (1870-1913).* New York: Exposition Press, 1962.

Checklist of the Exhibition

All works will be shown at the Whitney Museum of American Art,
The St. Louis Art Museum, the Seattle Art Museum and
The Oakland Museum, except those which are not available for
the entire tour and are denoted by the following symbols:

NY to be shown at the Whitney Museum of American Art
StL to be shown at the St. Louis Art Museum
S to be shown at the Seattle Art Museum
O to be shown at the Oakland Museum

EDWIN AUSTIN ABBEY (1852–1911)
Bottom and Titania
For *A Midsummer Night's Dream,* 1893
Ink and pencil on composition board; 20⅞ x 14¼ inches
Yale University Art Gallery, New Haven; The Edwin Austin Abbey
 Memorial Collection

Goneril and Regan
For *King Lear,* 1902
Oil on canvas, 30¼ x 17½ inches
Yale University Art Gallery, New Haven; The Edwin Austin Abbey
 Memorial Collection (Fig. 115)

JOHN WHITE ALEXANDER (1856–1915)
The Blue Bowl, 1898
Oil on canvas, 48 x 36 inches
Museum of Art, Rhode Island School of Design, Providence; Jesse H.
 Metcalf Fund (Fig. 23)

ALICE AUSTEN (1886–1952)
Rag Pickers and Hand Carts at 23rd Street and Third Avenue, 1896
Modern print made from original negative, 8 x 10 inches
Courtesy of The Staten Island Historical Society, New York (Fig. 184)

CECILIA BEAUX (1863–1942)
Dorothea in the Woods, 1897
Oil on canvas, 53¼ x 40 inches
Whitney Museum of American Art, New York; Gift of Mr. and Mrs.
 Raymond J. Horowitz (Fig. 25)

GEORGE BELLOWS (1882–1925)
Pennsylvania Station Excavation, 1909
Oil on canvas, 30¼ x 38¼ inches
The Brooklyn Museum, New York; A. Augustus Healy Fund (Pl. VI)

FRANK WESTON BENSON (1862–1921)
Girl Playing Solitaire, 1909
Oil on canvas, 50 x 40 ³/₁₆ inches
Worcester Art Museum, Worcester, Massachusetts (Fig. 82) *NY*

EDWIN BLASHFIELD (1848–1936)
Study of Figure in Panel of Music Room in House of Adolphe Lewisohn Esq.,
 c. 1903–04
Charcoal on paper, 28 x 17 inches
Graham Gallery, New York (Fig. 8)

ALICE BOUGHTON (1869–1950)
Sand and Wild Roses
From *Camera Work,* no. 26, April 1909
Photogravure, 8⅜ x 6¼ inches (image)
The Witkin Gallery, Inc., New York (Fig. 133)

WILL H. BRADLEY (1868–1962)
The Chap-Book ("Blue Lady"), 1894
Color lithograph, 20 x 14 inches (sheet)
Columbia University, New York; Engel Collection, Rare Book and
 Manuscript Library

The Chap-Book Thanksgiving No., 1895
Color lithograph, 20¾ x 13⅞ inches (sheet)
Columbia University, New York; Engel Collection, Rare Book and
 Manuscript Library (Fig. 54)

The Modern Poster, 1895
Color lithograph, 19½ x 12½ inches (sheet)
Columbia University, New York; Engel Collection, Rare Book and
 Manuscript Library (Fig. 52)

ANNE BRIGMAN (1869–1950)
The Bubble, 1905
Photograph, 7½ x 9½ inches
The Oakland Museum; Gift of Mr. and Mrs. W. M. Nott (Fig. 134)

The Dying Cedar, 1908
Platinum print, 9¼ x 6⅜ inches
The Oakland Museum; Gift of Mr. and Mrs. W. M. Nott

GEORGE DE FOREST BRUSH (1855–1941)
Miss Polly Cabot, 1896
Oil on canvas, 58 x 36 inches
Philadelphia Museum of Art; Gift of the Friends of the Philadelphia
 Museum of Art (Fig. 29)

THE BYRON COMPANY
Steerage Deck of the S.S. Pennland of the Red Star Line, 1893
Solio print, 7 x 9½ inches
Museum of the City of New York (Fig. 204)

Telephone Exchange, Cortlandt Street, 1896
Solio print, 7⁷/₁₆ x 9⅜ inches (image)
Museum of the City of New York (Fig. 169)

Recent Vision of Jollity in Central Park, 1898
Solio print, 7¼ x 9⅛ inches
Museum of the City of New York (Fig. 200)

Madison Square Park Cabstand, 1901
Solio print, 7¼ x 9⁷⁄₁₆ inches (image)
Museum of the City of New York (Fig. 187)

Richard Hall at Work on His Portrait of Cathleen Neilson, the Future Mrs. Reginald Claypool Vanderbilt, 1903
Solio print, 8⅜ x 10¼ inches (image)
Museum of the City of New York (Fig. 164)

Children's Party, 1906
Solio print, 10½ x 13¼ inches (image)
Museum of the City of New York (Fig. 163)

Mrs. James Gore King Duer and Her Daughters, Alice Duer Miller and Caroline King Duer, 1906
Solio print, 9⅜ x 7 ⁹⁄₁₆ inches (image)
Museum of the City of New York (Fig. 162)

MARY CASSATT (1844-1926)

Afternoon Tea Party, 1891
Drypoint and aquatint touched with gold paint; 13¾ x 10¾ inches (plate)
The St. Louis Art Museum; Purchase, funds donated by Mr. and Mrs. Warren McK. Shapleigh, Mrs. G. Gordon Hertslet, Mrs. Richard S. Brumbaugh and tax funds *StL*

The Fitting, 1891
Drypoint and soft-ground etching, 14¾ x 10⅛ inches (image)
The Metropolitan Museum of Art, New York; Gift of Paul J. Sachs, 1916 *NY*

In the Omnibus, 1891
Drypoint, soft-ground etching and aquatint, 14⁵⁄₁₆ x 10½ inches (image)
The Metropolitan Museum of Art, New York; Gift of Paul J. Sachs, 1916 *S*

La Lettre, 1891
Drypoint and aquatint, 13⅝ x 8⁵⁄₁₆ inches
The Metropolitan Museum of Art, New York; Gift of Paul J. Sachs, 1916 (Fig. 49) *NY*

Woman Bathing (La Toilette), 1891
Drypoint and aquatint, 14⁵⁄₁₆ x 10⁹⁄₁₆ inches
The Metropolitan Museum of Art, New York; Gift of Paul J. Sachs, 1916 (Fig. 50) *O*

Young Women Picking Fruit, 1891
Oil on canvas, 51⅜ x 35¾ inches
Museum of Art, Carnegie Institute, Pittsburgh (Fig. 21) *NY*

Feeding the Ducks, 1895
Drypoint (first state), 11⅝ x 15½ inches
The Metropolitan Museum of Art, New York; Bequest of Mrs. H. O. Havemeyer, 1929 (Fig. 47)

Baby Getting Up from His Nap, 1901
Oil on canvas, 36½ x 29 inches
The Metropolitan Museum of Art, New York; George A. Hearn Fund, 1909 (Fig. 10)

Tendresse Maternelle, 1908
Pastel on paper, 31 x 25 inches
Seattle Art Museum; Gift of Mr. and Mrs. Louis Brechemin (Fig. 39) *S*

ANDRÉ CASTAIGNE (1861–active to 1930)

Gone, 1893
For *Century Magazine,* April 1894
Monochrome oil on canvas, 29⅛ x 20⅝ inches
Library of Congress, Washington, D.C. (Fig. 112) *NY*

WILLIAM MERRITT CHASE (1849-1916)

Portrait of a Woman: Reverie, c. 1890
Monotype, 18⅞ x 15½ inches
The Metropolitan Museum of Art, New York; Purchase, Louis V. Bell, William E. Dodge and Fletcher Funds, Murray Rafsky Gift, and Funds from various donors, 1974 (Fig. 36) *NY*

The Golden Lady, 1896
Oil on canvas, 40⅝ x 32¾ inches
The Parrish Art Museum, Southampton, New York; Littlejohn Collection (Pl. II)

Good Friends, c. 1909
Oil on wood, 22⅛ x 30⅞ inches
Hirshhorn Museum and Sculpture Garden, Smithsonian Institution, Washington, D. C. (Fig. 73)

Portrait of Mrs. Chase, c. 1910
Pastel on paper, 20 x 16 inches
Collection of Mr. and Mrs. Raymond J. Horowitz (Fig. 38) *NY*

ALVIN LANGDON COBURN (1882-1966)

Mark Twain, 1908
Photogravure, 9⅛ x 6⅜ inches
International Museum of Photography at George Eastman House, Rochester, New York (Fig. 148)

Brooklyn Bridge
From *New York,* 1910
Photogravure, 8⅝ x 6 inches
Philadelphia Museum of Art; Gift of Mr. and Mrs. Adrian Siegel (Fig. 190)

The Tunnel Builders
From *New York,* 1910
Photogravure, 8¼ x 6¾ inches
Philadelphia Museum of Art; Gift of Mr. and Mrs. Adrian Siegel

CHARLES COX (UNKNOWN)

Bearings for Sale Here, 1896 (?)
Color lithograph, 18⅛ x 13½ inches (sheet)
The Currier Gallery of Art, Manchester, New Hampshire (Fig. 58)

KENYON COX (1856-1919)

Science Instructing Industry, 1898
Oil on canvas, 24 x 29 inches
Case Western Reserve University, Cleveland (Fig. 2)

Augustus Saint-Gaudens, 1908
Oil on canvas, 33½ x 46⅞ inches
The Metropolitan Museum of Art, New York; Gift of Friends of the Sculptor through August F. Jaccaci, 1908 (Fig. 3) *NY*

Design for Book Plate, n. d.
Soft pencil on paper, 18½ x 13¼ inches
Collection of Victor D. Spark

PALMER COX (1840–1924)

The Brownies, Tally Ho
From *Another Brownie Book,* 1890
Pencil and India ink on paper, 12¾ x 9½ inches
Cooper-Hewitt Museum of Decorative Arts and Design, Smithsonian
 Institution, New York (Fig. 128)

WILL CRAWFORD (1869–1944)

William Randolph Hearst and Albert Brisbane and William Jennings Bryan,
 c. 1890
Ink on paper, 14 x 20 inches
Collection of Mr. and Mrs. Benjamin Eisenstat

FRANK CURRIER (1843–1909)

Interior of a Kitchen, 1901
Photograph, 7½ x 9⅝ inches
The Museum of Modern Art, New York; Gift of Ernst Halberstadt,
 1944 (Fig. 170)

EDWARD S. CURTIS (1868–1952)

Woman Reaping, n.d.
Platinum print, 12⅜ x 16⁵⁄₁₆ inches
The St. Louis Art Museum; Purchase and funds given by Martin
 Schweig Memorial Fund for Photography (Fig. 166)

LEON DABO (1868–1960)

Sailboats on a Calm Sea, c. 1900
Oil on canvas, 27 x 36 inches
Collection of Marian W. Cobin

LOUIS DALRYMPLE (1865–1905)

The High Tide of Immigration—A National Menace
From *Judge,* 1903
Chromolithograph, 11 x 18 inches
Collection of Mr. and Mrs. Benjamin Eisenstat (Fig. 93)

ARTHUR B. DAVIES (1862–1928)

Many Waters, 1907–08
Oil on canvas, 17 x 22 inches
The Phillips Collection, Washington, D.C. (Fig. 213)

F. HOLLAND DAY (1864–1933)

Portrait of Mrs. Potter Palmer, c. 1890
Platinum print, 5⅝ x 4¹¹⁄₁₆ inches
The Metropolitan Museum of Art, New York; Alfred Stieglitz Collec-
 tion (Fig. 151) NY

Untitled (Head of a Turbaned Youth), 1907
Platinum print, 4⅝ x 3⅞ inches (image)
Library of Congress, Washington, D.C. NY

Untitled (Nude Boy in Stream), 1907
Platinum print, 7⅞ x 4¾ inches (image)
Library of Congress, Washington, D.C. (Fig. 137) NY

JOSEPH RODEFER DE CAMP (1858–1923)

The Guitar Player, 1908
Oil on canvas, 50½ x 45½ inches
Museum of Fine Arts, Boston; Charles Henry Hayden Fund (Fig. 81)

WILLIAM WALLACE DENSLOW (1856–1915)

I Was Only Made Yesterday; Said the Scarecrow
For *The Wonderful Wizard of Oz,* 1900
Ink over pencil on paper, 20 x 14 inches
Prints Division, The New York Public Library; Astor, Lenox and Tilden
 Foundations O

The Lion Ate Some of the Porridge
For *The Wonderful Wizard of Oz,* 1900
Ink over pencil on paper, 20 x 14 inches
Prints Division, The New York Public Library; Astor, Lenox and Tilden
 Foundations S

The Scarecrow Sat on the Throne, and the Others Stood Respectfully Before Him
For *The Wonderful Wizard of Oz,* 1900
Ink over pencil on paper, 19¹³⁄₁₆ x 14 inches
Prints Division, The New York Public Library; Astor, Lenox and Tilden
 Foundations StL

You Ought to Be Ashamed of Yourself
For *The Wonderful Wizard of Oz,* 1900
Ink over pencil on paper, 19⅞ x 14 inches
Prints Division, The New York Public Library; Astor, Lenox and Tilden
 Foundations (Fig. 127) NY

DETROIT PUBLISHING COMPANY

The Flatiron Building Being Built, c. 1902
Modern print made from original glass negative, 10 x 8 inches
Courtesy of the Library of Congress, Washington, D.C. (Fig. 192)
The Flatiron Building, n.d.
Modern print made from original glass negative, 10 x 8 inches
Courtesy of the Library of Congress, Washington, D.C. (Fig. 193)

THOMAS DEWING (1851–1938)

The Garland, 1899
Oil on canvas, 31½ x 42¼ inches
Clyde M. Newhouse and Newhouse Galleries, New York (Fig. 78)
Venetian Brocade, c. 1905
Oil on canvas, 20 x 25 inches
Washington University Gallery of Art, St. Louis (Fig. 79)
Dancing Girl, n.d.
Pastel on paper, 10¼ x 7 inches (sight)
Collection of Mrs. Fred S. Walter

FREDERICK DIELMAN (1847–1935)

Girl with Wreath, 1902
Watercolor on paper, 14 x 12 inches
Hirschl and Adler Galleries, New York (Fig. 7)

GUS DIRKS (1879–1901)

The Latest News from Bugsville, c. 1900
Ink and watercolor on paper, 12¾ x 21¼ inches
Graham Gallery, New York (Fig. 106)

L. MAYNARD DIXON (1875–1946)

Overland for August, 1896
Color lithograph, 17¼ x 11 inches (sheet)
Columbia University, New York; Engel Collection, Rare Book and
 Manuscript Library (Fig. 69)

ARTHUR G. DOVE (1880–1946)
And Reached Over and Just Tetched That Bill
For *Century Magazine*, April 1907
Ink on paper, 22⅜ x 17¼ inches (sheet)
Free Library of Philadelphia

ARTHUR W. DOW (1857–1922)
Modern Art, 1895
Color lithograph, 18⅞ x 14⅝ inches (sheet)
Columbia University, New York; Engel Collection, Rare Book and
 Manuscript Library (Fig. 67)

THOMAS EAKINS (1844–1916)
The Cello Player, 1896
Oil on canvas, 64⅛ x 48⅛ inches
Pennsylvania Academy of the Fine Arts, Philadelphia (Fig. 30)
 NY, StL

Salutat, 1898
Oil on canvas, 49½ x 39½ inches
Addison Gallery of American Art, Phillips Academy, Andover, Mas-
 sachusetts (Fig. 19) *NY*

Portrait of Henry O. Tanner, c. 1902
Oil on canvas, 24¹¹⁄₁₆ x 20⅛ inches
The Hyde Collection, Glens Falls, New York (Fig. 32)

THOMAS EAKINS (attributed)
Walt Whitman, n.d.
Silver print, 4¾ x 3⅞ inches
Philadelphia Museum of Art; Bequest of Mark Lutz (Fig. 149)

CHARLES WARREN EATON (1857–1937)
The Strip of Pines, 1908
Oil on canvas, 30 x 36 inches
Montclair Art Museum, Montclair, New Jersey

SAMUEL D. EHRHART (UNKNOWN)
Fowl Play (Caught with the Goods), c. 1900
Ink on paper, 12½ x 10½ inches
Collection of Mr. and Mrs. Benjamin Eisenstat *StL, S, O*

RUDOLPH EICKEMEYER, JR. (1862–1932)
Two Boys, 1906
Platinum print, 9⁵⁄₁₆ x 5⅛ inches
Hudson River Museum, Yonkers, New York (Fig. 139)

FRANK EUGENE (1865–1936)
Alfred Stieglitz
From *Camera Work*, no. 25, January 1909
Photogravure, 7 x 5 inches (image)
The Museum of Modern Art, New York; Gift of Edward Steichen
 (Fig. 156)

Princess Rupprecht and Her Children
From *Camera Work*, no. 30, April 1910
Photogravure, 6⅞ x 4¾ inches (image)
Philadelphia Museum of Art; Gift of Carl Zigrosser (Fig. 159)

ARTHUR BURDETT FROST (1851–1928)
The Monroe Doctrine, 1904
Gouache on paper, 17¾ x 24½ inches
New Jersey State Museum, Trenton (Fig. 125)

ARNOLD GENTHE (1896–1942)
Shop in Chinatown, 1896–1906
Photograph, 10⅜ x 13⅛ inches
The Museum of Modern Art, New York; Gift of Albert M. Bender, 1940
 (Fig. 165)

CHARLES DANA GIBSON (1868–1944)
Grandma Takes the Baby to the Photographers, 1904
Ink on paper, 19 x 28¾ inches
Library of Congress, Washington, D.C. (Fig. 96) *NY*

The Artist's Studio, n.d.
Ink on paper, 22 x 16 inches
Collection of Joel S. Post (Fig. 108)

CHARLES ALLAN GILBERT (1873–1929)
Wellesley College: Scribner's May, 1898
Color lithograph, 22½ x 13¾ inches (sheet)
Columbia University, New York; Engel Collection, Rare Book and
 Manuscript Library (Fig. 61)

FREDERICK VICTOR GILLAM (?–1920)
The Pig
From *Judge*, 1903
Chromolithograph, 11 x 18 inches
Collection of Mr. and Mrs. Benjamin Eisenstat (Fig. 91)

The Politicians' Easter Vision
From *Judge*, 1904
Chromolithograph, 20 x 13½ inches
Ben and Beatrice Goldstein Foundation, New York *StL, S, O*

LOUIS M. GLACKENS (1866–1933)
In the German Jam Closet
For *Puck*, November 30, 1908
India ink and colored pencil on paper, 15¾ x 14 inches
Free Library of Philadelphia (Fig. 104)

WILLIAM J. GLACKENS (1870–1938)
Scribner's Fiction Number, n.d.
Color lithograph, 21¾ x 14⅜ inches (sheet)
Columbia University, New York; Engel Collection, Rare Book and
 Manuscript Library

The Charge at El Caney
For *McClure's Magazine*, October 1898
Ink, wash and Chinese white on paper; 17 x 13¼ inches
Collection of Victor D. Spark (Fig. 111)

Hammerstein's Roof Garden, c. 1903
Oil on canvas, 30 x 25 inches
Whitney Museum of American Art, New York (Fig. 209)

Chez Mouquin, 1905
Oil on canvas, 48³/₁₆ x 36¼ inches
The Art Institute of Chicago; Friends of American Art Collection
(Pl. VIII) *NY*

Central Park: Winter, c. 1905
Oil on canvas, 25 x 30 inches
The Metropolitan Museum of Art, New York; George A. Hearn Fund,
1921 (Fig. 201)

The Boxing Match, 1906
Black wash heightened with white on paper; 13½ x 10½ inches
Collection of Arthur G. Altschul

ALICE GLENNY (1858–?)
Womens Edition (Buffalo) Courier, c. 1895
Color lithograph, 27½ x 18⅛ inches (sheet)
Columbia University, New York; Engel Collection, Rare Book and
Manuscript Libary (Fig. 63)

RUBE GOLDBERG (1883–1970)
Spring Sale of European Nobles, 1909
Ink on paper, 9¼ x 23½ inches
Whitney Museum of American Art, New York; Gift of Mrs. Rube
Goldberg

J. J. GOULD (UNKNOWN)
Lippincott's April, 1897
Color lithograph, 16¼ x 13⅛ inches (sheet)
Columbia University, New York; Engel Collection, Rare Book and
Manuscript Library (Pl. IV)

Cover Design
For *The Book Buyer*, 1900
Ink, wash and gouache on illustration board; 9 x 9¼ inches
Cooper-Hewitt Museum of Decorative Arts and Design, Smithsonian
Institution, New York

ELIZABETH SHIPPEN GREEN (1871–1954)
He Knew That He Was Not Dreaming
For *Harper's Monthly Magazine*, August 1907
Charcoal and watercolor on illustration board, 13 x 14⅝ inches (image)
Library of Congress, Washington, D.C. (Fig. 121) *NY*

LILIAN WESTCOTT HALE (1881–1963)
L'Edition de Luxe, 1910
Pastel on canvas, 23 x 15 inches
Museum of Fine Arts, Boston; Gift of Miss Mary C. Wheelwright
(Fig. 83) *NY*

PHILIP LESLIE HALE (1865–1931)
Portrait of a Woman, c. 1900
Silverpoint on paper, 14⅞ x 10 inches (sheet)
Cooper-Hewitt Museum of Decorative Arts and Design, Smithsonian
Institution, New York

JAY HAMBIDGE (1867–1924)
*Christmas on the East Side—A Prayer of Thanksgiving That He Lives in a Free
Country*
For *Century Magazine*, December 1897
Ink and white gouache on paper, 26⅛ x 17¼ inches (sheet)
Free Library of Philadelphia (Fig. 113)

BIRGE HARRISON (1854–1929)
Fifth Avenue at Twilight, n.d.
Oil on canvas, 30 x 23 inches
The Detroit Institute of Arts; City Appropriation (Fig. 199)

FREDERICK CHILDE HASSAM (1859–1935)
Isle of Shoals, Celia Thaxter's Living Room, 1892
Watercolor on paper, 15¾ x 12¾ inches
Collection of Mr. and Mrs. Ralph Spencer (Fig. 41) *NY, StL*

Winter Scene in New York, 1900
Oil on canvas, 23 x 19 inches
Museum of the City of New York (Fig. 75) *NY*

The Hovel and the Skyscraper, 1904
Oil on canvas, 35 x 31 inches
Collection of Mr. and Mrs. Meyer P. Potamkin *NY*

FRANK HAZENPLUG (1873–?)
The Chap-Book, n.d.
Color lithograph, 13½ x 8 inches
Achenbach Foundation for Graphic Arts, The Fine Arts Museums of
San Francisco; Gift of the Arthur W. Barney Estate

ROBERT HENRI (1865–1929)
Laughing Child, 1907
Oil on canvas, 24 x 20 inches
Whitney Museum of American Art, New York (Fig. 210)

LEWIS HINE (1874–1940)
German Family, Ellis Island, 1908
Photograph, 5 x 7 inches
Collection of Naomi and Walter Rosenblum

Jewish Immigrant, Ellis Island, 1905
Photograph, 10 x 8 inches
Collection of Naomi and Walter Rosenblum

Slovak at Ellis Island, 1904
Photograph, 6⅜ x 4⅝ inches
Collection of Naomi and Walter Rosenblum (Fig. 178)

Steelworkers at the Russian Boarding House, Homestead, Pennsylvania,
1907–08
Photograph, 4½ x 6½ inches
Collection of Naomi and Walter Rosenblum

Railroad Yards Near Pittsburgh, 1907–08
Photograph, 5 x 7 inches
Collection of Naomi and Walter Rosenblum (Fig. 174)

Washing Up in a Small Steel Mill, Pittsburgh, 1907–08
Photograph, 5 x 7 inches
Collection of Naomi and Walter Rosenblum (Fig. 173)

Making Flowers in a Slum Workshop, 1908
Photograph, 7½ x 9½ inches
Collection of Naomi and Walter Rosenblum

Painting Glassware, c. 1910
Photograph, 5 x 7 inches
Collection of Naomi and Walter Rosenblum (Fig. 176)

Workers at Warren, Rhode Island, Manufacturing Company, June 1909
Modern print made from original negative in
 the Library of Congress, 8 x 10 inches
Collection of Naomi and Walter Rosenblum (Fig. 177)

Child Mill Worker, South Carolina Mill, 1908
Photograph, 7⅝ x 9⅜ inches
Collection of Naomi and Walter Rosenblum (Fig. 179)

WINSLOW HOMER (1836-1910)

Coast in Winter, 1892
Oil on canvas, 28⅜ x 48⅜ inches
Worcester Art Museum, Worcester, Massachusetts; Theodore T. and
 Mary G. Ellis Collection (Fig. 17) *NY*

The Lookout—"All's Well," 1896
Oil on canvas, 40 x 30¼ inches
Museum of Fine Arts, Boston; William Wilkins Warren Fund
 (Fig. 18)

Shore and Surf, Nassau, n.d.
Watercolor on paper, 15 x 21⅜ inches
The Metropolitan Museum of Art, New York; Purchase, Amelia B.
 Lazarus Fund, 1910 (Fig. 42) *NY*

The Wrecked Schooner, (1903?)
Watercolor on paper, 15¼ x 21⅞ inches
The St. Louis Art Museum *StL, S, O*

GEORGE INNESS (1825-1894)

In the Valley, 1893
Oil on canvas, 24 x 36¼ inches
The Art Institute of Chicago; Edward B. Butler Collection
 (Fig. 11) *NY*

FRANCES B. JOHNSTON (1864-1952)

Agriculture. Butter Making, 1899-1900
From *The Hampton Album*
Platinum print, 7½ x 9½ inches
The Museum of Modern Art, New York; Gift of Lincoln Kirstein,
 1965 (Fig. 172)

A Hampton Graduate's Home, 1899-1900
From *The Hampton Album*
Platinum print, 5½ x 9½ inches
The Museum of Modern Art, New York; Gift of Lincoln Kirstein,
 1965 (Fig. 171)

Female Workers Posing with Mrs. Graham, 1910
Photograph, 9½ x 7⅝ inches
Library of Congress, Washington, D.C. *NY*

Mrs. Graham Standing Beside a Large Stack of Logs, 1910
Photograph, 7¾ x 9½ inches
Library of Congress, Washington, D.C. *NY*

GERTRUDE KÄSEBIER (1852-1934)

Joe Black Fox, a Sioux Indian from Buffalo Bill's Wild West Show, c.
 1895-1905
Platinum print, 8 x 6⅛ inches
Robert Schoelkopf Gallery, New York (Fig. 147)

*Rose O'Neill: Illustrator and Originator of the "Kewpie" Doll, Posed in the
 Photographer's New York City Studio,* 1900
Platinum print, 8 x 6 inches
International Museum of Photography at George Eastman House,
 Rochester, New York (Fig. 154)

Baron de Meyer, 1901
Platinum print, 4¾ x 7½ inches
The Museum of Modern Art, New York; Gift of Mrs. Hermine M.
 Turner, 1963

Evelyn Nesbit, c. 1903
Gelatin silver print, 8⅛ x 6⅛ inches
International Museum of Photography at George Eastman House,
 Rochester, New York (Fig. 153)

Mrs. Beatrice Baxter Ruyl and Infant, 1905
Platinum print, 7¼ x 9⅝ inches
The Museum of Modern Art, New York; Gift of Mrs. Hermine M.
 Turner (Fig. 138)

Joan Sloan, 1907
Photograph, 8⅛ x 6¼ inches (sight)
Collection of Mrs. John Sloan (Fig. 158)

Portrait of F. Holland Day, n.d.
Platinum print, 4¾ x 4¾ inches
The Museum of Modern Art, New York; Gift of Miss Mina Turner
 (Fig. 155)

Robert Henri, n.d.
Gum-bichromate print, 12¹³/₁₆ x 9¼ inches
The Museum of Modern Art, New York; Gift of Hermine M.
 Turner, 1963 (Fig. 157)

JOSEPH T. KEILEY (1869-1914)

Portrait: Miss DeC., 1908
Platinum print, 3¼ x 4⅜ inches
The Metropolitan Museum of Art, New York; Alfred Stieglitz
 Collection (Fig. 140) *NY*

EDWARD W. KEMBLE (1861-1933)

Cold Weather at the Zoo: Cast Off Clothing Thankfully Received, c. 1900
Ink on paper, 14¼ x 11 inches
Collection of Mr. and Mrs. Benjamin Eisenstat (Fig. 124)

JOSEPH KEPPLER (1838–1894)

The Same Old Act
For *Puck,* November 12, 1890
Hand-colored lithographic proof, 13⅜ x 10⅛ inches
Prints Division, The New York Public Library; Astor, Lenox and
 Tilden Foundations (Fig. 88) *NY*

Beneficence Welcoming People to Chicago Exposition of 1893, c. 1893
Hand-colored lithographic proof, 12⅛ x 17¼ inches
Prints Division, The New York Public Library; Astor, Lenox and
 Tilden Foundations *StL*

*Figures Around French's Statue of the Republic at the Chicago Exposition of
 1893,* c. 1893
Hand-colored lithographic proof, 19⁵/₁₆ x 12⅝ inches
Prints Division, The New York Public Library; Astor, Lenox and
 Tilden Foundations *O*

Looking Backward
For *Puck*, January 11, 1893
Hand-colored lithographic proof, 13⅜ x 19⅞ inches
Prints Division, The New York Public Library; Astor, Lenox and
 Tilden Foundation (Fig. 92) *NY*

Cover Design, Chicago Souvenir Number, c. 1893
Watercolor over pencil on paper, 14½ x 10½ inches
Prints Division, The New York Public Library; Astor, Lenox and
 Tilden Foundations *S*

Puck World's Fair Souvenir (Cover Design), 1893
Watercolor over pencil on paper, 14⅜ x 10½ inches
Prints Division, The New York Public Library; Astor, Lenox and
 Tilden Foundations (Fig. 107) *NY*

JOSEPH KEPPLER, JR. (1872–1956)
Time Nearly Up
From *Puck*, October 13, 1897
Chromolithograph, 13½ x 10 inches
Ben and Beatrice Goldstein Foundation, New York

JOHN LA FARGE (1835–1910)
Figure of Welcome, n.d.
Watercolor on paper, 13¾ x 10¾ inches
The Metropolitan Museum of Art, New York; Anonymous gift, 1944
 StL

Wheel of Fortune, n.d.
Watercolor on paper, 15¾ x 12⅜ inches
The Metropolitan Museum of Art, New York; gift of Susan Dwight
 Bliss, 1966 *NY*

ERNEST LAWSON (1873–1939)
Winter on the River, 1907
Oil on canvas, 33 x 40 inches
Whitney Museum of American Art, New York (Fig. 214)

JOSEPH C. LEYENDECKER (1874–1951)
An Easter Design, c. 1905
Gouache on illustration board, 17 x 17 inches
Collection of Mr. and Mrs. Benjamin Eisenstat

The August Century Midsummer Holiday Number, 1896
Color lithograph, 21¼ x 16 inches
Columbia University, New York; Engel Collection, Rare Book and
 Manuscript Library (Fig. 64)

WILL HICOK LOW (1853–1932)
Scribner's Fiction Number, c. 1895
Color lithograph, 21¾ x 14 inches (sheet)
Columbia University, New York; Engel Collection, Rare Book and
 Manuscript Library (Fig. 65)

L'Interlude, Jardin de MacMonnies, n.d.
Oil on canvas, 19¼ x 25 ½ inches
University of Virginia Art Museum, Charlottesville (Fig. 4)

GEORGE LUKS (1867–1933)
*Hanna: That Man Clay Was an Ass! It's Better to Be President Than to Be
 Right!*
From *The Verdict*, March 13, 1899
Lithograph, 12⁷⁄₁₆ x 9½ inches
Research Libraries, University of California at Los Angeles

The Spielers, 1905
Oil on canvas, 36 x 26 inches
Addison Gallery of American Art, Phillips Academy, Andover,
 Massachusetts (Fig. 211) *NY*

Roundhouses at Highbridge, 1909–10
Oil on canvas, 30⅜ x 36⅛ inches
Munson-Williams-Proctor Institute, Utica, New York (Fig. 188)

FLORENCE LUNDBORG (1871–1949)
The Lark: August, 1896
Woodcut, 16 x 12⅞ inches (sheet)
Columbia University, New York; Engel Collection, Rare Book and
 Manuscript Library (Fig. 53)

HENRY McCARTER (1865–1943)
New England Beach, c. 1900
Gouache on paper, 20 x 12½ inches
Collection of Mr. and Mrs. Benjamin Eisenstat

WINSOR McCAY (1869–1934)
Little Sammy Sneeze (At the Depot), c. 1907
Trial proof color lithograph, 10½ x 16⅛ inches (sheet)
Collection of Ray Winsor Moniz
Little Sammy Sneeze (At the Depot), c. 1907
Ink on paper, 12⅜ x 21¼ inches (sheet)
Collection of Ray Winsor Moniz
Little Nemo in Slumberland (Slide Down the Banister), 1909
Ink on paper, 28½ x 22½ inches (sheet)
Collection of Ray Winsor Moniz (Fig. 87)

BLANCHE McMANUS (1870–?)
The True Mother Goose, 1895
Color lithograph, 20⅝ x 14⅜ inches (sheet)
Columbia University, New York; Engel Collection, Rare Book and
 Manuscript Library (Fig. 57)

MARY L. MACOMBER (1861–1916)
St. Catherine, 1896
Oil on canvas, 34½ x 24 inches
Museum of Fine Arts, Boston; Gift of the Artist (Fig. 6) *NY*

JOHN MARIN (1870–1953)
Bridge Over Canal, Amsterdam, 1906
Etching (first state), 6 x 7½ inches
The Metropolitan Museum of Art, New York; Alfred Stieglitz
 Collection
Bridge Over Canal, Amsterdam, 1906
Etching (second state), 6 x 7½ inches
The Metropolitan Museum of Art, New York; Alfred Stieglitz
 Collection (Fig. 45)

ARTHUR F. MATHEWS (1860–1945)
Monterey Cypress, 1905
Oil on canvas, 48 x 52 inches
The Oakland Museum; Gift of Concours d'Antiques, Art Guild, The
 Oakland Museum Association (Fig. 14)

LUCIA K. MATHEWS (1870–1955)
Apricots No. 3, 1908
Pastel on gray paper, 20⅞ x 13¾ inches
The Oakland Museum; Gift of Mr. Harold Wagner (Fig. 40)

ALFRED H. MAURER (1868–1932)
An Arrangement, 1901
Oil on cardboard, 36 x 31¾ inches
Whitney Museum of American Art, New York; Gift of Mr. and Mrs.
 Hudson D. Walker (Fig. 24)

LOUIS MAURER (1832–1932)
A Still Life on the Theme Trilby, n.d.
Oil on canvas, 19 x 28 inches
Corcoran Gallery of Art, Washington, D.C.

GEORGE WILLOUGHBY MAYNARD (1843–1923)
Civilization, c. 1893
Oil on canvas, 54¼ x 36 inches
National Academy of Design, New York (Fig. 1)

WILLARD LEROY METCALF (1858–1925)
The First Snow, 1906
Oil on canvas, 26 x 29 inches
Museum of Fine Arts, Boston; Bequest of Ernest Wadsworth Long-
 fellow (Fig. 76) *S, O*

Red Bridge, n.d.
Oil on canvas, 26½ x 29½ inches
Collection of Mr. and Mrs. Ralph Spencer *NY, StL*

HARRY SIDDONS MOWBRAY (1858–1928)
The Destiny, 1896
Oil on canvas, 30 x 40½ inches
Hirschl and Adler Galleries, New York (Fig. 5)

FRANK A. NANKIVELL (1869–1959)
Theodore Roosevelt and Diaz
For *Puck*, October 18, 1910
India ink, pencil and tempera on paper; 22⅝ x 19¹/₁₆ inches
Free Library of Philadelphia (Fig. 99)

VIOLET OAKLEY (1874–1961)
Lenten Cover
For *Collier's*, 1899
Charcoal on illustration board, 17 x 14½ inches
Collection of Mr. and Mrs. Benjamin Eisenstat

ROSE O'NEILL (1875–1944)
Popularity à la Mode
For *Puck*, June 26, 1901
Ink on paper, 21½ x 15⅛ inches
Collection of Mrs. John Sloan (Fig. 120)

The Very Little Person, 1909
Ink on paper, 14½ x 20 inches
Collection of Walt Reed

FREDERICK BURR OPPER (1857–1937)
We Are the People—The Great Popularity of Americans, c. 1890
For *Puck*, March 19, 1890
Ink on paper, 14 x 12½ inches
Collection of Mr. and Mrs. Benjamin Eisenstat

RICHARD FELTON OUTCAULT (1863–1928)
Yellow Kid, 1896
Ink over pencil on paper, 10¹¹/₁₆ x 7⁹/₁₆ inches
Prints Division, The New York Public Library; Astor, Lenox and Tilden
 Foundations (Fig. 105) *NY*

MAXFIELD PARRISH (1870–1966)
The Century Midsummer Holiday Number. August., 1896
Color lithograph, 19⅞ x 13⅜ inches (sheet)
Columbia University, New York; Engel Collection, Rare Book and
 Manuscript Library (Fig. 62)

Scribner's Fiction Number. August, 1897
Color lithograph, 19⅞ x 14½ inches
Museum of Fine Arts, Boston *NY, StL, S*

WILLIAM McGREGOR PAXTON (1869–1941)
The Housemaid, 1910
Oil on canvas, 30¼ x 25⅛ inches
Corcoran Gallery of Art, Washington, D.C.

EDWARD PENFIELD (1866–1925)
Harper's May, 1896
Mixed media on paper, 22 x 12¾ inches
Collection of Jane Penfield

Harper's May, 1896
Color lithograph, 17¾ x 12 inches
Collection of Jane Penfield

Harper's August, 1896
Color lithograph, 18⅝ x 13⅝ inches (sheet)
Columbia University, New York; Engel Collection, Rare Book and
 Manuscript Library

Harper's May, 1897
Color lithograph, 18⅛ x 13¼ inches (sheet)
Columbia University, New York; Engel Collection, Rare Book and
 Manuscript Library (Fig. 60)

Harper's July, 1898
Color lithograph, 10 x 12¹¹/₁₆ inches
Delaware Art Museum, Wilmington; Gift of Walker Penfield (Fig. 59)

JOSEPH PENNELL (1860–1926)
From Cortlandt Street Ferry, 1908
Etching, 13 x 9¾ inches
The Metropolitan Museum of Art, New York; Harris Brisbane Dick
 Fund, 1917 (Fig. 195)

LILLA CABOT PERRY (1848–1933)
Landscape in Normandy, 1891
Oil on canvas, 18 x 22 inches
Collection of Mrs. Diana Bonnor Lewis (Fig. 72)

MAURICE PRENDERGAST (1859–1924)
The Shadow of a Crime, 1895
Lithograph, 14½ x 10½ inches
Delaware Art Museum, Wilmington; Gift of Mrs. John Sloan

Central Park, 1901
Watercolor on paper, 14⅜ x 21½ inches
Whitney Museum of American Art, New York (Pl. III)

Madison Square, 1901
Watercolor on paper, 15 x 16½ inches
Whitney Museum of American Art, New York; Bequest of Joan
 Whitney Payson (Fig. 215)

JOHN S. PUGHE (1870–1909)
Down in Chickentown
For *Puck,* February 1900
Ink on paper, 10 x 21¼ inches (sight)
Collection of Mr. and Mrs. Benjamin Eisenstat (Fig. 126)

HOWARD PYLE (1853–1911)
Fishing of Thor and Hymer, c. 1901
Watercolor on paper, 7¾ x 4⅛ inches
Delaware Art Museum, Wilmington (Fig. 116)

Sir Kay Interrupts Ye Meditations of Sir Percival, c. 1903
Ink on paper, 9¼ x 6¼ inches
Delaware Art Museum, Wilmington (Fig. 117)

He Watched Me as a Cat Watches a Mouse, c. 1909
Oil on canvas, 26½ x 17¼ inches
Delaware Art Museum, Wilmington

WILLIAM RAU (UNKNOWN)
Main Line Along the Susquehanna Near Steelton #6, 1890s
Photograph, 17¼ x 21¼ inches (image)
Collection of Samuel J. Wagstaff (Fig. 185)

Stone Bridge at Coatesville #2, 1890s
Photograph, 17⅛ x 21⅜ inches (image)
Collection of Samuel J. Wagstaff

The Susquehanna West of Steelton #5, 1890s
Photograph, 17¼ x 21¼ inches (image)
Collection of Samuel J. Wagstaff (Fig. 186)

EDWARD WILLIS REDFIELD (1869–1965)
Hillside at Center Bridge, 1904
Oil on canvas, 36 x 50 inches
The Art Institute of Chicago; W. Moses Willner Fund (Fig. 16)

ETHEL REED (1878–?)
Folly or Saintliness, 1895
Color lithograph, 18⅝ x 13¾ inches
Achenbach Foundation for Graphic Arts, The Fine Arts Museums of
 San Francisco; Gift of the Arthur W. Barney Estate (Fig. 56)

Pierre Puvis de Chavannes—A Sketch, before 1896
Color lithograph, 22 x 15½ inches
Museum of Fine Arts, Boston; Gift of L. Prang & Co. *NY, StL, S*

ROBERT REID (1862–1929)
The Mirror, c. 1910
Oil on canvas, 37⅞ x 30⅜ inches
National Collection of Fine Arts, Smithsonian Institution, Washington,
 D.C.; Gift of William T. Evans (Fig. 80)

FREDERIC REMINGTON (1861–1909)
Picket Line, Tampa, Florida, 1898
Ink and wash on paper, 22 x 28 inches
Graham Gallery, New York (Fig. 114)

LOUIS J. RHEAD (1857–1926)
Meadow-Grass, 1895
Color lithograph, 17 x 10 inches (sheet)
Columbia University, New York; Engel Collection, Rare Book and
 Manuscript Library

Scribner's for Xmas, 1895
Color lithograph, 18⅝ x 14 inches
Achenbach Foundation for Graphic Arts, The Fine Arts Museums of
 San Francisco; Gift of the Arthur W. Barney Estate

Prang's Easter Publications, 1896
Color lithograph, 24 x 17 inches
Museum of Fine Arts, Boston; Gift of L. Prang & Co. (Fig. 55)
 NY, StL, S

JACOB RIIS (1849–1914)
Iroquois Indians at 511 Broome Street, early 1890s
Print made by Alexander Alland from original negative, 4 x 5 inches
Museum of the City of New York (Fig. 180)

What the Boys Learn There, early 1890s
Print made by Alexander Alland from original negative, 4 x 5 inches
Museum of the City of New York (Fig. 182)

Ready for the Sabbath Eve in a Coal Cellar on Ludlow Street, 1895
Print made by Alexander Alland from original negative, 4 x 5 inches
Museum of the City of New York (Fig. 181)

Hester Street, the School Children's Only Playground, n.d.
Print made by Alexander Alland from original negative, 4 x 5 inches
Museum of the City of New York

Minding the Baby, Cherry Hill, n.d.
Print made by Alexander Alland from original negative, 4 x 5 inches
Museum of the City of New York (Fig. 183)

Night School, n.d.
Print made by Alexander Alland from original negative, 4 x 5 inches
Museum of the City of New York

Sweat Shop in Ludlow Street Tenement, n.d.
Print made by Alexander Alland from original negative, 4 x 5 inches
Museum of the City of New York

Typhus Lodger in an East Side Police Station, n.d.
Photograph, 4½ x 5¼ inches
Museum of the City of New York

FRANK A. RINEHART (?-1929)
Sioux—Little Sunday, Eagle Elk, Prairie Dog, 1898
Platinum print, 7¹/₁₆ x 9¼ inches (image)
The Witkin Gallery, Inc., New York (Fig. 168)

THEODORE ROBINSON (1852-1896)
A Normandy Mill, 1892
Watercolor on board, 9⅞ x 15 inches
Collection of Mr. and Mrs. Raymond J. Horowitz *NY*

Evening at the Lock, 1893
Oil on canvas, 21¾ x 32 inches
Piedmont Driving Club, Atlanta, (Fig. 71)

Columbian Exposition, 1894
Oil on canvas, 25 x 30 inches
Collection of Jeffrey R. Brown (Pl. V)

WILLIAM ALLEN ROGERS (1854-1931)
Brooklyn's Peril
For the New York *Herald,* October 14, 1903
Ink on paper, 15¹/₁₆ x 20½ inches (sheet)
Prints Division, The New York Public Library; Astor, Lenox and Tilden
 Foundations *NY*

The Upheaval
For *Harper's Weekly,* February 4, 1905
Ink on paper, 16⅝ x 14½ inches (sheet)
Prints Division, The New York Public Library; Astor, Lenox and Tilden
 Foundations (Fig. 103) *NY*

I'll Sweep Your Streets if No One Else Will
For the New York *Herald,* December 27, 1906
Ink on paper, 15¹¹/₁₆ x 19⅞ inches (sheet)
Prints Division, The New York Public Library; Astor, Lenox and Tilden
 Foundations (Fig. 102) *NY*

He Doesn't Study Us: He Only Hunts Us
For the New York *Herald,* May 25, 1907
Ink on paper, 15 x 19¾ inches (sheet)
Prints Division, The New York Public Library; Astor, Lenox and Tilden
 Foundations (Fig. 100) *NY*

It Was a Merry Jest, 1907
Ink on paper, 10½ x 13½ inches
Graham Gallery, New York *StL, S, O*

JOHN SINGER SARGENT (1856-1925)
Male Model Resting, 1890s
Oil on canvas, 22 x 28 inches
The Forbes Magazine Collection, New York (Fig. 20)

Study of a Young Man Seated, 1895
Lithograph, 11⁹/₁₆ x 9⁹/₁₆ inches
The Metropolitan Museum of Art, New York; Gift of Mrs. Francis
 Ormond, 1950 (Fig. 51)

Henry G. Marquand, 1897
Oil on canvas, 52 x 41¾ inches
The Metropolitan Museum of Art, New York; Gift of the Trustees,
 1897 (Fig. 26) *S, O*

Mr. and Mrs. Isaac Newton Phelps Stokes, 1897
Oil on canvas, 84¼ x 39¾ inches
The Metropolitan Museum of Art, New York; Bequest of Edith
 Minturn Phelps Stokes, 1938 (Fig. 28) *NY*

Joseph Pulitzer, 1905
Oil on canvas, 38½ x 28 inches
Collection of Joseph Pulitzer, III (Fig. 27) *NY, StL*

Garden Near Lucca, n.d.
Watercolor on paper, 14 x 10 inches
The Metropolitan Museum of Art, New York; Gift of Mrs. Francis
 Ormond, 1950 *O*

Italian Model, n.d.
Watercolor on paper, 14½ x 22½ inches
The Metropolitan Museum of Art, New York; Gift of Mrs. Francis
 Ormond, 1950 *S*

Figure with Red Drapery, n.d.
Watercolor on paper, 14½ x 21³/₁₆ inches
The Metropolitan Museum of Art, New York; Gift of Mrs. Francis
 Ormond, 1950 (Fig. 43) *NY*

W. ELMER SCHOFIELD (1867-1944)
Winter, c. 1899
Oil on canvas, 29½ x 36 inches
Pennsylvania Academy of the Fine Arts, Philadelphia (Fig. 15)

EVA WATSON SCHÜTZE (1867-1935)
Woman in a Velvet Dress, 1905
Platinum print, 8 x 4⅝ inches
Collection of Paul F. Walter (Fig. 132)

ADDISON SCURLOCK (1883-1964)
Grant's Rear Guard, c. 1905
Modern print made by the photographer's grandson, Robert Scurlock,
 from original negative, 8 x 10 inches
Courtesy of Scurlock Studios, Washington, D.C. (Fig. 161)

GEORGE SEELEY (1880-1965)
Autumn
From *Camera Work,* no. 29, January 1910
Photogravure, 8 x 6⅜ inches
Philadelphia Museum of Art; Gift of Carl Zigrosser (Fig. 142)

EVERETT SHINN (1876-1953)
Sixth Avenue Elevated After Midnight, 1899
Pastel on paper, 8 x 12⅜ inches
Collection of Arthur G. Altschul (Fig. 203)

Lunch Wagon, Madison Square, 1904
Pastel on paper, 8½ x 13 inches
Collection of Arthur G. Altschul (Fig. 202)

The Orchestra Pit, Old Proctor's Fifth Avenue Theatre, c. 1906–07
Oil on canvas, 17⁷⁄₁₆ x 19½ inches
Collection of Arthur G. Altschul (Pl. VII)

Revue, 1908
Oil on canvas, 18 x 24 inches
Whitney Museum of American Art, New York

FLORENCE SCOVELL SHINN (1869?–1940)
On the Fences and Walls Throughout Ohio from *Mr. Perkins of Portland,*
1899
Ink on paper, 16¼ x 14½ inches
Free Library of Philadelphia (Fig. 123)

JOHN SLOAN (1871–1951)
On the Court at Wissahickon Heights, 1892
For the Philadelphia *Inquirer*
Ink on paper, 9¾ x 6⅝ inches
Collection of Mrs. John Sloan (Fig. 129)

On the Court at Wissahickon Heights
From the Philadelphia *Inquirer,* 1892
Newspaper reproduction, 6 x 4 inches
Collection of Mrs. John Sloan

She Blew a Ring of Smoke, 1895
Ink on paper, 10½ x 6¾ inches
Collection of Mrs. John Sloan (Fig. 130)

Cinder-Path Tales, 1896
Color lithograph, 23⅜ x 13½ inches (sheet)
Columbia University, New York; Engel Collection, Rare Book and
 Manuscript Library (Fig. 68)

The Schuylkill River, 1900–02
Oil on canvas, 24 x 32 inches
Kraushaar Galleries, New York (Fig. 189)

Don't You Want the Umbrella?
For *The Steady,* 1904
Crayon on paper, 18 x 12 inches
Collection of Mrs. John Sloan (Fig. 131)

Fun, One Cent, 1905
Etching, 4¾ x 6¾ inches (plate)
Whitney Museum of American Art, New York (Fig. 206)

Turning Out the Light, 1905
Etching, 4¾ x 6¹³⁄₁₆ inches (plate)
Whitney Museum of American Art, New York (Fig. 207)

The Women's Page, 1905
Etching, 4⁹⁄₁₆ x 6¾ inches (plate)
Whitney Museum of American Art, New York

Roofs, Summer Night, 1906
Etching, 5¼ x 6¹⁵⁄₁₆ inches (plate)
Whitney Museum of American Art, New York

The Picnic Grounds, 1906/07
Oil on canvas, 24 x 36 inches
Whitney Museum of American Art, New York (Frontispiece)

Election Night in Herald Square, 1907
Oil on canvas, 25⅜ x 31¾ inches
Memorial Art Gallery of the University of Rochester, New York;
 R.T. Miller, Jr., Fund (Fig. 212)

Copyist at the Metropolitan Museum, 1908
Etching, 7⁵⁄₁₆ x 8¹³⁄₁₆ inches (plate)
Whitney Museum of American Art, New York

Night Windows, 1910
Etching, 5⅛ x 6¹³⁄₁₆ inches (plate)
Whitney Museum of American Art, New York (Fig. 208)

JESSIE WILLCOX SMITH (1863–1935)
Mother and Child, c. 1908
Mixed media on paper, 24 x 18 inches
Collection of Mr. and Mrs. Benjamin Eisenstat (Fig. 119)

EDWARD STEICHEN (1879–1973)
J.P. Morgan, 1903
Modern print made by Rolf Petersen from original negative,
 16¾ x 13½ inches
The Museum of Modern Art, New York; Gift of the Photographer,
 1964 (Fig. 150)

Night Landscape, c. 1905
Oil on canvas, 25 x 21 inches
Whitney Museum of American Art, New York; Gift of Mr. and Mrs.
 Ira Spanierman (Fig. 13)

The Pool
From *Camera Work,* no. 2, April 1903
Photogravure, 8 x 6¹⁄₁₆ inches (image)
Ex Libris, New York (Fig. 144)

Self Portrait with Brush and Pencil, 1901
Gum-bichromate print, 8¼ x 6⅜ inches
Collection of Eugene M. Schwartz (Fig. 143) NY

JOSEPH STELLA (1877–1946)
Study for "Three Heads," n.d.
Pastel and chalk on paper, 7¼ x 5½ inches
Collection of David Daniels (Fig. 37)

ALICE BARBER STEPHENS (1858–1932)
Please Wait a Moment
For *McClure's Magazine,* December 1906
Pastel on board, 15⅛ x 17⅛ inches
Library of Congress, Washington, D.C. (Fig. 122) NY

ALFRED STIEGLITZ (1864–1946)
Winter, Fifth Avenue, New York, 1893
Photogravure, 8½ x 6⅛ inches
The Museum of Modern Art, New York; Transferred from the Library
 (Fig. 198)

The Glow of Night, 1897
Photogravure, 4¾ x 9¼ inches
The Museum of Modern Art, New York (Fig. 194)

The Flatiron, 1903
Photogravure, 12⅞ x 6⅝ inches
The Museum of Modern Art, New York; Purchase, 1949 (Fig. 197)

The Street, Design for a Poster
From *Camera Work,* no. 3, July 1903
Photogravure, 7 x 5¼ inches
The Metropolitan Museum of Art, New York; Gift of J.B. Neumann,
 1958 *NY*

Steerage, 1907
From *291,* 1915
Photogravure, 13⅛ x 10⅜ inches (image)
Collection of Robert Mapplethorpe (Fig. 205)

The City of Ambition, 1910
Photogravure, 13⅜ x 10¼ inches
The Museum of Modern Art, New York; Purchase, 1949 (Fig. 196)

ALFRED STIEGLITZ and CLARENCE H. WHITE
Torso, 1907
Platinum print, 9½ x 8¼ inches
The Museum of Modern Art, New York; Extended loan from the
 Estate of Lewis F. White (Fig. 136)

THOMAS S. SULLIVANT (1854–1926)
Hunter and Elephant, c. 1905
Ink on paper, 14 x 22 inches
Graham Gallery, New York

JAMES SWINNERTON (1877–1974)
Little Jimmy (Jimmy—He's a Bird), 1909
Ink and watercolor on paper, 9¼ x 14¾ inches
Collection of Robert C. Graham

HENRY O. TANNER (1859–1937)
Les Invalides, Paris, 1896
Oil on canvas, 13 x 16 inches
Collection of Mrs. Diana Bonnor Lewis (Fig. 74)

Portrait of the Artist's Mother, 1897
Oil on canvas, 29¼ x 39½ inches
Collection of Mrs. Raymond Pace Alexander (Fig. 33) *NY*

Two Disciples at the Tomb, 1906
Oil on canvas, 51 x 41⅞ inches
The Art Institute of Chicago; Robert Waller Fund (Fig. 22) *S, O*

Landscape in Palestine, n.d.
Oil on fabric, 23 x 27¾ inches
Vassar College Art Gallery, Poughkeepsie, New York; Gift of Mrs.
 Walter Driscoll, Mrs. F. Rodman Titcomb and Mrs. Robert J.
 Sivertsen *StL, S, O*

EDMUND CHARLES TARBELL (1862–1938)
Josephine and Mercie, 1908
Oil on canvas, 28¼ x 32¼ inches
Corcoran Gallery of Art, Washington, D.C. (Fig. 84)

Mr. Frick and Daughter Helen, n.d.
Oil on canvas, 31 x 23 inches
National Collection of Fine Arts, Smithsonian Institution, Washington,
 D.C.; Loan from Mrs. John Wilson McLain (Fig. 35)

CHARLES JAY TAYLOR (1855–?)
Another Shotgun Wedding with Neither *Party Willing*
From *Puck,* December 1, 1897
Chromolithograph, 13½ x 10 inches
Ben and Beatrice Goldstein Foundation, New York (Fig. 90)

ABBOTT THAYER (1849–1921)
Roses, 1896
Oil on canvas, 22⅜ x 31⅜ inches
National Collection of Fine Arts, Smithsonian Institution, Washington,
 D.C.; Gift of John Gellatly (Fig. 86)

Young Woman, 1899
Oil on canvas, 39⅝ x 31⅝ inches
The Metropolitan Museum of Art, New York; Gift of George A. Hearn,
 1906 (Fig. 9)

DWIGHT W. TRYON (1849–1925)
Before Sunrise, 1906–07
Oil on canvas, 30 x 40 inches
Washington University Gallery of Art, St. Louis (Fig. 12)

JOHN HENRY TWACHTMAN (1853–1902)
The Damnation of Theron Ware or Illumination, 1895
Color lithograph, 20⅝ x 13½ inches (sheet)
Columbia University, New York; Engel Collection, Rare Book and
 Manuscript Library (Fig. 66)

Winter Harmony, c. 1900
Oil on canvas, 25¾ x 32 inches
National Gallery of Art, Washington, D.C.; Gift of the Avalon
 Foundation (Fig. 77)

Meadow Flowers, c. 1890–1902
Oil on canvas, 33¼ x 22¼ inches
The Brooklyn Museum, New York; Caroline H. Polhemus Fund

JAMES VAN DERZEE (b. 1886)
Blacksmith, Virginia, 1908
Photograph, 8 x 10 inches
The James Van DerZee Institute, Inc., New York (Fig. 175)

Music Teacher and Wife at Whittier, n.d.
Print made from original glass negative, 8 x 10 inches
Courtesy of The James Van DerZee Institute, Inc., New York (Fig. 160)

ELIHU VEDDER (1836–1923)
A Soul in Bondage, 1891
Oil on canvas, 37⅞ x 24 inches
The Brooklyn Museum, New York; Gift of Mrs. Harold G. Henderson
 (Pl. I)

ADAM CLARK VROMAN (1856–1916)
Plaza at Shungopavy, c. 1902
Platinum print, 6 x 8⅛ inches (image)
Collection of Samuel J. Wagstaff (Fig. 167)

Indian Woman and Papoose in Interior, n.d.
Platinum print, 8 x 4¾ inches (image)
Collection of Robert Mapplethorpe

HENRY OLIVER WALKER (1843–1929)
Mrs. William T. Evans and Her Son John H., 1895
Oil on canvas, 36⅛ x 29⅛ inches
National Collection of Fine Arts, Smithsonian Institution, Washington,
 D.C.; Gift of William T. Evans (Fig. 34)

T. DART WALKER (1869–1914)
Harvesting Ice on the Waterways of the Exposition Grounds at Chicago, 1893
Gouache and Chinese white on illustration board; 12⅞ x 19⅜ inches
Anonymous lender (Fig. 110)

Home from Europe—The Customs Ordeal on the Pier, 1894
Gouache, gray wash and Chinese white on illustration board; 13¼ x
 21⅜ inches
Anonymous lender (Fig. 118)

JULIAN ALDEN WEIR (1852–1919)
The Factory Village, 1897
Oil on canvas, 29 x 38 inches
Collection of Mrs. Charles Burlingham (Fig. 70)

JAMES ABBOTT McNEILL WHISTLER (1834–1903)
Fruit Shop, Paris, 1890s
Etching, 5 x 8½ inches (sheet)
Collection of Paul F. Walter (Fig. 46)

Siesta, 1896
Lithograph, 6½ x 8¾ inches (sight)
Collection of Paul F. Walter (Fig. 48)

The Thames, 1896
Lithotint, 10½ x 7⅝ inches
The Metropolitan Museum of Art, New York; Harris Brisbane Dick
 Fund, 1917 (Fig. 44)

CLARENCE H. WHITE (1871–1925)
Blind Man's Bluff, 1898
Platinum print, 7¾ x 5⅞ inches
The Museum of Modern Art, New York

Spring—A Triptych, 1898
Platinum prints; center panel: 16⅛ x 8⅛ inches; side panels, 15 x 2⅜
 inches
The Museum of Modern Art, New York; Mrs. Douglas Auchincloss
 Fund (Fig. 146)

Telegraph Poles, c. 1899
Platinum print, 8 x 4⅜ inches
The Museum of Modern Art, New York; Purchase, 1942

Untitled (Woman on Loveseat), c. 1899
Platinum print, 7¾ x 6 inches
The Museum of Modern Art, New York; Gift of Mr. and Mrs. Clarence
 H. White, Jr., 1976 (Fig. 141)

Winter Landscape, Newark, Ohio, c. 1900
Platinum print, 8⅛ x 6¼ inches
The Museum of Modern Art, New York; Gift of Mrs. and Mrs.
 Clarence H. White, Jr., 1971 (Fig. 145)

Nude (The Mirror), 1909
Platinum print, 9½ x 7⅝ inches
The Museum of Modern Art, New York; Purchase, 1971 (Fig. 135)

N. C. WYETH (1882–1945)
The Hunter, 1906
For *Outing Magazine,* June 1907
Oil on canvas, 40 x 27 inches
Brandywine River Museum, Chadds Ford, Pennsylvania

FREDERICK C. YOHN (1875–1933)
Hurdy Gurdy, c. 1905
Gouache and ink on paper, 17⅜ x 14 inches (sight)
Cooper-Hewitt Museum of Decorative Arts and Design, Smithsonian
 Institution, New York

EUGENE ZIMMERMAN (1862–1935)
At It Again
From *Judge,* September 30, 1905
Chromolithograph, 13¾ x 10 inches
Ben and Beatrice Goldstein Foundation, New York (Fig. 89)

Springing Up Like Mushrooms
From *Judge,* April 15, 1899
Chromolithograph, 13 x 20 inches
Ben and Beatrice Goldstein Foundation, New York

Designed by Joseph Bourke Del Valle
Composition by Cardinal Type Service, New York
Printed by Eastern Press, New Haven, Connecticut

PHOTOGRAPH CREDITS
Geoffrey Clements, and Will Brown, Joseph Crilley,
Jerome Drown, Frick Art Reference Library, D. Gulick,
Helga Photo Studio, Piaget, John D. Schiff,
Joseph Szaszfai, Taylor and Dull, Malcolm Varon